Neck *Relief* Now!

Robert L. Swezey, MD, FACP, FACR

Annette Swezey, MSPH, CHES

(Inside Front Cover)

Neck *Relief* Now!

Robert L. Swezey, MD, FACP, FACR
and Annette Swezey, MSPH, CHES

Illustrations by Michael Everitt

Cequal Publishing Company
Santa Monica, California

Published by Cequal Publishers

Santa Monica, California

This book represents the authors' opinions and best advice to neck pain sufferers. The guidelines that we give you to help assess your pain level and determine appropriate treatment strategies are designed to inform you as to what steps you can take to help relieve your neck pain. The danger of self-diagnosis and self-treatment is all too apparent. The information in this book should be used in conjunction with the advice and consent of your physician. In the final analysis, only your physician knows your case and can determine what is best for you.

Library of Congress Cataloging-in-Publication Data

Swezey, Robert L.

Neck Relief Now!

Robert L. Swezey and Annette M. Swezey.

-1st ed.

p. cm.

ISBN 1-881206-08-4

1. Neck Pain 2. Neck Ache ---

10 9 8 7 6 5 4 3 2

First Edition

To our beloved parents,
Dr. Samuel and Birdie Swezey, and Jack and Pauline Maler,
and to the memory of our dear nephew, Steven Maler.

A PAIN IN THE NECK is no joke. Anyone who has suffered from neck pain recognizes why it has become a symbol and a metaphor for any particularly distressful and debilitating experience.

In contrast, our experience over the years of diagnosing and treating neck pain at the Arthritis and Back Pain Center (The Swezey Institute) in Santa Monica, California, has proven to be most gratifying - and anything but a pain in the neck.

The positive reception of our book *Good News for Bad Backs* by physicians and patients alike motivated us to now share with you our knowledge and expertise and the techniques to help you help your body heal neck pain.

We thank all of our patients, staff and colleagues who helped make *Neck Relief Now!* a reality. We especially want to thank Michael Everitt for his superb design, illustrations, and editing, and Susan Anderson who helped put our thoughts and words on paper.

It is our hope that our patients and our co-workers' contributions will be rewarded by the help that you receive from this book.

Thanks to you all.

"What a pain in the neck!"

That's a universal expression of frustration, but what if the pain *is* in the neck? Then you have a painfully frustrating problem and you will want *Neck Relief Now*!

There are many kinds of pains in the neck. They can include the next door neighbor, a stressful day at work, or a neck that is so painful that even the slightest movement can cause excruciating pain.

When skeletal, muscular and nerve tissue in the neck are painfully irritated, we can experience neck pain and/or muscle spasms (tight knots in the muscles), and we may also have numbnesss or weakness in the shoulders, arms or hands. More often with milder neck conditions, we experience only annoying aching or stiffness at times when the neck is strained. This can occur while dressing or driving, when working at a computer, doing routine chores or even just watching TV.

Sometimes a pain in the neck is an indication of a more serious condition that needs prompt diagnosis and treatment.

Whatever is causing you to have neck pain, whether it is the result of a whiplash, arthritis or a neck strain, or even when neck pain results from the stress of coping with someone who is a "pain in the neck," *Neck Relief Now!* can help you discover the cause and guide you to the proper treatment, including special exercises, for anything from a mild to severe neck pain problem.

Neck Relief Now! will help you understand what goes on inside your neck and why it hurts. It will help you determine if your neck pain is *Severe, Moderate, Mild* or *Minimal* and it will tell you what to do to get relief, no matter how severe your neck pain.

Neck Relief Now! gives you the up-to-date information on diagnosing and treating neck pain disorders with emphasis on the *nonsurgical management* developed over many years at the world renowned Swezey Institute's Arthritis and Back Pain Center in Santa Monica, California.

The Easy Guide to Neck *Relief* Now!

- Find out what might be causing your neck pain.

- Discover how to relieve the pain and control the underlying causes.

- List your concerns before you visit your doctor.

- Anticipate questions from Specialists.

- Learn about the false alarms and blind alleys that neck pain sufferers sometimes face.

- Recognize the physical and the psychological aspects of neck pain.

- Review basic neck anatomy.

- Understand **your** neck problem.

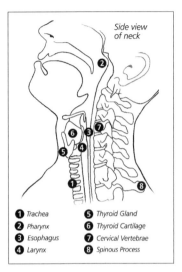

Side view of neck

❶ Trachea	❺ Thyroid Gland
❷ Pharynx	❻ Thyroid Cartilage
❸ Esophagus	❼ Cervical Vertebrae
❹ Larynx	❽ Spinous Process

Find out the best
- medications,
- exercises and
- techniques for dealing with your level of pain.

- *Decision Points*

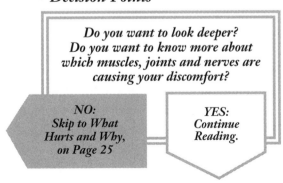

Do you want to look deeper?
Do you want to know more about
which muscles, joints and nerves are
causing your discomfort?

NO:
Skip to What
Hurts and Why,
on Page 25

YES:
Continue
Reading.

- Skip parts that don't apply to you - Clearly marked decision points help *you* decide what's important and relevant for *you* to read.

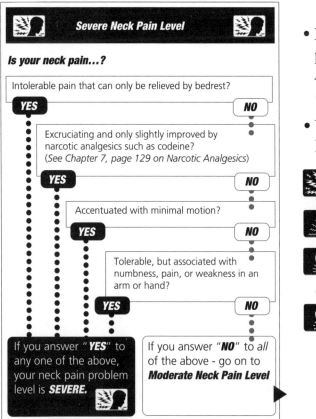

Severe Neck Pain Level

Is your neck pain...?

Intolerable pain that can only be relieved by bedrest?

YES **NO**

Excruciating and only slightly improved by narcotic analgesics such as codeine?
(See Chapter 7, page 129 on Narcotic Analgesics)

YES **NO**

Accentuated with minimal motion?

YES **NO**

Tolerable, but associated with numbness, pain, or weakness in an arm or hand?

YES **NO**

If you answer "**YES**" to any one of the above, your neck pain problem level is **SEVERE**.

If you answer "**NO**" to *all* of the above - go on to **Moderate Neck Pain Level**

• **Determine** your personal *Neck Pain Level.* *(Chapter 4)*

• Your Neck Pain Level may be:

SEVERE

moderate

mild

or

minimal

Assisted Neck Forward Flexion Stretch (Head Hang)

Purpose: To loosen and stretch tense and tight muscles and ligaments at the back of neck and upper back by gravity assisted stretch. To increase motion of neck as it bends forward. To relieve chronic tension and strain.

• Do the **Exercises** in Chapters 10 & 11 that are right for your pain level.

• Most of all - find out what you can do to enjoy -

Neck *Relief* Now!

Neck *Relief* Now!

Chapter 1 Page
The Anatomy of a Pain in the Neck **1**

Chapter 2
**Is it Just a Pain in the Neck,
or Should I be Worrying?** **25**

Chapter 3
Are You Sure it Isn't Arthritis? **39**

Chapter 4
**But I *Still* have a Pain in the Neck.
How Can I Tell How Serious it is?** **51**

Chapter 5
Diagnosis-What's Really Wrong? **85**

Chapter 6
Now What Should I Do About It? **103**

Chapter 7
Medication for Neck Pain Relief **125**

Chapter 8
The Gravity of Neck Posture**141**

Chapter 9
Ergonomics — Necks at Work **145**

Chapter 10
Exercise for Relief and Recovery**189**

Chapter 11
Exercise for Fun . **235**

Resources . **247**

Index . **253**

Chapter 1

The Anatomy of a Pain in the Neck

What does the neck do for us?

It's definitely there to turn the head. You might possibly notice the Adam's apple bobbing when you feel tense or even choked up. But once you get a pain in the neck – or a stiff neck – and start to feel around to where it hurts, or turn your neck in various directions to see what makes it hurt, a lot of anatomy that you're probably not aware of comes to hand. A little knowledge of anatomy can then come in handy.

We are definitely more than skin and bones.

O.K. - let's take a look.

Hold your head up.
It takes *muscle* action and *ligament* function to position your head over the *cervical vertebrae* (neck bones). Now, take in a deep breath - that sucks the air right down your windpipe (*trachea*). Swallow hard - you're working your lower *pharynx* and upper *esophagus* right behind your trachea. Now speak up and "say your piece."

Side view of neck

❶ Trachea ❺ Thyroid Gland
❷ Pharynx ❻ Thyroid Cartilage
❸ Esophagus ❼ Cervical Vertebrae
❹ Larynx ❽ Spinous Process

That uses your *larynx,* the voice box that bobs up and down when you clear your throat. All this activity is going on in your neck.

Well, there's more — If the thought of learning anatomy gives you a tight feeling in the throat, that is a subtle clue to the vital importance of the structures of the neck. Do you feel nervous and shaky? It may be that your *thyroid gland* which is just below your Adam's apple (*thyroid cartilage*) is overworking. Do you

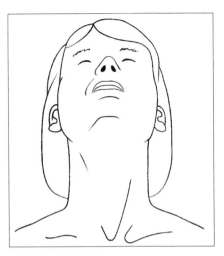

Bones

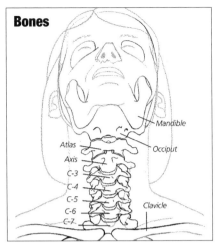

Mandible

Atlas
Occiput
Axis
C-3
C-4
C-5
C-6
Clavicle
C-7

Nerves

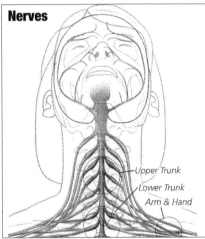

Upper Trunk
Lower Trunk
Arm & Hand

Arteries

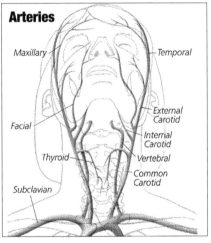

Maxillary
Temporal

External
Carotid
Facial
Internal
Carotid
Thyroid
Vertebral
Common
Carotid
Subclavian

Muscles

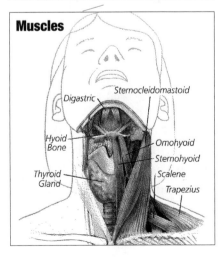

Digastric
Sternocleidomastoid

Hyoid
Bone
Omohyoid
Sternohyoid
Thyroid
Gland
Scalene
Trapezius

Lymph Nodes Veins

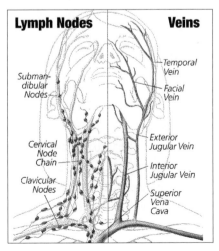

Subman-
dibular
Nodes
Temporal
Vein

Facial
Vein
Cervical
Node
Chain
Exterior
Jugular Vein
Clavicular
Nodes
Interior
Jugular Vein
Superior
Vena
Cava

feel light-headed, dizzy or actually faint? It could be that there is a spasm or obstruction of the *carotid arteries* that carry blood from the heart into your brain. Do you feel numb or weak in your arms or legs? This could result from pressure on the *spinal cord* or nerves in the neck from a disc, or arthritis, or even from a tumor. Do you have cold, sweaty palms? This is probably from stimulation of the small nerves that control circulation and transmit pain messages called the *sympathetic nerves*. Yes, they too originate in your neck and become overstimulated by nervousness or by cold weather.

Do you have a sore throat or tender swollen glands around your neck? These are the *lymph glands* that drain infection from the throat, often swelling and becoming tender. There's a lot more going on in your neck than meets the eye.

The Behind the Scenes Drama of the Neck

Like a play or a movie, coordinating staging, musical background, acting and scripting are all functions of many small and unseen players whose efforts are critical to what is seen on the stage or screen. Without the interactions of our vital organs in the neck, including the tongue, the windpipe, the voice box, the esophagus (swallowing), the spinal cord, the nerves and muscles, we would not exist. But even if we existed, we could not coordinate all the functions of the neck responsible for eating, seeing, hearing, smelling, talking and singing that result from the ability to position and hold in optimal alignment our heads. The neck supports the head and the brain, the most essential organ of all.

The neck is a lot more than skin and bones and it does a lot more than just hold your head up. Let's take a closer look at the neck. First identify those structures just below the skin. Then we can probe deeper until we actually reach the spinal column and the major nerves of the neck. Although many of the vital neck organs

and structures literally determine whether we will live or die, we will mainly focus on the typical pain in the neck and the muscles, nerves and skeletal structures that usually account for this pain.

Are You Interested In Knowing More About The Inside Story Of Your Neck?

YES:
Continue Reading.

NO:
Skip To Chapter 2,
Is it Just a Pain in the Neck, or Should I be Worrying? on Page 25.

Poking and Prodding (Palpation)

Before you begin poking and prodding, remember, if you have a sore neck, be gentle. Put your hands behind your neck. Feel the middle of the bottom of the back of the skull (the *occiput).* Now bend your head downward and press just below the occiput in the midline of the back of the neck and you can feel a bump.

That is the *spinous process* of the *second cervical vertebra -* the *axis.* The axis allows your head to turn around and helps the *atlas* (the first cervical vertebra) support the occiput. With your head still down, you can barely feel the small bumps of the third, fourth, fifth and sixth spinous processes, and then you should usually be able to feel the spine of the seventh

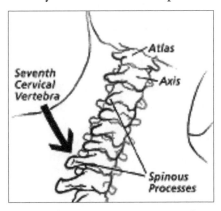

You can feel the spinous processes under the skin of the back of your neck

and last cervical vertebrae. Alongside of the spines of the cervical vertebrae you can feel the thick muscle mass of the *paraspinal* ("along the spine") *muscles* and the upper *trapezius muscles* (which reach down to your shoulder blades), but cannot be readily distinguished as individual muscles. Raise your head up and notice as you twist your head from side to

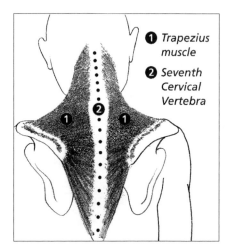

❶ *Trapezius muscle*

❷ *Seventh Cervical Vertebra*

side, the spine of the *seventh cervical vertebra* is the last one that you can feel moving from side to side. The spines of the thoracic vertebrae, in contrast, by virtue of their rib attachments, and the rib attachments to the breast bone (or sternum), move so slightly that it is difficult to detect any motion between them.

Do you feel "it" in your bones? Probably not, but there is a lot going on in your bones that starts in your neck. The *parathyroid glands,* which lie just behind the thyroid gland, secrete an essential hormone called *parathormone* which regulates the amount of calcium in your blood and in your bones. Calcium is essential to all bodily functions and is also essential to maintaining the structure of bones and thereby preventing osteoporosis and fractures. So what is "it" you are feeling in your bones? Is "it" an intuition which has nothing to do with calcium, or is "it" pain from a fracture that occurred because your bones have insufficient calcium, or from other causes?

So as usual when we poke and prod we discover more evidence that we are much more than skin and bones.

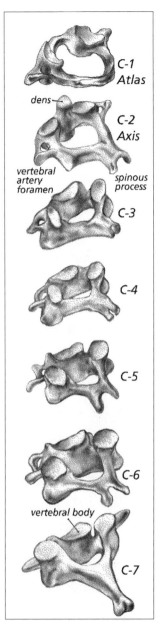

C-1
Atlas

dens

C-2
Axis

vertebral
artery
foramen

spinous
process

C-3

C-4

C-5

C-6

vertebral body

C-7

Skin and Bones and Much More

Let's start with the bones. If you are a warm-blooded creature, whether you're a giraffe, a guinea pig, or a human, you can bet on it - you will only have seven neck bones (**_cervical vertebrae_**). And seven will not become eleven even if you are a giraffe. As far as the bones in the neck are concerned, that is the long and the short of it.

The first cervical vertebra is a ring-like structure with flat sockets on either side that cradle rounded knobs on the base of the skull. This bone is known as the **_atlas (C1),_** because like Atlas, it holds your head for all the world to see on its "shoulders." (Remember when you were prodding and poking? Because the ring-like atlas does not have a spinous process, it is very difficult to feel.) The second cervical vertebrae called the **_axis (C2)_** has a large spinous process that is easy to feel. It is also the largest one. It has a long tooth-like projection at the top that connects with and serves as the pivot (the axis) for rotation of the atlas and, therefore, the head and neck. The tooth-like projection is called the **_dens_** as in "dentistry."

Whether we nod our heads, or look up, or turn to the side, about 50% of neck motion occurs between the base of the skull (the **_occiput_**) and the atlas and the axis. Motion beyond that occurs in

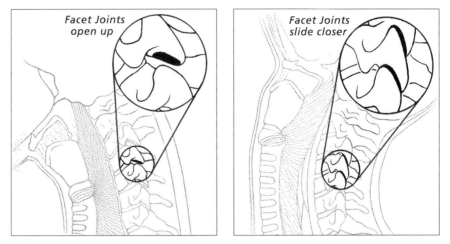

Facet Joints open up

Facet Joints slide closer

the remainder of the cervical spine from below *C2* (the second cervical vertebra) through *C7* (the seventh cervical vertebra).

Our necks are constructed so that we can bend our heads further forward than we can extend them backwards. Because of the arrangement of the small facet joints located behind the vertebral bodies, side bending is always accompanied with some rotation, and rotation of the neck and head is always accompanied with some side bending.

Of practical importance is that bending the head forward tends to open up the canals, or channels, through which the spinal nerves move. This is the reason why neck bracing, or the use of a "cervical collar", is usually done with the head tilted slightly downward (See *Cervical Collars*, page 110).

The Muscles, Tendons and Ligaments of the Head and Neck

The muscles of the head and neck work like a symphony orchestra. The movement is conducted by the brain, and the spinal cord is the conductor's baton. The orchestra is the many muscles large and small that stabilize the neck, move the neck in any direction, and turn it ever so slightly or ever so quickly. All these

movements occur without the
need for conscious awareness
on our part. Muscles, like
musical instruments, come in
many shapes and sizes. Each
arranged in a manner to per-
form its task when called

Wrist-Finger
Tendons

upon to allow for the smooth and rhythmical flow of body move-
ment (*See* **What You See Isn't all of what You Get,** *page 20, and*
the **Extended Muscle List,** *page 16*).

Each muscle has at either end a ***tendon.*** This can be a broad
band of tissue attaching to bone, or a tendon can be a fine string-
like strand connected to a bone. Take a look at the undersurface
of your wrist. As you make a fist, bend your hand toward you and
you can see some of those string-like tendons pop out beneath
your skin. The tendons are rigid and do not move unless the
muscle tightens, shortens, and pulls on them.

Anterior
Longitudinal
Ligament

The ligaments hold the skele-
tal bones together and allow
for varying amounts of move-
ment depending on how
they're arranged. The muscles,
pulling on their tendons, con-
tract with varying degrees of
intensity to position and move
the head, neck and all other
structures in the body.

So whether it's a sprained ankle ligament, a tennis elbow tendon
tear, or a strained muscle in the neck, the same principles of
injury and response occur. When they are applied to the neck,
they can be a real pain in the neck.

Ligaments, The Right Connections

An archeologist will tell you that it is rare to find an ancient skeleton that is still intact. Mummies from Egypt, or natural mummies frozen in the Arctic or dried in the deserts, sometimes can preserve much of the body's structure and keep the bones attached. With those rare exceptions, once dead and buried, nothing remains but the bones, loose and in disarray. The binding connections of the ligaments have disintegrated and the bones are no longer attached. So it's the ligaments that form the fibrous and sometimes slightly elastic struts and bindings that hold the bones together. They determine how far one bone can move over the adjacent bone at its joint surface, and thereby prevent excessive movement, dislocations and injuries.

Each ligament in the spine is engineered to do a specific job. Some ligaments are heavy and rigid, while others are delicate and elastic, but each ligament is designed with a purpose. If we are exhausted, and our head hangs down with the muscles relaxed, it's the ligaments that keep everything in place. By the same token, if there has been an injury to the ligaments, then a prolonged postural strain will fatigue the muscles that support the head and neck. Tilting your head back (when seated too close to the screen at the movies) or forward (working the computer without your glasses on) for too long can produce ligament strain and aches and pain.

What about the Discs?

The *discs* are natural shock absorbers placed between the vertebrae connecting each vertebra to the ones adjacent to it. The discs consist of rings of heavy fibrous tissue that surround and contain the gooey inner, shock-absorbing, molasses-like center cushion. They allow for a few degrees of movement between the

vertebrae and help to cushion against any jolts and strains that might occur. The outer disc border is a unique ligament consisting of rings of dense, slightly elastic fibrous connective tissue.

Do you want to look deeper?
Do you want to know more about which muscles, joints and nerves are causing your discomfort?

YES:
Continue Reading.

NO:
skip to Is it Just a Pain in the Neck? on page 25

The Vital Link in the Spinal Cord and the Hangman's Noose

The Spinal Canal

The spinal canal is essentially a tunnel below the skull that runs behind the main body of each of the vertebrae and the discs. The vertebrae and discs form the floor of the tunnel. The side walls are small bones *(pedicles)* attached to either side of the vertebrae. From the pedicles, the wing-like side projections called ***transverse processes*** emerge. The ***vertebral arteries*** run up from the heart, following along the sides of the vertebrae to the brain by passing through the wing-like projections (transverse processes) just below the ***facet joints***. The facet joints are located on the outer and back sides of the spinal canal where they guide the bending and

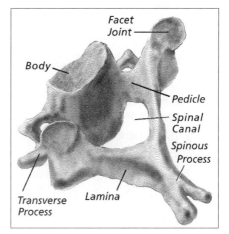

Facet Joint

Body

Pedicle

Spinal Canal

Spinous Process

Transverse Process

Lamina

twisting motions of the vertebrae. Connected with the pedicles and forming the roof of the tunnel are plates of flattened bone called *laminae* (because of their flat table-like structure). Where two laminae meet behind to form the dome of the tunnel, a spinous process is connected. This forms the bony part of the spine that you can poke at the back of your neck.

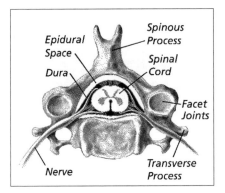

The Epidural Space

In the neck the spinal canal is a relatively narrow tunnel for the vital *spinal cord* which runs through it. It does not leave much room for bulging discs that can press back between the bodies of the vertebra and into the spinal canal. The *epidural space* is a narrow space that lies between the ligaments that cover the inner walls of the spinal column (the vertebral bodies, the pedicles and the laminae) and the *dura* (the firm plastic-like tube that holds the spinal fluid and shields the spinal cord).

The epidural space consists of loose connective tissue, fat, and small blood vessels. It serves as an additional cushion for the spinal cord and nerve roots to protect against a bulging disc. Injections of corticosteroids (cortisone-like drugs) are sometimes placed in the epidural space to reduce inflammation and swelling from a ruptured disc. This can relieve the pressure on a swollen cervical nerve root (*See Medications, page 59*).

If the ligaments that support the discs and hold the vertebrae in position are weakened by previous injury or disease there may be slippage of one vertebra over another. Similiarly, if there has been an overgrowth of bone at the edges of the discs or at the facet joints secondary to wear-and-tear arthritis, then a bony pressure on the spinal cord or nerves can occur. This is particularly apt to occur when the neck is bent or twisted. Even more

commonly, pressure from swollen ligaments and bone hypertrophy can cause a pinching of the cervical nerves within the *foramina* (the small channels that protect the nerve roots as they pass beyond the vertebrae into the soft tissues of the neck). This can result in numbness and/or weakness and pain extending into the shoulder and arm, or hand.

Although there are only seven cervical vertebrae, there are actually *eight* cervical nerves on either side of the neck. They run from the cervical spinal cord up into the scalp, into the neck, and into the shoulders, arms and hands. From the first cervical vertebra through the seventh cervical vertebra, the nerve on either side emerges over the top of the vertebra; but at the seventh cervical vertebra, an eighth cervical nerve emerges below the vertebra. From the seventh vertebrae downward in the dorsal and lumbar spine, one pair of nerves per vertebra emerge at the level of the disc.

The Hangman's Noose Takes Your Breath Away

The most vital nerves to emerge from the neck are the *phrenic* nerves. As they cause the muscles of the *diaphragm* to contract and expand the lungs, they are therefore essential to normal breathing. If both phrenic nerves are crushed or paralyzed, death will result unless a respirator is immediately available (*See It Takes a Lot of Nerve to get a Pain in the Neck, page 14*).

The phrenic nerves are formed by branches of the third, fourth, and fifth cervical nerves. It is this anatomical arrangement that allows the hangman to successfully ply his craft. He draws the knot of the noose tight under the jaw, where it is held in position by a sliding ring. He then pulls the lever, allowing the prisoner to fall through a trap, thereby fracturing, or dislocating, the first three cervical vertebrae. The vital centers in the spinal cord are crushed, eliminating any possibility for breathing.

The Cervical Nerves at work

So the cervical nerves are essential not only to life, but to all functions of the neck, arms and hands. The messages that our fingertips send back through the nerves to our spinal cord and up to and back from the brain result in our reacting to a painful finger burn by quickly withdrawing the arm and hand. Messages directly from the brain through the spinal cord to the hand might cause us to reach out to grasp a treasure. The nerves that emerge from the spinal cord in the neck spread out like branches on a tree to the fingertips. They carry messages to all the muscles and tissues of the upper extremities and back to the spinal cord and brain. So without these messages passing back and forth through the nerves to our brain, we would have much less to think about - no pain, but no gain!

It Takes a Lot of Nerve to Get a Pain in the Neck

The Territorial Domain of the Cervical Nerves

Yes, it takes a lot of nerve because nerves must branch out from the spinal cord to cover the body. Each nerve root has its own region on the body with some overlap with the adjacent nerves.

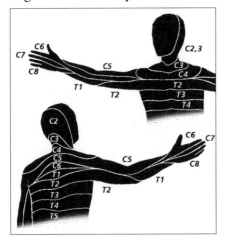

For example, if the sixth cervical nerve root is irritated or pinched, you may have pain radiating down the arm to the thumb. This may be associated with some numbness of the thumb side of the arm and of the thumb, a weakening of the biceps muscle and the muscles that extend the wrist, and impairment of the biceps tendon reflex. Whereas, if the

eighth cervical nerve root was compressed it would affect the middle and ring fingers and the adjacent portions of the arm and hand. So a sixth cervical nerve injury could give you a numb thumb and difficulty in pinching or writing, while an eighth nerve injury might make it impossible to play the guitar or to type using all of your fingers.

Do you want to look still deeper?

YES:
Read On...

NO:
Skip to More Poking and Prodding, on Page 21

Take a Look in the Mirror

Facing the mirror, with your chin up slightly and your shirt or blouse loosened, the area in question lies below your chin and above your collarbones. In that region, all of the major body organs of the neck with the exception of the spinal cord, lie in front of the vertebrae of the neck. Take a good look in the mirror, and then push your chin out forcibly. You will see bands of muscles in the front of your neck tighten and stand out. These are the fibers of the *platysma* muscle which lies just beneath the skin. This muscle functions much like the facial muscles, tensing the skin of the neck to express anger, fear, or excitement. You also contract the platysma to relieve the choking feeling of a too tight collar.

Remember the lump that you noted in the middle of your neck moving as you swallow or talk. This is the *thyroid cartilage* which covers the larynx or voice box. You may also be able to actually see the outline of your thyroid gland just below and on either side of the thyroid cartilage as you tilt your head back and swallow (*See More Poking and Prodding, page 21*).

digastric muscle
myohyoid muscle
hyoid bone
sternohyoid muscle
omohyoid muscle
longus capitus muscle
thyroid cartilage
cricothyroid muscle and ligament
thyroid gland
subclavius muscle
clavicle (collarbone)

facial artery and vein
levator scapulea muscle
scalenus medius muscle
comon carotid artery and jugular vein
omohyoid muscle
bottom of sternocleidomastoid muscle
trapezius muscle

In terms of muscles alone, the list below makes it clear there is a lot more beneath the surface:

The Extended Muscle List

To **extend** the neck there is the:

1 *splenius capitis*
2 *splenius cervicis*
3 *semispinalis capitis*
4 *semispinalis cervicis*
5 *longissimus capitis*
6 *longissimus cervicis*
7 *interspinalis rectus capitis*
8 *posterior major rectus capitis*
9 *posterior minor rectus capitis*
10 *oliquus capitis superior*

To **flex** the neck, in addition to the *sternomastoid*, there is the:

11 *longus colli*
12 *longus capitis*
13 *rectus capitis anterior*
14 *iliocostalis cervicis multifide*
15 *intertransversarii obliquus capitis*
16 *inferior obliquus capitis*
17 *superior obliquus capitis*
18 *superior rectus capitis lateralis*
19 *thyrohyoid*
20 *omohyoid*
21 *thyrohyoid muscle*

Turn your head to the right or left and you will see a thick strap of muscle extending from just below the ear behind the jaw (the *mastoid* bone) to where it attaches to the breast bone (or *sternum*). This is the *sternomastoid,* or *sternocleidomastoid* (*sterno* = breast bone; *cleido* = collar bone) muscle, a major neck muscle that turns your head to the side opposite of the contracting muscle. It also helps to tilt your head to the side. When both sternocleidomastoid muscles contract simultaneously, they will tilt your head forward, or tilt and turn your head to one side, depending on which muscle contracts the strongest.

Check out more Muscles on your own Neck

It has been calculated that your neck moves about six hundred times every hour day and night. It is obvious therefore that the neck is a busy place and at any point in time there is a lot going on there.

Take a deep breath. You may see the bare outlines of some small strap-like muscles on the side of your neck that lie just behind the sternomastoids (or sternocleidomastoid muscles). These are the *scalene muscles* and are important in assisting the sternomastoid muscles in head turning and side bending. These muscles are attached to the transverse processes (wing-like projections) that jut out at the sides of the third through sixth cervical vertebrae. They also attach to the first and second ribs. The scalene muscles are very important in assisting deep breathing. By pulling upward on the upper chest, they help fully expand the lungs. Very rarely these muscles are misaligned in their attachments to the upper ribs and can create a taut band that squeezes the blood vessels and a network of nerves (called the *brachial plexus*) that passes from the neck through the scalene muscles out to the arm. Sometimes this can cause the so-called *Thoracic Outlet Syndrome (TOS).* This can lead to numbness and weakness and even more rarely, circulatory changes in the arm similar to the much more common nerve pinch that occurs from a disc

For **rotation** and **lateral flexion**, in addition to the *sternomastoid*, there is the:

22 *scalene group*
23 *splenius capitis*
24 *splenius cervicis*
25 *longissimus capitis*
26 *levator scapulae*
27 *longus colli*

And if that is not enough, there are the:

28 *mylohyoid*
29 *digastric*
30 *sternohyoid*
31 *sternothyroid*

splenius capitus muscle

semispinalis capitis muscle

splenius cervicus muscle

levator scapulae muscle

sternocleidomastoid muscle

splenius capitus muscle

trapezius muscle

in the neck. Interestingly, these tissues and the blood vessels along the sides of the neck are also vulnerable to injury by the over-the-shoulder seat belt strap — nothing is perfect, and that too can be a pain in the neck.

If you need to take a deep breath and sigh, the scalene muscles are in the neck for that. If you have to duck your head, there are muscles there (the sternomastoids) to help you do it, and if you want to hold your head high, there are muscles (the upper trapezeii) to help with that too. If your pain in the neck makes you want to scream out, there are muscles there to help you do it. If you are tense and choke up, there are muscles there to help make that happen.

Shrug your shoulders up and you will notice the muscles on both sides of the back of your neck that are attached to the shoulder blades hunching up on either side. These are the upper portions of the trapezius muscles (the "traps") that run from the neck and thoracic spine to the shoulder blades. The trapezius muscles assist in head turning, bending the head backward and play a major role in positioning the shoulder blades for activities of the upper arms.

> *Do you want to probe still deeper into the mysteries of the neck? Do you want to learn even more about neck muscles, neck joints and the normal lumps and glands and the abnormal swollen glands in your neck?*

YES:
Read on about more muscles, facet joints and neurocentral joints. Learn how to find your trachea, voice box and thyroid gland and learn when a swollen gland in your neck demands medical attention.

NO:
Skip ahead to More Poking and Prodding, on Page 21

From the standpoint of relieving your pain in the neck, you've got to condition the muscles to hold your head in good postural alignment. We'll teach you more about that in Chapter 7 (*See* ***Exercise for Relief and Recovery***, *page 187*).

What you See isn't all of what you Get

The very powerful muscles which lie still deeper in the neck are called ***paraspinal muscles.*** These muscles help turn the head and help support the neck. There are large muscles on either side of the back of the neck called the ***levator scapulae*** (shoulder blade elevators) which also play an important role in raising and positioning the shoulder blades so that the arm can function in activities such as reaching, throwing, punching or holding (*see page 18*). There are many other small muscles that help to turn, twist, and hold the head and neck in various positions. And last, but not least, are the small strap-like neck muscles that attach to the ***hyoid bone*** just behind the chin which support and position the tongue for everything from licking to swallowing (*see page 16*).

Big Words for Small Joints

Zygapophyseal (facet joint): The *zygapophyseal,* or facet joints, (*see page 11*) are small joints located at the outer edges of the bony plate, or lamina, that overlies the neural canal through which the spinal cord runs. These joints, about one-half the size of your fingertip joints, lie on either side of the neck and have flattened or faceted inner surfaces. They permit a few degrees of motion in rotation, bending or extending the neck. From the inner edge of the facet joints, small fibrous pads called ***menisci*** protrude partway into the joint. They somewhat resemble the cartilages at the edges of the knee joints. Like those cartilages they can be pinched by a sudden unguarded twist of the head, as

might occur in turning over in bed. A careful therapeutic manipulation will sometimes shorten the duration of residual discomfort when the symptoms do not subside promptly (*See **Manipulation**, page 114*).

A pinched facet fat pad can be quite painful, but it does not lead to further facet joint problems. Like all joints, the facet joints will undergo degenerative or osteoarthritic changes after injury, or with the normal wear and tear effects of aging, but only rarely are osteoarthritic facet joints a source of neck pain.

Uncovertebral Joint/Neurocentral Joint/Joints of Luschka:
The joint is called the *joint of Luschka* because many years ago the German anatomist Hubert von Luschka described it in detail. It is called the ***uncovertebral joint*** because it has a hooklike projection (an uncus) that is found on either side on the front of the upper portion of each vertebrae. These joints are not present at birth, and only appear at around age ten. As we get older, the hooklike projections squeeze the back edges of the disc to form a pair of joints against the lower side of the vertebra above them. They are called ***neurocentral*** joints. *Central* because they are located adjacent to the disc near the central portion of the vertebrae. *Neural* because the cervical nerve emerges in the cervical canal just behind and is protected by the ***uncinate process***, or uncus. An important aspect of these joints is that although they commonly show osteoarthritic changes as we age, they are rarely associated with neck pain.

More Poking and Prodding

Slide your fingers about 2 inches forward from the back of your neck and push deeply into the sides of your neck. You may be able to feel small, nodular bumps at each level of your cervical spine. They can be slightly tender when you poke them. These are the transverse processes of the cervical vertebrae and

although you can't feel this, these transverse processes have little tunnels through which the vertebral arteries that deliver blood from the heart to the brain pass.

Move your fingers forward, just in front of the sternomastoid muscle and you will feel a strong pulse. This is the ***carotid artery***, the major blood supplier to the brain (*See Page 3*).

Now slide your fingers to the front of the neck and just below the back of the jaw on either side. You may be able to feel a hard object that you can move slightly from side to side. This is the outer edge of a horseshoe-shaped bone, the ***hyoid bone*** which supports the tongue and which you can feel moving up and down as you talk or swallow.

So, to summarize: the normal lumps and bumps that you can feel in your neck include the hyoid bone at the top; the thyroid cartilage which is the big Adam's apple in front that houses the larynx, or voice box; and the cricoid cartilage which, like the thyroid cartilage, has a firm plastic-like feel and lies at the top of the trachea, or windpipe. On either side of the trachea, a firm fleshy tissue can sometimes be felt. There also may be a similar band of tissue that can be felt crossing in front of the upper portion of the trachea. This is the ***thyroid gland*** and the band is called the *isthmus* of the thyroid. Sometimes the thyroid can swell and form a goiter, and nodules or tumors can also occur there.

With the exception of abnormally large thyroids, or goiters, or hard tumors in the thyroid, the lumps and bumps that we have talked about are normal anatomical features. These do not represent any disease or abnormal musculoskeletal condition of the neck.

Lumps and Swollen Glands

There are two other common lumps and bumps which you may discover if you are poking around your neck. It is not uncommon to feel pea-to-almond-sized firm nodules deep in the tissues on the front or sides of the neck. These are swollen lymph glands and they will typically enlarge during an episode of tonsillitis or pharyngitis. Sometimes after an infected tooth or tonsillitis these glands may remain swollen for a considerable period of time. Persistent swelling of these firm, typically slightly movable, deep nodules can also be indicative of a more serious condition such as a tumor affecting the lymph glands. Have your doctor check any questionable lumps or swollen glands in the neck or elsewhere.

You've now had an in-depth look and literally a good feel for how the neck works. But if it isn't working right, or if it is giving you pain, it can definitely worry you. Chapter 2 will help you sort out when a pain in the neck is worth worrying about.

Chapter 2

Is it just a Pain in the Neck, or should I be Worrying?

It has been said that, "Worry is the interest that you pay on a debt that you never incurred." But sometimes there is a real cause for concern - more than just a pain in the neck. There are danger signals that should definitely get your attention.

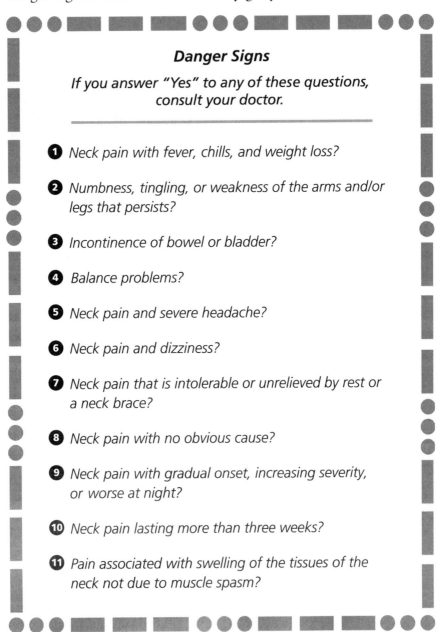

Danger Signs

If you answer "Yes" to any of these questions, consult your doctor.

1 Neck pain with fever, chills, and weight loss?

2 Numbness, tingling, or weakness of the arms and/or legs that persists?

3 Incontinence of bowel or bladder?

4 Balance problems?

5 Neck pain and severe headache?

6 Neck pain and dizziness?

7 Neck pain that is intolerable or unrelieved by rest or a neck brace?

8 Neck pain with no obvious cause?

9 Neck pain with gradual onset, increasing severity, or worse at night?

10 Neck pain lasting more than three weeks?

11 Pain associated with swelling of the tissues of the neck not due to muscle spasm?

If it wasn't Whiplash, then How did I Get it?

What if it was a whiplash? Why does it hurt? In the days of the horse and buggy there were plenty of whips being lashed but the term "whiplash" as applied to the neck had not yet been invented. The pace of life was slower and the number of carriages on the road was fewer. There were no traffic lights and no freeway traffic jams to create the conditions for sudden stops and consequent rearendings and other collisions.

The carriage driver's long whip would uncoil backwards and then snap forward in a sudden cracking sound. Unlike the highly flexible strap-like structure of a whip, the neck consists of the seven cervical vertebrae separated by discs and bound together by ligaments. These ligaments are designed to allow a small amount of movement between each vertebrae, but not the almost limitless flexibility of the whip. This means that when the neck is violently thrust forward and backward, or just backwards, or forwards, or sideways, the ligaments and muscles that normally restrain movement may be torn from their moorings on the vertebrae.

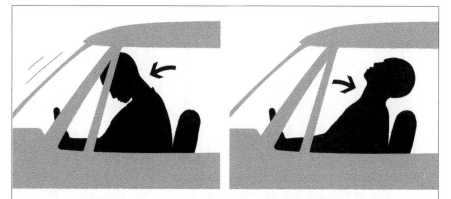

Classic whiplash is due to the head being thrown violently forward and backward in an accident

This results in painful swellings of the ligaments and deep tissues in the neck similar to what most of us have experienced in the ligaments with a sprained ankle.

Thus, a whiplash of the neck has much in common with a sprain in the ankle. They both hurt and they both tend to heal. But if the ligaments in the ankle are severely torn, they may need to be surgically repaired. Similarly, if the neck is so badly injured that healing cannot occur, surgical intervention will be required. Moreover, whereas a sprained ankle does not endanger vital structures beyond the foot, the outer ligament fibers of a sprained cervical disc can tear, allowing the disc to protrude and compress the spinal cord or spinal nerves. These tissues in turn can become injured or bruised and swollen. If the nerve tissues are bruised and swollen, they too can heal. For a period of time (weeks and occasionally months), one may experience weakness and numbness in the arm or shoulder blade as well as pain in the neck. But by and large, like a sprained ankle, this will resolve by virtue of the healing process that Nature has provided to help repair injured tissues.

Pain - Spasm - Pain

There are a number of medical (as well as legal) factors that tend to make it seem that neck pain resulting from a "whiplash" is somehow being "faked" or grossly exaggerated. It is the very subtleties and the vagaries of a whiplash that often makes it necessary to obtain both knowledgeable legal and medical information to help clarify the nature and consequences of a whiplash problem.

So, it is not difficult to see how sprained tissues can cause pain and that as a result of the painful stimulus of the injured tissues, muscles of the neck will go into spasm to restrict painful movement. It is as though nature had provided a soft collar or brace of tightened muscles to prevent painful movement and to help facilitate the healing process. The downside of this is that just as one may become weakened and stiff from prolonged wearing of a cast or brace, the muscles and ligaments that surround the discs and

support the spine weaken and may become too tight. Muscles that have gone into spasm to protect the neck may persist in their painful spasm. This is because the body now perceives the painful protective reflex muscle spasm and the local area of muscle tenderness and distress to be the actual source of pain that needs protecting, even though the injured ligaments may have actually healed. A reflex of pain-spasm-pain can then become self-perpetuating long after the worst of the neck injury has subsided (*See Myofascial Pain, page 44*). So even though Nature does an excellent job by and large, both Nature and your neck appreciate a little therapeutic help. Find out more in Chapter 6, including: *When To Get Help?, What Kind of Help Will You Need?,* and *Who Should Provide It?*

Lawyers and a Pain in the Neck

Although the word "whiplash" when applied to the neck is easily understood as derived from the snapping motion of a carriage whip, it now has a firm place in our vocabulary. It is the term for a classic injury of the neck which frequently leads to medical, and particularly legal, consequences. Few argue that there should be no compensation for injuries - whiplash or otherwise. In fact, some doctors have reported that the chance of recovery from injury that is under litigation is about half as good as when no legal action is taken[1].

Because there are no nerve endings on the inner fibers of a disc, a significant disc injury or tear can occur there without any immediate pain being felt. It can literally take several days for the swelling and further inflammation of the ligaments of the discs to reach the nerve fibers in the outer rim of the disc, and for the whiplashed neck to "cry out" in pain. Another aspect is that whereas the initial injury may have been painless and capable of self-remedying, the lack of protective pain stimuli allows the

[1]DG Borenstein, SW Weisel, and S Boden. *Neck Pain. Medical Diagnosis and Comprehensive Management*. Page 30. 1996, W.B. Saunders and Co., Philadelphia, Pennsylvania.

injured person to continue with customary activities that in and of themselves would not be harmful, but cumulatively further injure the already damaged discs and adjacent tissues. It is a little like someone with a tennis elbow who can comfortably play one set, but not two, before the strain and irritation painfully aggravate the weakened and damaged tissues where the forearm muscles attach at the sides of the elbow. "If it ain't broke, don't fix it" is always a good idea, but if your neck has taken a real jolt, you may be advised to avoid awkward neck stresses and postural strain for the next few days.

So there is a role for lawyers. We all need legal protection and we all hold in high regard the protections provided by the Constitution and the laws of the land. Nonetheless, when there is a vested interest in compensation for a painful injury, a subtle psychological painful process can, and often does, ensue. The injured person has to find a way to pay for costly medical expenses, lost time from work, and inability to function in a variety of household, vocational and recreational activities. The injured client's attorney has an interest in obtaining compensation for his/her client. Because the attorney is typically compensated on a percentage of the total settlement for the case, this creates a stimulus either consciously or unconsciously for a medical and legal process that tends to escalate the costs of care and prolong disability.

Psychological factors can again subtly creep into the picture. The whiplashed patient may become more focused on his or her pain and the suffering and disability that it causes. This can change brain function, spinal cord function and nerve function in such a way as to intensify and perpetuate a painful disorder. It is not a secret that all medical centers treating patients with chronic pain incorporate psychological help as well as medications that affect the psychological aspects of painful conditions. This does not mean that patients who have suffered acute whiplash or similar types of injuries may not develop chronic pain as a consequence.

Nor does it mean that patients who have been injured and require legal assistance that insidiously perpetuates their painful problem do not have true pain and disability. What it does mean is that the nature of the legal proceedings, the financial stakes, and the antagonistic aspects of the legal process may have negative consequences for the therapeutic outcome.

But I never had a whiplash — why me? Why a Pain in the Neck?

When you stop to think about it, from the time we were toddlers and on through childhood and adolescence into adulthood we have experienced pratfalls and somersaults. We have experienced jostling in crowds, sudden stops in traffic, falls and near falls and a myriad of minor and even a few major traumas that have faded into obscurity. Our necks have surely been buffeted about and subject to normal wear and tear and some unavoidable abuse. For most of us, fortunately, there was no major injury except, perhaps, a recent whiplash that we can recall. By the time that we are in our forties, the likelihood is that x-rays, MRIs or CAT scans will show at least some evidence of wear and tear on some of the discs and secondary osteophytes (bony outgrowths) around the discs and the small facet joints. This is most apt to be seen between the fourth through the seventh cervical vertebrae. So if you walked into the doctor's office at age 40 with a hoarse voice and he said, "Let's do an MRI," perhaps to check a problem with your larynx, the odds are that about 40% of you who have never been aware of a neck problem will show some of these abnormalities. The odds go to 50% at age 50 and approach almost 100% thereafter.

If you have looked at your feet lately, or at anyone else's, the chance of seeing a mildly arthritic bunion is about the same, and most people with bunions don't have sore feet. Some do have pain if they walk too long or wear high heels or tight shoes, but

this promptly subsides with proper foot care. But some do have sore feet all the time, particularly those who don't pay attention to proper foot wear. The same is true for the neck when poor head and neck posture (which can even be brought on by a poorly fitted hat) can literally turn an otherwise comfortable neck into a painful one.

It has been said that you can't read "ouches" on x-rays. This, with exceptions for a fracture, a major dislocation, or a tumor, is true. Very often we see x-rays and MRIs that show tremendous degenerative changes in the discs and in the adjacent bones and joints of the neck in patients who have fully recovered from their neck problem and are no longer symptomatic. What you do see on those x-rays, MRIs or other studies is evidence of the wear, tear and repair process that accompanies age, trauma and disc degeneration. The lack of suppleness and shock absorption efficiency of these worn discs and adjacent ligaments makes us potentially more vulnerable to stresses and strains. This makes us more susceptible to injury, stiffness and pain from what in the past may have been a tolerable stress.

Questions for your doctors — even if they think you're a pain in the neck.

So if the doctor looks at your x-rays and tells you that you have "a lot of arthritis" in your neck, ask for a further explanation. Question: "How long has the arthritis problem been there before my symptoms began?" Ask if the findings on x-rays, MRIs or CAT scans preclude your getting better. If the answer is, "You can't get well without surgery," be sure and get a second opinion.

Do you want more in-depth information
on Second Opinions?

NO:
Read On…

YES:
Go on to Diagnosis
on Page 85

Pain and Suffering

"Look out! It's going to hit us"!

"Are you all right"?

"I don't know - I think so. How about you"?

"I feel shaky - thank God for the seat belt."

Two people in the same car - both dazed, shaken and "whiplashed." Initially neither aware of much pain and both glad to be alive. As the day wears on, both have aches and pains, especially in their necks.

J.B., the driver, has just been laid off from work and is not getting along well with his wife. He has felt tense and stressed for the past several months. As the day progresses and with subsequent days, the neck pain and muscle spasm intensify. He sleeps fitfully, awakening with pain and/or anxiety about his future.

P.G. was initially horrified at the sight of the oncoming car, and the inevitable crash. She was dazed, shaken, and then relieved to be alive and not suffering any major painful injuries. P.G. enjoyed her work and personal life. Marriage and financial status were secure. She, too, experienced neck, back and head discomfort as the day wore on. P.G. took some analgesic medication and used cold packs. After a day of rest, P.G. was able to return to her desk work and light household activities even though she still had neck pain. Her neck symptoms were tolerable and the doctor assured her that there was no serious injury. P.G. continued to have neck discomfort for several weeks but was able to go ahead with her daily life.

J.B. also saw his physician. Although he too was told that his neck injury was not serious - he needed more and more pain medication. J.B. couldn't sleep. He was unable to look for work. The pain was relentless. He had physical therapy, acupuncture and chiropractic treatment with only a few hours of relief at best. J.B. consulted several specialists and had x-rays, blood tests, an MRI, and electrodiagnostic studies. Nothing helped. He was depressed and as the weeks progressed to months, he became a "chronic pain patient."

Although J.B. had been advised to get psychological counselling he insisted that the pain was not in his mind, that the pain was real. It was. But so was the effect of psychological stress on his pain. Finally, J.B. agreed to psychological counselling. The counselling, along with antidepressant medication and then vocational training, helped him cope with the pain and himself; and he finally was able to find work. The neck pain ceased to be the albatross around his neck. The neck pain was "no longer a pain in the neck."

Two people, side by side, may sustain the same injury to the neck, or any other part of the body for that matter. One may experience severe pain and one may be able to shrug it off and go on with what he or she was doing. One may find the pain interfering with activities to the extent that he or she is suffering from the loss of quality of life or self-esteem. The other may find ways to go about the day's activities and make the best of it, experiencing pain, but not suffering. So if you can't read the ouches on the x-rays, you certainly can't accurately assess another person's degree of pain, discomfort and suffering as a consequence of a painful neck or any other painful disorder.

Can this pain in the neck be all in my head?

If your brain wasn't working, you wouldn't feel anything, let alone pain. If your brain is working, then you know when something is painfully wrong in your neck and you have to come to grips with it. If the pain is mild and you know that you brought it on by twisting your neck or jerking your neck when you stumbled, the odds are that it won't worry you because you know that the pain will soon go away. You might use a cold pack or take an aspirin, Tylenol (acetominophen), Aleve (naproxen) or Advil (ibuprofen) just to take the edge off of it. On the other hand, if you have just recovered from a severe painful neck disorder and now, for no apparent reason, you have felt some additional twinges that really haven't gone away, your attitude about this is going to be much different.

If your personal or work situation (or both) have become very stressful, you may have experienced your neck tensing up and you may have developed tension headaches. You may have begun sleeping poorly and thrashed around in bed, twisting your head and neck in various positions and awakening with pain in the neck. You may have found that you can't perform certain functions. You can't work at your computer or drive. This creates more tension and worry for you and causes you to lose more sleep. You may have to deal with somebody that you can't stand, but you can't avoid. Dealing with that person is a "pain in the neck."

Is it all in my mind?

The practical point is that anything that causes pain in your body has to be dealt with in your mind as well. The implications of the pain, the severity of the discomfort, previous experiences, current life stresses, social and economic worries all play a role in how

the pain affects us and how we in turn respond to it. Persisting pain is not all in your mind, but it is there as well. If acute pain has threatening implications for you, and whenever chronic pain is causing relentless suffering, then psychological counselling and/or the use of medicines that relieve psychological stresses, can and should play a major role in the treatment of your pain. This is true if the pain is in the neck, or wherever else chronic, relentless pain may occur.

If I didn't have a whiplash, why am I hurting now?

Granting that as a result of multiple minor traumas and the wear and tear of daily activities, over time the neck gradually loses its resiliency and tends to develop the changes of degenerative arthritis which render it more vulnerable to otherwise tolerated stresses and strains. What are these stresses and strains that mysteriously sneak up on us and give us that pain in the neck?

RSD stands for **repetitive stress disorders**. This group of conditions in the work place accounts for at least as much pain, disability and litigation as the whiplash. There are many occupations in which one has to work with a machine which can be anything from a computer and keyboard to a heavy factory work station which requires placing the head and neck, arms, legs or back in positions that can be tolerated for short periods of time. But this may not be tolerated over a long period of time.

A Classic Example

M.J., a 40 year old legal secretary, spent many long days and even a few evenings working at her word processor.

She didn't realize that it was time for her to get new eyeglasses. The lighting at her computer station was erratic — too bright at noon and too dark in the evenings. Her chair didn't fit her and her desk was too low. Her neck and arms were hurting, her

hands were getting numb. Although the symptoms seemed mysterious to her, there was no mystery. It would have been difficult to have designed a work situation more likely to have caused RSD than her very own.

With some sustained activities, such as straining the head to look overhead, working at a keyboard that is placed too high or too low, or straining the neck twisting in a chair to properly visualize the computer while holding the hands and arms in an awkward position to manipulate the keyboard, anyone might suffer from RSD. These are issues of ergonomics which can be compounded by eye strain resulting from glare or the use of poorly fitted glasses, or glasses that are not designed for sharp vision at the distances required at a work station.

Another Case in Point

J.C. is a 50 year old physician who works long hours, and whenever possible, relaxes by playing the violin. He is quite gifted, but no real master of the violin. He practiced hard with his head bent over the instrument, his arms and hands somewhat awkwardly placed as he diligently, and often exhaustingly, sought relief from the fatigue and stress of the day. Clearly, music was therapeutic, but the repetitive stress and postural strain made severe neck and arm pain the unfortunate result. With proper instruction in stretching exercises, limiting the frequency and intensity of his practice sessions and the incorporation of good ergonomics with his violin practices (proper seating, well positioned music stand, and a specially designed violin chin rest) his practice became more enjoyable, more productive, and even the music was a little sweeter.

Traditionally most of the equipment that we use has been designed for its economy of production, ease of installation and function, and not with the question of how the employee, driver or homemaker has to adapt to the tools and equipment in order to use them. We have now learned a costly lesson in terms of

work-related injuries. This has lead to the development of the science of ergonomics (*ergo* means work, and **nomics** is shorthand for economics or efficiency). Ergonomics deals with adapting work situations and tools to the human form to enhance productivity and to minimize musculoskeletal fatigue, stresses and strain (For more on ergonomics, *see* **Ergonomics**, *page 145*).

Chapter 3

Are you Sure it isn't Arthritis?

LIKE THE BUNION, which occurs in about half of the adult population, osteoarthritis in the spine after age fifty is essentially a universal phenomenon. This is not the kind of arthritis that spreads over your body and causes crippling. This is an arthritis that is due to "wear and tear" on the discs, ligaments and vertebrae and the secondary repair by the body in which additional bone is built up around the areas that are subject to stresses and strains to "spread the load" of those stresses and strains over a wider area.

Nature seems to understand that if you take a sharp fingernail and apply it with some pressure against the skin, you will produce pain; but if you take your thumb pad and apply it with the same pressure, there will be little discomfort. So nature tends to enlarge the bony surface area where stresses and strains are applied, in order to broaden the surface that is being compressed, and thereby lessen the likelihood of irritation. By and large this works well. But in the process, the extra bone that is built up can narrow the canals that the nerves and arteries pass through or block some of the movement in the small uncovertebral joints (*See* **Big Words for Small Joints**, *page 20*) in front and the facet joints in the back of the spine. In occasional cases, particularly in people who have inherited a congenitally narrow spinal canal, the added bone actually encroaches upon and can compress the spinal cord.

So the point is that it is not unlikely that you will have some of the wear and tear, or so-called degenerative osteoarthritis in your neck. This does not imply an arthritic process that is generalized throughout the body, nor does it imply that you are going to end up with a crippling arthritis. If you are having neck or neck and arm pain, the presence of osteoarthritis on x-rays of your cervical spine may have little to do with your neck or arm pain, nor in any way preclude the possibility of your recovering from it. In fact, if you take x-rays after your neck pain is long gone, the x-

rays will still show the "arthritis," but your neck won't care (*See What About the Discs?*, *page 10*).

Arthritic Disorders of the Neck from Rare to Rarely Ever

Rare

Rheumatoid arthritis
Spondyloarthritis
 Ankylosing spondylitis
 Reiter's syndrome
 Psoriatic arthritis

Very Rare

Infections Discitis
Osteomyelitis

Rarely Ever

Gout
Pseudogout
Osteoporotic cervical fracture

Rare Neck Pain Problems

There are, however, times when arthritic diseases do affect the spine. Rheumatoid arthritis, which notoriously affects the joints of the hands, wrist and knees, can affect joints anywhere in the body and, rarely, affect the cervical spine as well. Rheumatoid arthritis can weaken the ligamentous structures that support the discs and keep the vertebrae in alignment. When the ligaments become very weak and overstretched, one cervical vertebra can begin to slide over the one below. This can lead to actual spinal cord compression. Fortunately, this too is a rare occurence.

Another group of arthritic disorders that can affect the neck are called the spondyloarthropathies (*spondylo* means spine, *arthropathies* means joint disorders). These include ankylosing spondylitis (*ankylosing* meaning fusing of joints, *spondylitis* means inflammation of the spine); Reiter's syndrome (named after Dr. Hans Reiter who described a joint inflammatory disorder that also can affect the spine and other organs); psoriatic arthritis (a skin condition that can affect the joints and even more rarely affects the spine).

Very Rare - Infections will sometimes affect the spine and produce a septic discitis (infection in a disc). Germs that pass through the blood stream can lodge in the disc. This can produce a painful, destructive disc infection that left untreated, can lead to a secondary bony infection (osteomyelitis) in the adjacent vertebrae. This disorder tends to occur in people who have a suppressed immune system as a result of the use of drugs to treat malignancies, or from AIDS, or from the use of contaminated needles by drug abusers. Septic discitis (usually accompanied by fever and pain localized to the area of the infected disc), if suspected, is readily diagnosed and requires prompt antibiotic treatment.

Rarely if ever - Gout is a notoriously painful joint disorder. Until the last century, almost all forms of arthritis were called gout. We now recognize that gout occurs only in people who accumulate an excessive amount of a normal substance (uric acid) in their bloodstreams. Excessive uric acid can then be deposited in a joint as uric acid crystals and act almost like ground glass in the joint tissues producing a severe irritative reaction. But gout is selective. Whereas it will commonly strike the big toe, it almost never affects the neck. The fact that you may have an elevation of uric acid in your blood does not mean that any joint or spinal disorder that you have will be due to gout. Gout affecting the neck is so extraordinarily rare that if your doctor has made that diagnosis, it would be advisable to seek a second opinion from a rheumatologist (arthritis specialist). You might otherwise spend your remaining days and dollars taking pills for a gouty condition that you may not have.

Osteoporosis - Not for Necks

Osteoporosis means "porous bones." Osteoporosis is known as the "silent disease" because the porous bone doesn't hurt. But the porous bone is prone to fracture and can then cause severe pain. When that occurs, osteoporosis is anything but silent. Fortunately, even though osteoporosis which affects all of the bones in the body including the neck, rarely if ever results in a fracture of the vertebrae in the neck — unless a major injury has occurred. This is in contrast with the dorsal spine (behind the chest) and the lumbar spine (small of the back) where patients with severe osteoporosis will commonly experience a fracture, often without any obvious cause. The exception to this is that if the osteoporosis in the neck is caused by a tumor, then the cervical vertebrae can become so weakened by destruction from the tumor that they will collapse and fracture.

Osteoporosis is a treatable disease. Even if it does not cause symptoms in the neck, if osteoporosis has been noted on x-rays

of your neck or elsewhere and if there is no other disease to account for it, this should be evaluated further. Although the cervical spine is not actually tested, there are several diagnostic tests for osteoporosis of which the DXA is the most precise. Then, if indicated, your physician can institute proper treatment to prevent further bone loss and the risk of the crippling effects of painful fractures elsewhere in the body.

All Too Common Pains in the Neck

Referred Pain from Within

It is well known that crushing pains in the neck, as well as pains in the jaw, arm and chest, are commonly experienced during heart attacks. Could you imagine a stomach ache causing pain in the neck? There is no doubt that having a stomach ache can be a pain in the neck, but we are talking about a real neck pain that is coming from inside your abdomen. It is well recognized that a gallbladder attack is often associated with pain above the shoulder blade. This is because the same nerve roots that supply the trapezius muscle in the neck and shoulder region, also go to the diaphragm and can become stimulated by an inflamed gallbladder just beneath it. This can be associated with muscle spasm in the trapezius muscle, in a manner similar to a painful disc in the neck, causing referred pain to the shoulder blade, shoulder or arm. Occasionally stomach acid leaks into the esophagus and causes similar symptoms.

Myofascial Pain

Most of us at one time or another have rubbed a sore spot in a muscle that was strained. The sore spot may be the actual injured tissue, like the sore ligaments of a sprained ankle, or it may be muscle soreness and spasm due to referred myofascial pain (*myo* = muscle, *fascial* = the connective tissue wrapped around the

muscle). Another word much less commonly used by doctors is ***myogelosis***. This word comes from the knot-like muscle swellings *(myo = muscle / **gel** = firm swelling)* that when pressed are very painful and can refer or "shoot" pain and are hence called "trigger points." Trigger points at the base of the skull can refer pain into the head. Trigger points at the lower side of the neck above the shoulder blades can refer or direct pain to the shoulder and arm. Pain referral occurs when some body disturbance or irritation stimulates a

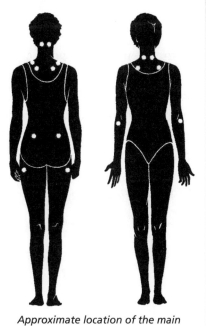

Approximate location of the main trigger points on the body

particular nerve that then passes that information along the nerve's pathways to another area of the body that is also supplied by the same nerve. Some people have multiple areas of myofascial pain without any apparent cause - this is called fibromyalgia.

Trigger points seem to be Nature's way of stimulating certain reflexes to cause small muscle spasms in order to help restrict movement to injured tissues that might otherwise be harmful and prevent healing. Nature is telling you not to overdo it, because if you do, you will surely get a pain in the neck.

But, unfortunately, sometimes these trigger points take on a life of their own. The message that has been sent to the trigger point to stimulate a muscle spasm begins to send a stronger message back to the spinal cord and brain. Now the message is that there is something wrong in the trigger point and more muscle spasm

is needed. When this happens, we have persistent myofascial pain.

Another feature of myofascial pain is called a "tender point." Tender points at the neck, shoulder and elbow are commonly found in patients who have chronic neck pain. This is regional myofascial pain and with proper neck treatment, which may include physical therapy, therapeutic exercises, medication, and local injections of trigger points and tender points, acupuncture, and acupressure, these areas of myofascial irritability will ease (*See **What To Do,** page 57*).

Do you want to dig deeper on the subject of fibromyalgia?

YES:
Read On...

NO:
Go on to a special DISH on Page 48

Fibromyalgia

The main body of the medical profession no longer doubts that there is a disorder called fibromyalgia. It is a disease of the body, and it is strongly affected by one's mind and mental state. *Fibromyalgia* used to be called *fibrositis,* but it had no *"itis",* or inflammation, and it mostly affects muscles and not fibrous tissue. It is now called fibromyalgia which means "connective tissue that binds the muscles and the muscles themselves are aching" (*fibro* = connective tissue / *myo* = muscles / *algia* = aching).

Fibromyalgia has much in common with regional myofascial pain and a lot more. Regional myofascial pain appears to be a normal protective reaction (that does sometimes get out of hand) to painful neck disorders. Fibromyalgia on the other hand is a much

more generalized illness. It can be aggravated by injury and in fact can be first brought to light by an injury such as a whiplash, but then takes on a life of its own, irrespective of what tissues were injured.

With fibromyalgia the trigger points and tender points are no longer in a region such as on one side of the neck, shoulder and arm, or low back, buttock and thigh. Rather, they are found more or less symmetrically on both sides, and typically occur around the neck, shoulder blades, along the ribs, on selected points on the pelvis, buttocks and thighs, and even on the inner aspects of the knees. These tender points and trigger points are the only manifestation of fibromyalgia as there are no x-ray findings, no laboratory tests and no diagnostic procedures beyond the doctor's ability to identify these trigger points and tender points by palpation or poking and feeling for them.

Fibromyalgia is often accompanied by other problems, including chronic fatigue, migraine and irritability of the bowels and of the bladder. It can be a very disabling condition and one that is often dismissed as a purely neurotic disorder.

The symptoms of fibromyalgia can also accompany rheumatoid arthritis, low thyroid function, and chronic viral diseases. So fibromyalgia is clearly more than just a pain in the neck but *it can certainly be a pain in the neck.*

For those of you with neck problems and fibromyalgia, the neck should be treated according to the guidelines in Chapter IV, *Do's, Doze and Don'ts* for severe or mild symptoms. That treatment must be coordinated with the therapy for fibromyalgia. The treatment for fibromyalgia consists of encouraging as much exercise as can be tolerated and commonly the use of certain antidepressant medications in low dosages to help improve the quality of sleep and relieve the muscular irritability. Biofeedback and psychological counselling as well as a good diet and avoidance of excessive physical, postural and emotional stress can all help keep

this disorder under control and permit a useful and productive lifestyle. Fibromyalgia is not a life-threatening disorder, but untreated, it definitely threatens the quality of life. So if fibromyalgia could be the cause of your neck pain, get medical help from a physician or specialist who recognizes the disease and knows how best to treat it.

DISH - Arthritis of the Neck, or a Real Dish?

DISH?

DISH stands for:

D = Disseminated (or all over the place)
I = Idiopathic (no one knows what causes it)
S = Skeletal (skeleton)
H = Hyperostosis (too much bone)

DISH is a condition that affects the spine, usually affecting the thoracic spine (back of the chest), but it can extend down to the pelvis and up into the neck. DISH is a painless condition in which for some reason the ligaments around the discs turn to bone. This creates a rigid bony fusion between the vertebrae that restricts spinal movement. DISH does not cause pain. It is not an illness, but it definitely causes stiffening of the spine. These ligaments that have turned into bone can resemble severe osteoarthritis, but DISH is not arthritis.

The major problems from DISH are due to the increased movement of the vertebrae above or below the areas where bony fusion has taken place. This has the same consequence as the effect of a surgically performed fusion, in that the segments that have not yet become involved with DISH tend to move excessively in order to compensate for the rigidness where DISH has affected the spine. This can lead to neck or back strain and pain in the still mobile vertebrae. But by and large DISH looks bad on

x-rays and causes some limitation of spinal movement, but does not hurt. If you have DISH, it is important to do stretching exercises to try to keep your spine as mobile as possible.

Cervical Spondylolisthesis

You have to wonder how doctors can come up with such long and strange words - disseminated idiopathic skeletal hyperostosis, and now spondylolisthesis. Speaking in defense of the medical profession, I can truthfully say that none of us invented these words, we all had to learn them and that took a lot of work, so now we like to use them.

Spondylolisthesis. (*spondylo* = spine; *listhesis* = slippage). Let's face it, spine slippage does not sound anywhere near as impressive, let alone as worrisome as spondylolisthesis. Spondylolisthesis, or spinal slippage, is sometimes described as a "subluxation" which means a partial dislocation — an ominous word for a potentially troublesome slippage of one vertebra over or under an adjacent one.

Vertebrae may slip forward or backward and cause pain

When the discs wear down from injury or aging, they tend to shrink. But the ligaments that surround the shrunken disc may become relatively too long and one vertebra can begin to slip over the next. This is particularly apt to occur if you were born with loose ligaments and are double jointed. It can also occur because of gradual overstretching of ligaments above or below a surgical fusion or a congenitally

fused vertebrae or DISH. A vertebra may slip forward slightly, or backward, and in either case, this is a potential source of pain. Greater slippage can cause encroachment on the nerve root channels or may actually cause a vertebra to press against the spinal cord. By and large, mild degrees of cervical spondylolisthesis causes no symptoms, or if associated with neck discomfort, spondylolisthesis needs to be treated no differently than any other neck pain. But if pain is severe, and if the spinal cord is being compressed and is causing neurological complications, then either major bracing and/or surgical fusion to position and stabilize the slipping vertebrae must be done.

If you have spondylolisthesis, DISH, fibromyalgia, or other cervical disorders your neck pain may be anything from mild to severe. Now let's determine the severity of your neck pain.

Chapter 4

**But I still have a
Pain in the Neck.
How can I tell how
Serious it is?**

If your neck pain is associated with any of the following danger signals, and there is no discernible cause for the pain, then you should consider your neck pain problem level to be **SEVERE**.

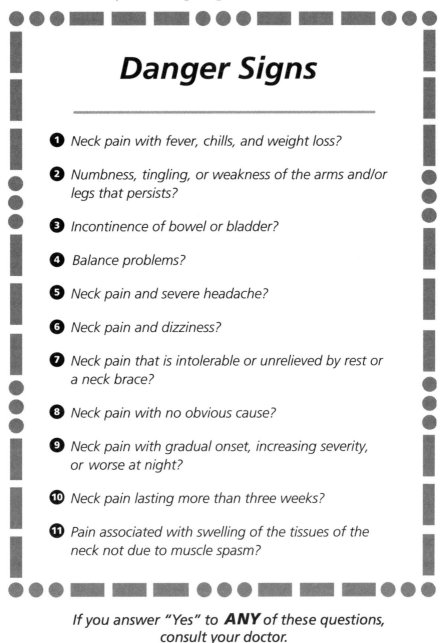

Danger Signs

❶ *Neck pain with fever, chills, and weight loss?*

❷ *Numbness, tingling, or weakness of the arms and/or legs that persists?*

❸ *Incontinence of bowel or bladder?*

❹ *Balance problems?*

❺ *Neck pain and severe headache?*

❻ *Neck pain and dizziness?*

❼ *Neck pain that is intolerable or unrelieved by rest or a neck brace?*

❽ *Neck pain with no obvious cause?*

❾ *Neck pain with gradual onset, increasing severity, or worse at night?*

❿ *Neck pain lasting more than three weeks?*

⓫ *Pain associated with swelling of the tissues of the neck not due to muscle spasm?*

*If you answer "Yes" to **ANY** of these questions, consult your doctor.*

To judge the severity of your neck pain problem, and to find your pain level – *ask yourself the following questions:*

Severe Neck Pain Level

Is your neck pain...?

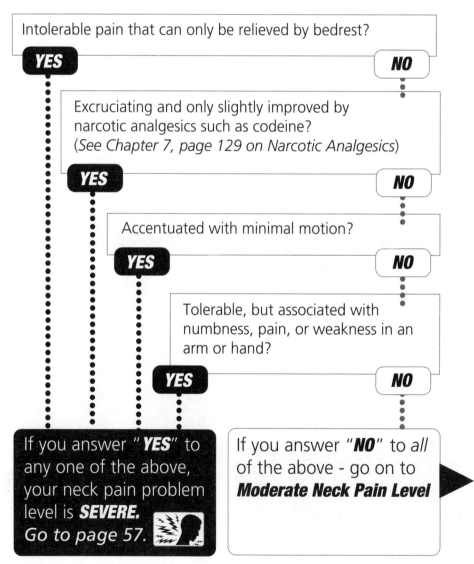

Intolerable pain that can only be relieved by bedrest?

YES **NO**

Excruciating and only slightly improved by narcotic analgesics such as codeine?
(*See Chapter 7, page 129 on Narcotic Analgesics*)

YES **NO**

Accentuated with minimal motion?

YES **NO**

Tolerable, but associated with numbness, pain, or weakness in an arm or hand?

YES **NO**

If you answer "**YES**" to any one of the above, your neck pain problem level is **SEVERE.**
Go to page 57.

If you answer "**NO**" to all of the above - go on to **Moderate Neck Pain Level**

Moderate Neck Pain Level

Is your neck pain...?

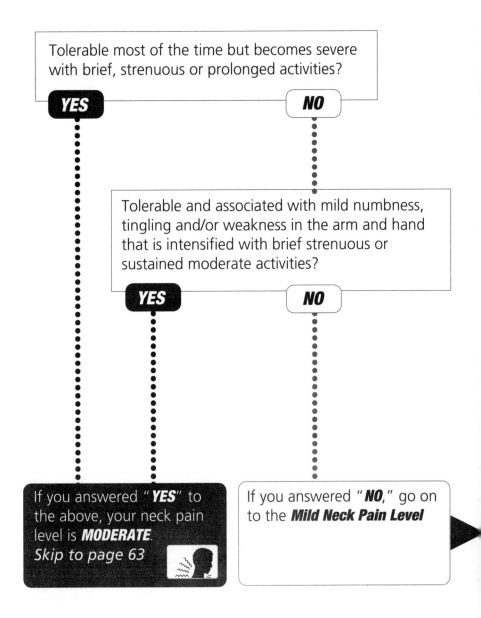

Tolerable most of the time but becomes severe with brief, strenuous or prolonged activities?

YES **NO**

Tolerable and associated with mild numbness, tingling and/or weakness in the arm and hand that is intensified with brief strenuous or sustained moderate activities?

YES **NO**

If you answered "**YES**" to the above, your neck pain level is **MODERATE**. *Skip to page 63*

If you answered "**NO**," go on to the **Mild Neck Pain Level**

Mild Neck Pain Level

Is your neck pain...?

or any numbness noticeable in arms or hands with overuse, prolonged static neck postures (such as when reading, working at computers, telephoning, watching television or movies, long drives)?

YES **NO**

Brought on by vigorous activities, but rarely sufficient to cause you to stop the pain-aggravating activity?

YES **NO**

If you answered "**YES**" to the above, your neck pain problem level is **MILD**. *Skip to page 65*

If you answered "**NO**" to the above, go on to **Minimal Neck Pain level**.

Minimal Neck Pain Level

Is your neck pain...?

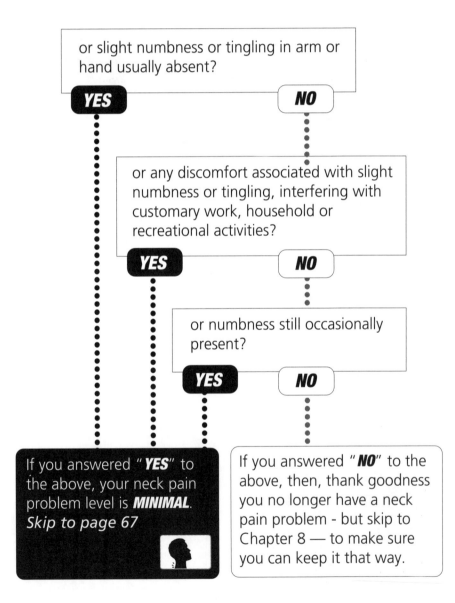

or slight numbness or tingling in arm or hand usually absent?

YES **NO**

or any discomfort associated with slight numbness or tingling, interfering with customary work, household or recreational activities?

YES **NO**

or numbness still occasionally present?

YES **NO**

If you answered "**YES**" to the above, your neck pain problem level is *MINIMAL*. *Skip to page 67*

If you answered "**NO**" to the above, then, thank goodness you no longer have a neck pain problem - but skip to Chapter 8 — to make sure you can keep it that way.

SEVERE Neck Pain Problem

EMERGENCY

In the event of a **major accident** where a fractured spine may have occurred, if at all possible, do not move the person and call 911 for assistance.

WHAT TO DO - NECK FIRST AID

If acute neck pain occurs after an injury, neck strain or sudden movement, or if neck pain is accompanied by arm numbness or weakness, your neck pain is severe. You need relief and you need it now! If your neck pain was moderate or mild, and suddenly takes a twist, literally a severe turn for the worse, you need **Neck First Aid** and "**RICE**" to help hold the pain in check until professional help is available.

R = **Rest** (*see DOZE, SEVERE, page 62*)

I = **Ice** (cold compresses)

C = **Cervical collar** (brace, towel or scarf✱)

E = **Easing exercises** (*Shoulder Shrug, see page 194*)

✱Wrap a hand towel or scarf fixed with a safety pin and fold some newspaper within the towel or scarf for added firmness. If a scarf or towel is not available use a T-shirt, nightgown, shirt or sweater. Position the head and the chin slightly down and avoid bending the head backwards.

Neck Second Aid

First aid with "**RICE**" can help, but it may not be enough, especially if the severe neck pain won't let up. Then you'll need more than "**RICE**." You'll need all of the additional pain relieving measure we call "***Neck Second Aid.***"

Above all, use your head - and use your neck carefully (ergonom-
ically) to avoid added strains and pains.

Medicine cabinet - pain pills

Neck protection (ergonomics)

- soft collar

- cervical pillow

- "bowtie" pillow (*See page 181*)

- **chin in, head-up position** (*See 1-2-3--2 Posture, page 143*)

Home Therapy

- ice (cold compresses)

- heat (always try cold first and use heat for any added comfort)

- massage (gentle for severe neck pain)

- traction (if you've already been taught how to use it)

- general assistance (ask for help if you need it)

- diet (soft foods and liquids if chewing and swallowing is
 uncomfortable)

Medical Backup

All severe medical conditions, and neck pain is certainly no
exception, require prompt diagnosis and, whenever possible,
skilled professional treatment. Once you have instituted
Neck First Aid and **Neck Second Aid**, you will want to check with a
physician to determine the next (neck's) best steps to relieve
pain, avoid preventable complications, and to speed recovery.

Accurate medical diagnosis is the essential step in medical man-
agement. If your neck pain is **SEVERE,** you should seek a prompt
medical diagnosis so that the appropriate treatment to prevent

further complications and to speed recovery expeditiously is implemented. If your neck pain is *moderate,* it is always advisable to consult your physician, but it may be safe to wait a few days to see if the symptoms will improve with **Neck First Aid** and **Neck Second Aid.** If your neck pain is *mild* or *minimal,* once again a physician's evaluation may be advisable, but there is probably no rush to make an appointment. (See diagnostic procedures and techniques that will include history, physical examination, blood tests, x-rays, CAT scans, MRIs and electrodiagnostic studies.)

Medications

For **SEVERE** pain, narcotic analgesics such as codeine, Vicodin™, Percodan™, Darvon™, Ultram™ (non-narcotic), and muscle relaxants may be required. For pain that is less severe *(moderate* or *mild),* acetaminophen, aspirin, or nonsteroidal anti-inflammatory drugs may suffice. If the pain is relentless, high doses of cortisone-like drugs or even injections of cortisone into the epidural space surrounding the spinal cord and spinal nerves may be required (*See **Medication for Neck Pain Relief,** page 125*).

In *moderate* and *mild* cases, injections of local anesthetics (Lidocaine™ or Novocain™) into the focal trigger points of muscle spasm may help bring relief.

Non-Pharmacological Treatment

Pain control treatment may include physical therapy, a soft collar or bracing, electrical stimulation (transcutaneous nerve stimulators), acupuncture, massage, and very gentle mobilization. If manipulation techniques are used they must be carefully administered when no signs of nerve compression (weakness, numbness or tingling in an arm or hand) are present. Last, and definitely not least, surgical intervention may be required where the risk of spinal cord injury or permanent nerve injury is otherwise unavoidable (*See **Surgical Consultants,** page 73*).

Psychological Counselling

As part of medical backup, psychological counselling is appropriate in any case, acute or chronic, where the stress of dealing with the pain in the neck is significantly depleting one's coping ability and delaying the healing process. This means that if you find that sleep deprivation is interfering with your ability to function, or if you are unusually grumpy or angry, or if you are withdrawing from social contacts or just not doing the things that you know can help make you feel better, you may literally be prolonging the agony.

Denial and Delays

Typical examples of putting off what needs to be done to help heal your neck are: not wearing a soft collar; not bothering to have proper back seat support at home, at work, or in your car; not bothering to get new glasses if you are suffering from eye strain and therefore neck strain; cradling a phone rather than obtaining a speaker phone or head set if you need that; not doing your exercises as prescribed or engaging in exercises and activities that you know are stressful for your neck. If you find yourself impatient and anxious to go on with your life and not making it easy for your neck to recover, you may be in conflict with yourself, and need counselling so that you can do the things that you must do to participate positively in the healing process.

When your neck pain is **SEVERE** you should do whatever it takes to prevent strain, minimize pain, and promote healing. Even though your neck pain is severe, you may have no choice but to try and function in order to meet some of your essential personal and vocational responsibilities. These **DO'S** and **DON'TS** will help you **DO** just that.

DO'S, DOZE, and **DON'TS** for pain in the neck

When the pain is **SEVERE**

DO'S

- **Do** use a soft collar or brace for pain control during work activities that cause stressful neck postures, on visits to the dentist, hairdresser, and doctor, especially the anesthetist, if you are anticipating any kind of surgery

- **Do** relax by breathing slowly in and out

- **Do** take cold compresses for 20 minutes as often as every hour for pain relief

- **Do** use a long straw for drinking

- **Do** converse sitting across from, rather than alongside friends and associates to avoid twisting your head

- **Do** maintain your dynamic posture and remember, "Heads Up, 1-2-3-2, Feet First" (*See The Gravity of Neck Posture, page 143*)

- **Do** wear proper glasses (unifocal, bifocal, trifocal, progressive lenses, or access glasses) as best suits the situation to avoid straining eyes and neck

- **Do** wear a hearing aid if you need it

- **Do** wear a scarf in the cold to avoid chill

- **Do** have home, office and car arranged for ergonomic efficiency (*See Ergonomics, page 145*)

- **Do** use a telephone headset or speaker phone wherever possible, including when in your car

When the pain is **SEVERE**

DOZE

- Use a soft collar if needed for dozing

- Sleep on your back or side

- Use a cervical pillow that supports the head in sidelying and maximizes head and neck comfort in all positions

- Use a comfortable, nonsagging, supportive but not rigid mattress

- Hold your chin with your hand when you change positions and "log roll" to turn in bed

- Wear a soft collar for reading and/or napping upright in bed

- Use nose drops, antihistamines, or cough medicine if needed to minimize sneezing and coughing

- Use muscle relaxants and analgesics if needed. But never use narcotics, analgesics, muscle relaxants or sedatives if you must drive or make difficult decisions

When the pain is **SEVERE**

DON'TS

- **Don't** slouch or crane your neck

- **Don't** sleep face down

- **Don't** twist or look upward

- **Don't** cradle the phone between your neck and shoulder and be especially careful with a car phone

- **Don't** see the hairdresser, dentist, or doctor without your soft collar or brace - or, if possible, reschedule your appointment

- **Don't** attempt any athletics

- **Don't** sit in uncomfortable chairs, couches, or in awkward positions at computer stations (*See Ergonomics, page 145*)

- **Don't** forget to stop, relax and very gently stretch your neck and shoulders (*See Exercise for Relief and Recovery, page 187*)

When the pain is *moderate*

When your neck pain is *moderate*, or if **SEVERE** pain has moderated, you can be a little more relaxed, but the **SEVERE** level **DO'S, DOZE,** and **DON'TS** are still very important to prevent your neck pain from becoming **SEVERE**.

DO'S

- **Do** use a soft collar or brace for pain control during work activities that cause stressful neck postures, on visits to the dentist, hairdresser, and doctor (Especially the anesthetist, if you are anticipating any kind of surgery)

- **Do** use cold compresses for neck spasms for 20 minutes as often as every hour for pain relief

- **Do** relax by breathing slowly in and out

- **Do** use warm showers prior to gentle stretching exercise

- **Do** change positions frequently

- **Do** converse sitting across from, rather than alongside friends and associates to avoid twisting your head

- **Do** wear proper glasses (unifocal, bifocal, trifocal or progressive lenses) as best suits the situation to avoid straining eyes and neck

- **Do** wear a hearing aid if you need it

- **Do** wear a scarf in the cold to avoid chill

- **Do** arrange home, office and car for ergonomic efficiency (*See* **Ergonomics,** *page 145*)

- **Do** use a telephone headset or speaker phone wherever possible, including when in your car

- **Do** maintain your dynamic posture and remember, "Heads Up, 1-2-3-2, Feet First" (*See* **The Gravity of Neck Posture,** *page 141*)

When the pain is *moderate*

DOZE

- Use a soft collar if needed for dozing

- Sleep on your back or side

- Use a cervical pillow that supports the head in sidelying and maximizes head and neck comfort in all positions

- Use a comfortable, nonsagging, supportive but not rigid mattress

- Hold your chin with your hand when you change positions and "log roll" to turn in bed

- Wear a soft collar for reading and/or napping upright in bed

- Use nose drops, antihistamines, or cough medicine if needed to minimize sneezing and coughing

- Use muscle relaxants and analgesics if needed. But never use relaxants, narcotic analgesics or sedatives if you must drive or make difficult decisions

When the pain is *moderate*

DON'TS

- **Don't** slouch or crane your neck

- **Don't** sleep face down

- **Don't** twist or look upward

- **Don't** cradle the phone between your neck and shoulder and be especially careful with a car phone

- **Don't** see the hairdresser, dentist, or doctor without your soft collar or brace

- **Don't** over-exercise (*See Sports For Sore Necks, page 226*)

- **Don't** sit in uncomfortable chairs, couches, or in awkward positions at computer stations (*See Ergonomics, page 145*)

- **Don't** forget to stop, relax and stretch your neck and shoulders (*See Exercises for Relief and Recovery, page 189*)

- **Don't** exercise without a warmup

When the pain is *mild*

Your neck pain is mild - but it hasn't gone away. The basic **DO'S, DOZE,** and **DON'TS** still apply. So whenever possible take the precautions to prevent aggravating or intensifying your neck pain problem.

DO'S

- **Do** use a soft collar if you know that you'll be doing activities that might strain your neck such as visits to the dentist, hair-

dresser, and doctor (especially the anesthetist, if you are antici-
pating any kind of surgery).

- **Do** use warm showers prior to gentle stretching exercise

- **Do** change positions frequently

- **Do** converse sitting across from, rather than alongside, friends
 and associates to avoid twisting your head

- **Do** wear proper glasses (unifocal, bifocal, trifocal or
 progressive lenses) as best suits the situation to avoid straining
 eyes and neck

- **Do** wear a hearing aid if you need it

- **Do** wear a scarf in the cold to avoid chill

- **Do** arrange home, office and car for ergonomic efficiency (*See
 Ergonomics, page 145*)

- **Do** use a telephone headset or speaker phone wherever
 possible, including when in your car

- **Do** maintain your dynamic posture and remember,
 "Heads Up, 1-2-3-2" (*See The Gravity of Neck Posture, page
 143*)

When the pain is *mild*

DOZE

- Use a cervical pillow that supports the head in sidelying and
 maximizes head and neck comfort in all positions

- Use a comfortable, nonsagging, supportive but not rigid
 mattress

When the pain is *mild*

DON'TS

• **Don't** slouch or crane your neck

• **Don't** cradle the phone between your neck and shoulder and be especially careful with a car phone

• **Don't** over-exercise (*See* **Sports For Sore Necks,** *page 236*)

• **Don't** sit in uncomfortable chairs, couches, or in awkward positions at computer stations (*See* **Ergonomics,** *page 145*)

• **Don't** forget to stop, relax and stretch your neck and shoulders (*See* **Exercises for Relief and Recovery,** *page 189*)

• **Don't** exercise without a warmup

• **Don't** forget 1-2-3–2

When the pain is *minimal*

When your neck problem is minimal, most of the time you can do what you feel like and not take any special precautions. Still, it literally won't hurt to do the **DO'S, DOZE,** and **DON'TS** recommended for *mild* neck pain.

Should I see a physician?

YES:
You have decided to see your physician. Read on.

NO:
Skip to Now, What Should I do About It? on page 103
OR: Skip to Diagnosis-What's Really Wrong? on page 85

Help! I have a Pain in the Neck! Whom Should I See?

The Family Physician

If you have a pain in the neck that is more than mild, and certainly if there are any danger signals, you should first contact your family physician. If you don't have a family physician, use the Neck First Aid section to help control your pain. Then contact your local medical association or nearby emergency care facility. To prepare you for your visit to a physician, see *What can You Expect from a Visit to the Doctor?* (*page 88*).

Medical Specialists

Physiatrists (Rehabilitation Specialists): The non-surgical specialty with the broadest approach to the diagnosis and treatment of neck, back and other musculoskeletal disorders is the specialty of Physical Medicine and Rehabilitation, or PM&R. These physicians are physiatrists (*phys* = physical, and *iatrist* = physician). Physiatrists are knowledgeable in the use of various physical therapy treatment modalities and exercise therapy, and most are very competent to diagnose and treat painful neck disorders. But as is the case with all specialists, there are physiatrists whose major skills may involve treating strokes or spinal cord injuries and may not be particularly competent in the management of neck and disc disorders. So inquire and ask the hard questions. Be sure that if you are consulting a physiatrist that he or she is a specialist in treating neck and back pain problems rather than in the rehabilitation of stroke and brain injuries or other conditions.

Rheumatologists are physicians trained first in internal medicine and then in the treatment of arthritic conditions. They are particularly knowledgeable in diagnosing medical diseases that cause arthritis anywhere in the body, including the spine. Rheumatologists are highly skilled in the use of medication to treat a variety of illnesses that affect joints as well as any other

organs in the body. Some, but not all, are skilled in overseeing the physical therapy and rehabilitation aspects of treatments including musculoskeletal conditions such as neck pain.

It is appropriate for me to mention that I make these statements as a Board-Certified specialist in Internal Medicine, in Rheumatology and in Physical Medicine and Rehabilitation, and as a Professor who has spent many years in teaching and training both physiatrists and rheumatologists.

Neurologists are, as the name implies, specialists in the diagnosis and medical treatment of disorders of the nervous system. When symptoms of nerve damage occur in association with a cervical radiculopathy, a neurologist may be consulted. Some, but not all, neurologists have an interest in, and develop skills in the nonsurgical management of disorders of the cervical and lumbar spine. These neurologists can be helpful in the evaluation and management of neck disorders with nerve dysfunction. Neurologists who deal mostly with brain trauma, multiple sclerosis, or stroke patients may not be skilled in handling neck pain problems
- ask if a significant part of their practice deals with neck pain problems.

Osteopaths

Currently almost all osteopaths are trained as physicians and for the most part participate in all of the activities of the medical profession. In addition, osteopaths are trained and have a special interest in the diagnosis and treatment of muscular and skeletal disorders.

Some osteopaths primarily treat neck and back problems and use a variety of therapeutic measures, including manipulation to do so. The osteopathic physician with a special interest in conservative treatment of neck and back pain can provide useful assistance to the back or neck pain sufferer.

Other Therapies

Chiropractors (DC)

Just as there are a variety of medical as well as osteopathic spe-
cialities, chiropractic is no longer a uniform therapy discipline.
Chiropractics, which means "done by hand," was founded in
1895 by Daniel David Palmer. He was a grocer and a "magnetic
healer" in Davenport, Iowa. Chiropractic was originally based on
the concept that adjusting misaligned vertebrae can relieve nerve
tension and heal disease. Chiropractors who follow this theory
are called "Straights."

Chiropractors who recognize that there are other causes of dis-
ease such as germs, tumors, etc. and accept conventional medical
diagnoses, are called "Mixers." Both Straights and Mixers will
use hands-on (chiropractic) therapies to help relieve muscu-
loskeletal pain by manipulation, massage, and other spinal-mobi-
lizing maneuvers.

Today, chiropractors, osteopaths, physical therapists, and many
M.D. physicians use various forms of manipulative and manual
therapies to treat their patients. There are about 100 different
manipulative techniques. Whether the practitioner is a chiro-
practor or a physician, osteopath, or therapist, the accuracy of
diagnosis, and the precision and particularly the gentleness of the
manual therapy or manipulation that is applied, will enhance the
possibility of temporary benefit and reduce the risk of manipula-
tion injury to the neck (*See **Hands-On Manual Therapies,** page 114*).

Therapists

Physical Therapists (PT)

A physical therapist is trained in the use of physical (nonmedical) treatments which typically include heat, cold, ultrasound, diathermy, electrical stimulation, traction, bracing, massage, and exercise. Some physical therapists are also trained in manual therapies which include combinations of massage, musculoskeletal mobilization and manipulation (*See **Hands-On Manual Therapies,** page 114*). There are a variety of these techniques and different schools emphasize different aspects of training for therapists with a special interest in manual therapy. As in all professions, physical therapists have varying knowledge, skills, and experience. Be sure to check that the physical therapist who treats your neck is one who has had the appropriate training and experience to do so. Physical therapists should be working in coordination with your physician (who is also knowledgeable in the management of neck conditions).

Occupational Therapists (OT)

"Occupational Therapist" is the name for a profession that does far more than keep you occupied until your neck pain goes away. The occupational therapist originally was a person who tried to find activities or occupations that one could do in order to help stretch or strengthen injured or impaired tissues. This role still exists and remains a useful one.

The primary purpose of occupational therapists with regard to neck pain is to use ergonomic principles (***ergo*** = work and ***nomic*** = economic or efficient) to help find ways for you to get through all of the activities of the day from sleeping in bed, to driving your car, and to working at various household or vocational tasks without aggravating your neck pain problem. These are the activities of daily living or life skills that may need to be modified

to permit you to function effectively and without interfering with the healing process. The occupational therapist will employ a variety of techniques including bracing, splinting, posture instruction and the use of adaptive equipment that might help you to read or reach without straining your neck, arms or any other portion of the body that might require treatment.

Occupational therapists are usually affiliated with major hospitals or clinics, but unfortunately are not available in all communities. As in all disciplines and professions, not all occupational therapists are skilled in the treatment of neck and back disorders, and therefore the posture and ergonomic guidelines in Chapters 8 and 9 may be of particular benefit to you.

Massage Therapists

Massage therapists may or may not be well trained and licensed. They can utilize a variety of hands-on therapies similar to what the other health care disciplines use, but massage therapists do not, and certainly should not perform any manipulative treatments. Soothing, kneading massage can make almost anyone, sick or well, feel better, at least for a while.

Acupressure Therapists

Deep acupressure (Shiatsu) or Rolfing-type massage is sometimes helpful in giving relief from persistent painful myofascial irritations. These techniques can be painful and occasionally injurious and therefore should only be used by highly skilled massage therapists, preferably under the guidance of a physician.

Acupuncture Therapists

Acupuncture can help relieve pain and requires the use of specially designed very thin needles. Knowledge of the appropriate traditional acupuncture points that are utilized for the relief of various pain and other disorders is essential. Acupuncture should only be administered by a specially trained physician or a licensed acupuncture therapist (*See Acupuncture, page 113*).

Surgical Consultants

The decision to consult a surgeon for your neck should be based on the premise that there is in all likelihood no alternative. Surgical treatment may be needed because of the failure to get relief from carefully supervised conservative treatment for the neck pain and/or for cervical radiculopathy, or less commonly, because of the risk of permanent paralysis. The choice of a neurosurgeon versus an orthopedic surgeon depends on the individual surgeon's training and the presence or absence of nerve involvement.

Remember, it's your pain in the neck. So you have the right to be a "pain in the neck" in the eyes of the surgeon by asking the hard questions about their experience with neck pain problems, and by conferring with both the doctor who referred you, as well as with the surgeon.

Orthopedic Surgeons

The broad spectrum of musculoskeletal problems ranging from sprains of ankles to bone tumors are the province of the orthopedic surgeons. As in all specialities, there are those within the specialty who have special expertise. There are orthopedic surgeons whose major interest is in arthritic knee or hip joint replace-

ments; there are others who are proficient in sports medicine; and still others who have a major focus on disorders of the spine. Because of training and interest, surgeons are generally particularly interested in the surgical management of the conditions that they see. This is not to say that an orthopedic surgeon may not be well versed in conservative treatment. Indeed, there are a number of orthopedic surgeons who have laid the groundwork for conservative management of neck and back disorders. When consulting an orthopedic surgeon, it is advisable to inquire of your referring physician not only about the orthopedist's skills as a surgeon, but as to his/her **experience and overall approach to the diagnosis and management of neck pain.**

Neurosurgeons

The neurosurgeon, like the neurologist, is specially trained in treating those conditions that affect the central (brain and spinal cord) or peripheral nervous system. With regard to neck pain, by and large this includes in particular those patients who have developed cervical radiculopathy. Much more rarely, patients who have complications due to tumor, disease, or to disc protrusion that impair the function of the spinal cord will require neurosurgical consultation. There is a great deal of overlap between the role of the orthopedic surgeon and the neurosurgeon regarding the surgical treatment of neck/disc disorders, just as there is a considerable divergence of opinion as to what the best surgical procedures might be.

Surgery - To Operate Or Not To Operate

When a tumor is present in the neck that can't be treated by drugs or x-ray therapy and where there is a possibility of a cure by surgery, no one hesitates to recommend surgery. But, when there is no life-threatening complication, when the issue is pain, comfort, ability to function and quality of life, the decision to

operate or not to operate becomes more complex. At the very least you should ask how long and how difficult the recovery is going to be (*See pages 78 - 79*).

To use the word **surgery** is a little bit like using the word **exercise.** Are we talking about walking or weight lifting? Are we talking about boxing or lawn bowling? Whatever will qualify as "exercise" is what we may be talking about. The same applies to surgery. There are a variety of surgical options and a variety of indications for them. Sometimes there are several ways of getting the same surgical job done, but by techniques that are very, very different from each other.

For our purpose, we will not pretend to discuss all of the possible surgical procedures that might be considered for diseases, tumors, congenital abnormalities, fractures, or infections that can affect the cervical spine. We will give some thought to some of the more common surgical procedures relating to neck pain and disc disorders.

The Surgery You Don't Want To Know About

Surgeons are physicians who are trained to cut and who like to cut. Fortunately, most surgeons are highly skilled diagnosticians and highly conscientious physicians. But most is not all, and we have to be reminded that although the first law of medicine is "First do no harm," this is not always obeyed. There are the (fortunately rare) less inhibited surgeons who follow the philosophy "If it's movable, remove it"; or "If it is sticking out, take it out"; or "If it's still moving, fuse it." Clearly there is a place for all of the above, but that place has to be carefully considered. Surgical procedures for neck disorders should be used only when there is a risk of severe paralysis or when a failure to respond to appropriate conservative treatment leaves no other reasonable alternative (*See **Less May Be More**, page 91*).

Needless to say, no matter what procedure is undertaken, the surgeon must be intimately familiar with all of the anatomy of the neck from the skin to the spinal cord, and not only the normal anatomy, but the anatomy that has been distorted by injury, disease, or congenital anomalies. Based on the anatomy, a selection of procedures and techniques have been developed over time, and are being further developed, to try to find the best way to accomplish the surgical task at hand. You can ask your surgeon to explain his or her particular choice for you.

It's up to the Surgeon

Removing a protruding disc is the most common procedure facing the surgeon. There are basically two ways to do this:

1) Entering the neck from the front, or the *anterior approach*

The **anterior approach** is somewhat simpler for the surgeon but has the disadvantage that in removing the disc from the front of the vertebra, the spinal cord and nerves cannot be readily visualized. This makes the possibility of severe damage to the spinal cord a very real concern. Further, removal of the disc usually requires a bony fusion. This necessitates taking a plug of bone from the pelvis and inserting it between the two vertebrae on either side of the disc to help maintain stability and prevent subluxation (slipping or overriding of one vertebra on the other). A problem of fusing two vertebrae is that the fusion doesn't always stick. When it does fuse properly, the disc and vertebrae above and below now have to take more motion and they may undergo more rapid degenerative changes as a consequence.

2) Entering the neck from behind, or the *posterior approach*.

The **posterior approach** allows the surgeon far better visualization of the disc but may require removal of a considerable amount of the laminae (bony plate behind the spinal canal) in order to get at the disc. This in turn can lead to instability of the spine and possible spinal cord injury.

A *third* possibility

Often these problems can be avoided by what is called a "posterolateral (back-side) approach" in which the foramen or channel through which the nerve root passes is widened to decompress a pinched nerve root.

Microsurgery is utilized when the surgical procedure can be done under magnification and thereby minimize the amount of bone and soft tissue removal.

None of these procedures are uniformly successful. The results depend on the bias and skill of the surgeon; the criteria for excellent, good (the surgeon may be satisfied, but you may not), fair, or poor results; the duration of followup to determine if what appeared to be an early success remains so over the years; and an accounting for the complications that occur with or following the operation.

At this time, the choice of procedures is basically determined by the surgeon's experience and preference. At best, favorable results occur in about 90% of cases, which means that about 10% of patients have unsatisfactory results and/or serious complications.

When surgery is performed to relieve pressure on a single nerve root, the problem is difficult enough but the outcomes are generally favorable. When multiple nerve roots and/or pressure on the spinal cord are involved, the surgery is more complex, more risky, and the results are often less favorable.

Informed Consent

When the indications for surgery are such that there is very little choice, you are pretty much obliged to take the risks. But when there is the possibility of improving over time with conservative treatment or "just living with it," then you need to look at more than the qualifications of the surgeon and the concurrence of an unbiased surgeon's second opinion. You must also deal with the difficult classic issues that are raised when you give your informed consent for a surgical procedure.

The Risks of Surgery

The infection rate is typically 1-2%, which can usually be successfully treated by antibiotics. Clots in the lower legs may impair circulation in the legs or break loose and cause severe clotting in the lungs that can be fatal. These are of particular concern in the aging population and diabetics. Urinary tract infections commonly occur after surgery, particularly in the male patient with a history of prostatic enlargement or in a female patient with a history of recurrent urinary infections. Damage to the spinal cord resulting in paralysis can occur in about one in every 200-300 cases operated on for treatment of nerve root compression. Nerve root damage resulting from surgery will occur in about 2-3% of cases. Occasional injury to the carotid arteries and vertebral arteries may lead to impaired circulation to the spinal cord causing paralysis, or to the brain causing strokes. Excessive removal of bone during the more conservative *foraminotomies* (widening of the cervical nerve root canal) can, rarely, lead to instability of the neck facet joints.

Most Neck Patients do not require surgery but they do require patience!

If the clinical condition demands surgery, most surgery will be successful. But clearly, one should think once, twice, and thrice before deciding on surgery to relieve the neck problem. The

odds are at least 9 out of 10 that if you need a "simple" nerve root decompression, you will improve. But the odds are also between 1 in 10 and 1 in 20 that you might end up no better off, and possibly much worse off than before the surgery. If the surgery is unavoidable, it is indeed unfortunate to have an unfavorable outcome. But if the surgery was avoidable, as it is in the majority of patients with neck pain and nerve root compression symptoms, then any unneeded surgical complication is tragic indeed.

Help! The Surgery Didn't Work

No operation is perfect, no treatment always works and sometimes some things do go wrong. We know that. If you have had an operation and are no better, or if you are worse off than you were before, what should you do? If a surgical procedure fails to relieve your pain; if following the procedure you have more pain or weakness in your arm or hand; if your neck is stiffer than it was before the operation, it is tempting to want a second operation to fix what went wrong or what didn't go right in the first one. But the results of second operations are nowhere near as good as the results that can be expected the first time around. The chances of things going more wrong after a second operation are even greater. Clearly, before considering a second procedure, the need for a second and even a third opinion by skilled surgeons, known and respected by their peers, should be sought. Under some managed care programs this may be difficult to accomplish, but every effort to do so should be made. And what if the decision of the consulting surgeons is that no further surgery will be helpful? What then? You may still be able to get relief of suffering by consulting a pain treatment center.

Pain Treatment Centers

There are in almost every large city specialized treatment centers that help people with chronic pain disorders stemming from disease, injury, or tumors. These specialized centers are staffed with physicians and health care professionals who are skilled in a variety of techniques for relieving pain. These techniques include all of the pain relieving methods that have been discussed here, including medications, physical therapy, exercise, psychological counselling, biofeedback, and various forms of electrical stimulation. In extreme cases, neurosurgical procedures to interrupt pain pathways may be utilized. Although the pain center treatment may not result in the eradication of pain, it can provide a better way of dealing with it so that the pain no longer controls your life. You can move from a life full of intolerable pain to tolerable pain and a full life.

Caveat Emptor - Buyer Beware

In a world, and indeed a nation where corruption can occur in business and in politics, corruption in health care can also occur. Patients with chronic pain can become desperate. They might then put their faith in a variety of procedures and with a variety of health professionals whose motivation may be their own financial gain and not relief of your neck pain. Check with your personal physician, with your County Medical Association, with the American Pain Society or The American Academy of Pain Management to verify the credibility of any pain treatment method or pain treatment center.

Holistic Medicine

What is a holistic approach? If you are a golfer this may mean your approach shot to the hole on the green, but the word holistic means a concern for the "whole" or for all aspects of the patient's medical, psychological, social, economic or environmental needs. With a pain in the neck, you may be frustrated,

angry, worried, experiencing pain and unable to go out dancing or to work. To some extent almost every illness or injury impacts on your total being. From a stubbed toe that keeps you from walking or jogging, to a severe neck disc sprain that keeps you home in a brace and taking pain pills, at some level any condition has holistic implications and merits the use of some of the components of the "whole treatment" implicit in "holistic medicine."

Holistic medicine has taken on the meaning that any treatment that avoids medical treatment and/or medicines has to be somehow safer and better than using more conventional medical practices. If your pain in the neck is of a self-limiting nature or one that can heal by itself, then a variety of approaches may prove "beneficial" or, indeed, unnecessary. On the other hand, if your neck problem has any of the danger signals, then reliance on non-mainstream medicine may lead to dire consequences.

The holistic approach can be found in the mainstream of medicine where a variety of health care professions such as those listed in this section, from physicians to massage therapists, may perform useful therapeutic interactions to help relieve your pain and improve your function. A holistic approach can also include meditation, yoga, acupuncture, and nutritional counselling as well as herbal medicine. Some of the components of holistic medicine such as neck-protected yoga may be very useful for mild neck pain, whereas others such as non-supervised "organic herbal medicines," that may contain a variety of contaminants, can actually be dangerous. Perhaps the *greatest danger* of non-medical "holistic" treatment is *procrastination* from proper medically supervised care with the resultant consequences of delayed diagnosis and missed opportunities for early resolution of painful neck problems or other diseases that may have their origin in the neck.

The temptation to believe that if something is "natural" it is good needs a second look. Tobacco, marijuana and opium are natural substances that may make you feel good, but they are not good for you.

Quackery

The further you remove yourself from the center of the "hole" in holistic medicine, the more likely is the possibility that you may find yourself in the hands of a naive and perhaps misguided healer or, worse, a malicious deceiver. If someone offers you a simple, almost magical cure, you may be tempted to try it. The feeling that you have nothing to lose, and that you'd rather stay away from doctors, surgeons, medicines or whatever else you might fear, makes you a very tempting target for the quack. At a time when millions of people are unable to afford health care, over a billion dollars a year is spent to line the deep pockets of the quacks.

How do quacks do it and why do people keep coming back and spending their money on them? Many disorders, not the least of which is neck pain, will heal themselves. If you have taken a full dosage of some natural mega-mineral or herb pill and then felt some relief of your pain, you would swear by the quack's cure. If you swallowed the pill and then broke out in a rash and your neck pain got worse, you probably wouldn't tell anyone. A belief in the power of medical science, or a belief in the magic of non-scientific cures both embrace the power of the placebo, and therefore enhance the curing effect of anything that is perceived to be an effective treatment. Quacks know this all too well and they are fully prepared to take advantage of you and your mis-placed hope and faith in their phony cures.

Always beware of simple, soothing answers to your medical problems. Words such as "safe," "quick," "easy," and "cure" are used with abandon. "Research" that has never been published in a credible medical journal or that is out-of-date and long since refuted

will be cited to support the quack's "breakthrough" discovery. Any claims that a treatment for arthritis and neck pain can utilize one simple approach, whether it be diet, exercise, herbs or drugs, would presume that cervical radiculopathy, gout, rheumatoid arthritis, osteoporosis, infectious discitis, and osteoarthritis are similar disorders and susceptible to the same simple cure. Whether a quack uses diet, herbs, magnetism, electricity, special salves, perfumes or therapeutic vapors, you may find that you have been relieved of your excess cash, but not significantly relieved of your neck pain. That can truly be a "pain in the neck".

Clearly there are a lot of treatment choices. But each treatment choice is dependent on the right diagnosis. Chapter 5 will help lead you to the correct answer and the diagnosis of your pain in the neck.

Chapter 5

Diagnosis -
What's Really Wrong

— Check for the Danger Signs of neck pain —

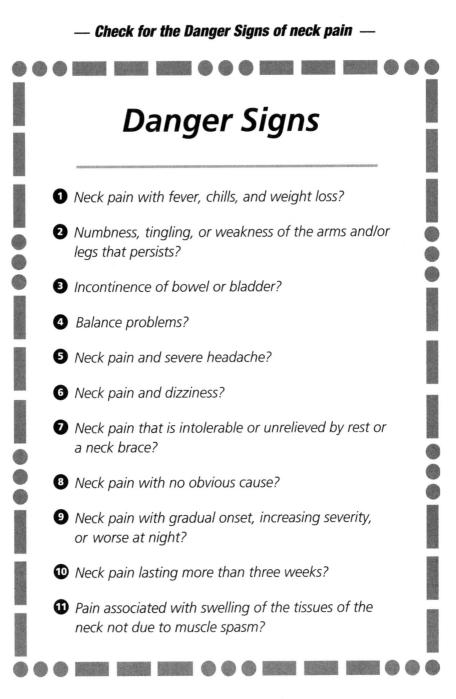

Danger Signs

1 *Neck pain with fever, chills, and weight loss?*

2 *Numbness, tingling, or weakness of the arms and/or legs that persists?*

3 *Incontinence of bowel or bladder?*

4 *Balance problems?*

5 *Neck pain and severe headache?*

6 *Neck pain and dizziness?*

7 *Neck pain that is intolerable or unrelieved by rest or a neck brace?*

8 *Neck pain with no obvious cause?*

9 *Neck pain with gradual onset, increasing severity, or worse at night?*

10 *Neck pain lasting more than three weeks?*

11 *Pain associated with swelling of the tissues of the neck not due to muscle spasm?*

*If you answer "Yes" to **ANY** of these questions, consult your doctor.*

Diagnosis

A pimple? A boil?? A tumor??? Whatever the medical problem might be, there are a range of diagnostic possibilities to be considered and either worries to be dispelled or vague concerns to be put into sharp focus. Did I just sleep wrong?

Could this be a tumor? Or is it just a pain in the neck??

Check the Danger Signs again *(See page 86)*

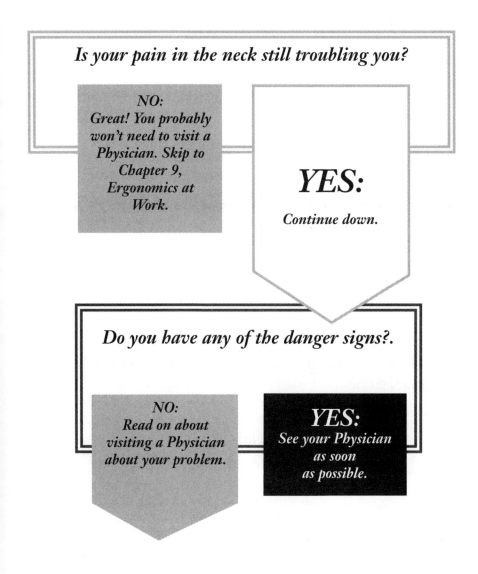

What Can You Expect From A Visit to the Doctor?

When you go to the doctor to find out why you have a pain in the neck, and more importantly, how to get relief, you should expect that your physician will want to work with you. Your physician may ask you what kinds of symptoms you are having:

1. - Are you having any pain?

If *YES*

- Where is it?
- Is it dull?
- Is it sharp?
- Is it burning?
- Is it achey?

2. - Do you have numbness, tingling, or weakness?

3. - Have you ever had any of these symptoms before?

4. - Were you ever in an accident or did you injure your neck in some other way?

If *YES*

- Was it recently?
- Was it a long time ago?
- Have you had more than one injury?

5. - Have you had any other illness along with your neck pain?

If *YES*

- Have you lost weight?
- Have you had fever?
- Are you under stress?

You will be asked these questions and probably many more, depending on your responses. If you have had previous problems with your neck, it is advisable to bring in any x-ray reports of your neck, or better, the x-rays themselves. If you have a major illness and are taking a variety of medications, or, indeed, if you have taken medication for your neck pain, and it hasn't worked or it has caused some side effects, by all means bring this to the attention of your doctor. All of this information will help lead your doctor to the proper diagnosis and treatment.

The Examination

By and large, if you are able to give your doctor a good history of your neck problem and other relevant medical conditions, the diagnosis will be evident. The physical examination will usually confirm what was suspected from your history.

What? Do I Need to Undress For My Neck Examination?

If you have a *minimal* neck strain, then it may not be necessary. If the problem is any more complicated than that, your doctor will want to look and feel beyond your neck. Once again, if your symptoms are very mild and straightforward, an extensive examination may not be required. Typically, in addition to examining your neck and arms, your blood pressure will be taken. If there is any question of an infection, your temperature will be taken and your pulse will be recorded. Your skin will be examined (this neck and arm pain could be early shingles) and other diseases that cause neck pain may also be identified. If your pain is associated with nerve root compression, twitchings or atrophy in some of your muscles may be noted. This could indicate a more severe problem.

Granting that each patient's problem is unique and each physician's approach will depend on the nature of the patient's problem, the more straightforward the diagnosis the less comprehensive can be the examination. So, in any given case, only portions

of the examination described below may be required, and other diagnostic tests may be needed.

Your physician may note your posture, and whether your head is tilted to one side or the other in spasm (a wry neck). The amount of movement in your neck, front-to-back and side-to-side will be observed, as well as the movement in your arms and hands. The bony spine of the neck may be carefully palpated to identify any local tenderness in any specific vertebra. The muscles of the neck, shoulder blades, shoulders, and arms can also be palpated to detect areas of myofascial irritability - the tender points and trigger points of myofascial pain.

What Is A Spurling's Test?

If there is pain radiating down your arms, or numbness or tingling, the doctor may put pressure on the top of your head and move your head back and to the side of the painful arm to see if this accentuates the symptoms of nerve root irritation, pain, numbness or tingling radiating into your arm or shoulder blade. This is called a Spurling's test. This test is performed gently but firmly and stopped if the symptoms are intensified.

Lhermitte's sign

If a tumor of the spinal cord in the neck is suspected, flexing the neck forward or bending it back may produce an electricity-like sensation down the back from the neck. This can also be noted rarely with cervical spondylolisthesis or multiple sclerosis. If any of these disorders are suspected, then further testing will definitely be required.

How Do Doctors Test Your Nerves?

Next, the functioning of the nerves to the arms and shoulders can be tested. Bear in mind that even though your doctor finds

evidence of impaired nerve function it does not preclude your recovering fully. Now let's get on with the testing.

The *reflex hammer* will be used to test the reflexes in your arms. Then your ability to feel light touch, pain, heat or cold will also be tested to determine if there is nerve impairment. The strength of the muscles in your arms or in the shoulder blades may be weakened when a nerve is pinched. This can then be tested by the clinician by placing your fingers, wrists, and arms in various positions, and asking you to push against the examiner. This is called "manual muscle testing." If your muscle force is overcome, it is an indication of weakness due to a neurological deficit, but pain can also prevent you from applying adequate force. In some cases, mechanical devices may be used to precisely quantify muscle strength.

By this time, the physician will in all likelihood have made the proper diagnosis, but because of either the severity of the problem, or concerns that there may be more complexity to your pain in the neck than is usual, additional testing may be suggested by your doctor or a consulting specialist.

Less May be More

A skilled physician, knowledgeable in the various aspects of neck pain, who has listened to your story (the patient's history) and has done a thorough examination, can then judge what further tests might be needed, or indeed, as is often the case, that no further tests are required. Just as a dermatologist can look at your skin and decide in the majority of instances what kind of a rash you have, the skilled physician can also examine you and determine what is wrong with your neck and why it hurts. But this is not always the case and additional diagnostic testing may be required.

What Are The Tests? Blood and Urine

I have a pain in the neck - is that in my blood? If there is a question about your having a systemic illness such as an infectious discitis, tuberculosis, ankylosing spondylitis, or tumor, then a blood count may be helpful and often times a sedimentation rate is measured. The sedimentation rate tells how rapidly your blood settles in a special tube (like muddy water in a glass). If as a result of inflammation in your system, the blood cells cling together and form larger clumps, they will precipitate to the bottom of the tube more rapidly. This is a rapid or elevated sedimentation rate. The elevated sedimentation rate doesn't tell what is wrong, but it tells us that something probably is wrong.

There are many other blood tests that might be required if there is a suspicion of some disease that is affecting your body elsewhere and only coincidentally your neck. By the same token, a urine test may also be done to test for diabetes and more rarely, other problems that affect the kidneys, bladder, and the body as a whole.

Another important reason for doing tests on the blood and urine is to determine whether or not it is safe for you to take certain medications such as antiinflammatory drugs; and/or, if you are taking them, to see if they are having any ill effects on your blood, liver, or kidneys. Further, you may be taking other medications for other problems. These could be causing abnormal results on these laboratory tests that need to be identified so that your physician would not be asking you to take a medicine that was not right for you.

Testing For Arthritis

If you have cervical osteoarthrosis, none of the laboratory tests can pinpoint the problem. If you have been diagnosed with rheumatoid arthritis, no additional blood tests should be necessary in the rare case where rheumatoid arthritis affects the neck.

(*See Are You Sure It Isn't Arthritis? page 39*). The same thing is true for blood tests for ankylosing spondylitis. But ankylosing spondylitis may sometimes affect the neck first (before the low back is involved) and may therefore not be suspected. Blood tests to help confirm the diagnosis may then be needed. The blood test that is usually positive in the patient with ankylosing spondylitis, in addition to the sedimentation rate, is the HLA B-27 test. This test on your white blood cells can identify a genetic predisposition to ankylosing spondylitis. You can have ankylosing spondylitis and be B27 negative, and you can also be B27 positive and never get ankylosing spondylitis. But if ankylosing spondylitis is suspected, and your blood test is positive, it does tend to make the diagnosis more likely.

How About Some X-rays, Doc?

If there is anything wrong with your bones and joints and a lot of other organs as well, x-rays are the time honored method for getting a look at them, and particularly at the bony tissues to determine what might be going on. If you have a pain in the neck for a week, and the history and physical examination reveals no worrisome aspect, and you have none of the danger signals, then you probably don't need an x-ray. On the other hand, if you have been in a recent accident, or if you have had problems with your neck in the past, and have been told that you have severe arthritis, or spondylolisthesis, or there are other worrisome aspects about your case, then x-rays may be helpful. They can provide useful information in determining the extent of your problem, and in assisting in decisions about your treatment.

What Will X-rays Tell The Doctor?

If you were in an accident and the doctor suspects a fracture, then clearly x-rays are warranted. If you were in an accident and now have a only some neck stiffness, you probably don't need them.

How Many X-rays Should Be Taken?

A front view of your neck, a side view of your neck, oblique (angled) views from either side of your neck, and x-rays of your neck flexed forward, in neutral, straight up and down, or extended might be considered. How many x-rays do you need? For the most part, a side (lateral) view of your neck will give the bulk of the information necessary. If no serious problem is suspected, that will be sufficient. If you have evidence of spondylolisthesis (**subluxation** - spinal slippage), and there is concern as to how much slippage is occurring, the additional side views with the neck flexed and extended can be helpful. The front views (anterior-posterior views) can determine whether or not you have arthritis in the joints of Luschka, but this is rarely useful information from a treatment standpoint. You can also tell whether there is some potentially dangerous malalignment of the upper cervical vertebrae. Rarely, a tumor may be identified on a front view of the neck. The oblique views can determine narrowing in the nerve root channels and arthritis in the facet joints. In the majority of cases, the value of this information in terms of treatment decisions is minimal and more useful information can be obtained from a CT scan or an MRI (*See* ***The MRI (MR) and the CT***, *next page*).

X-rays have to be paid for and x-rays also involve x-ray exposure which can have a cumulative effect on the bone marrow tissues and on the thyroid gland. They should therefore be used with discretion and only when your doctor feels that it is likely that useful information will be obtained. Further, if you are getting some gray hairs and wrinkles, you can be almost certain that there will be some mild narrowing between the vertebrae due to shrinkage of the disc. Wear-and-tear osteophyte (osteoarthritis) changes will probably be noted in some of the facet joints, the joints of Luschka, and around the vertebrae. These findings would have been present before your neck bothered you, and they will still be there after it feels better, even though you may have been told that you have *Arthritis*.

The MRI (MR) and the CT

The MRI and CT scans represent the most advanced technologies. They are fancy and expensive, but they can play an important diagnostic role.

The MR or MRI (for **Magnetic Resonance Imaging**) has been proven to be the most precise method for determining the extent of any disc protrusion, or for identifying disease of the spinal cord. When a decision about any invasive therapy from injections in and around the spinal cord to surgery needs to be made, the MRI is the key diagnostic tool to help make that determination. The MRI scan, like an x-ray or CT (CAT= **Computerized Axial Tomography**) scan, gives a picture in black and white and shades of gray, but unlike the x-ray and the CT scan, it shows the soft tissues (muscles, spinal cord, nerves, ligaments) in great detail. Therefore, the MRI can more precisely identify the soft tissue of a bulging disc, or the location of a pinched nerve in the spinal canal, or a soft tissue tumor in the bone or in the spinal canal.

The CT scan can also give information about the soft tissues but does not give it as reliably as the MRI scan. The CT scan also requires considerable x-ray exposure, as contrasted with the magnetic resonance imaging which uses a magnetic field rather than x-rays to obtain the image. The CT scan utilizes highly focused x-rays that are detected and analyzed by a powerful computer, thereby providing very detailed visualization of bone and soft tissue structures. The bone structures are better visualized by CT scans than by MRI, so the CT scan is the procedure of choice when *precise bone detail of the vertebrae* in the neck is necessary. Soft tissue structures such as the spinal cord or muscles in the neck are better visualized by MRI. In these cases, the MRI is usually the method of choice, unless there is some reason such as cardiac pacemakers, or metallic implants in the tissues that interfere with the magnetic fields and preclude the use of MRI scan.

How Does The MRI Work?

Think about the color of the rainbow. The shades of light and dark in the colors of all that surrounds us depends on light waves that reach the back of our eyes. There they stimulate nerves that transmit messages to the back of our brains, and allow us to determine what we see before us. The MRI is essentially a large tube with a surrounding, powerful magnet that stimulates the body tissues to emit detectable radiowaves. Depending on the force of the magnetic field and the concentration of water within the tissue, a different radio signal will be transmitted from bone, muscles, tumors, etc., and recorded by computers (the electronic "brain") and then made into pictures that we can see. This is not unlike the process whereby ordinary light passes through your camera and exposes the film, from which we make pictures.

The MRI is safe, although the presence of metal that may be placed in your body with surgery, such as wire sutures, a cardiac pacemaker, or other implanted metal equipment, may pose a hazard either by distorting the picture or even possibly causing injury. By and large, the major problems for you and me with the MRI is that some of us are quite claustrophobic (or too large to fit in the tube) and being enclosed in the tube can be disturbing and sometimes intolerable. This can usually be dealt with by using sedating medication or the somewhat less precise OA "open access" MRI. The other MRI problem which can definitely require sedating medication is the cost.

What does your doctor see on an X-ray, CT scan or MRI?

Whether you have an x-ray, a CT scan or an MRI, if you're past fifty the likelihood is very great that abnormalities will be seen. You may have been able to hide your gray hair and wrinkles with appropriate cosmetic measures, but you can't hide from the x-rays, MRIs or CT scans. The problem is that whereas you can see abnormalities, what you can't tell, unless there is an obvious fracture or tumor, is whether or not they are causing pain. With each

passing decade, the likelihood increases that we will have evidence of degenerative arthritis in the spine and some disc bulges. The larger the bulge, the greater the likelihood that it is causing a problem. But that is not an absolute, and the interpretation of these tests requires a thoughtful and experienced clinician.

Large disc protrusions or tumors that can be seen on CT scans, or MRIs, are likely to be causing symptoms and may require surgical treatment. Small disc bulges or even larger disc protrusions, or the bony proliferations and spurs that accompany age and wear and tear changes in the discs, facet joints, and joints of Luschka, do not preclude the possibility of arm or neck pain healing without surgery. This is true even when there is apparent nerve root compression. In fact, only occasionally will such findings alone be an indication for surgical treatment, and then only after a careful trial of conservative management has not proven successful.

Have you read enough about tests for necks or do you want to know more about the more esoteric ones?

YES:
Continue Reading.

NO:
Skip to Therapy Treatment Options on page 104

The Myelogram

Both the MRI and CT methods are expensive, but they are cost-effective when compared to the myelogram. A myelogram is a procedure in which a dye that can be detected by x-ray is injected into the spinal canal to determine if there are any disc bulges or tumors. The myelogram requires considerable x-ray exposure, and an injection into the spinal canal carries with it the risk of occasional severe reactions. Fortunately it is seldom needed today. You must hold still during an MRI or CT scan. A myelogram can be performed with the neck in motion on the rare occasion when it may be necessary to detect suspected abnormal vertebral movement or spinal cord pinching.

Thermography - Some Like It Hot

Thermography is a means of measuring heat waves emanating from the body surface. Various recording devices are used in order to determine if circulation to the skin in some part of the body is reduced or enhanced as a consequence of neck spinal nerve injury. The thermogram is the picture in color made by the recording device and is very impressive, but unfortunately the reliability of this method has been called into question. Thermography is only occasionally used at present because it adds little to the information that can be gained from a physician's examination. Although thermography has financial rewards for the thermographer and "some like it hot." In fact, as a diagnostic test, it is *not* so hot. Its main purpose seems to be to influence jurors in a court room that something is really wrong with the patient claiming to be injured, and/or as a second look at an apparently "neurotic" patient who has complaints of neck and arm pain without obvious cause.

Special Diagnostic Procedures

Cervical Discography

Isn't Nature wonderful! Yes. And underline "wonder" - as in "full of wonders" and "you've just got to keep wondering." Cervical discography was first used in 1957 and it seemed so logical that it hardly would require testing. One simply injected a dye that was visible on x-rays into the disc to determine if the disc was abnormal. Further, if the disc was abnormal, the patient should respond to the dye injection into the abnormal disc with an aggravation of his or her usual symptoms and thereby confirm that the abnormal disc was the source of the pain. The results, however, defied logic in that only about 50% of the time did the findings on discography actually predict a good outcome from surgery. Not only that, in a recent discography series 13% of the cases had serious complications, including one death. So discography can demonstrate that a disc is abnormal. But even when symptoms are provoked by irritation from the injection into the disc, it still doesn't tell us if the abnormal disc is producing the patient's pain. The 13% serious discography complication rate can be further compounded by the complications of what half the time may be unnecessary or ill-advised surgery. So one has to wonder and worry a lot. You should ask whatever is on your mind before submitting to this procedure.

Electrodiagnosis

The most serious complications of painful and sometimes painless neck disorders are damage to the nerves of the neck or spinal cord. It is essential to determine whether nerve dysfunction is a result of a problem in the neck or caused by some neurological disease, or by a disorder affecting the nerve further down the arm.

Nerve Conduction Response

Measuring the rate of conduction (by electrodes attached to selected sites on the skin) of an electrical stimulus down a nerve is a fairly simple procedure. A slowing of nerve conduction response can help determine the location and extent of nerve damage. The probabilities of recovery from an injured nerve in the neck, if not evident on the physical examination, may be ascertained by serial nerve conduction studies.

EMG - Electromyography

EMG or electromyography (*electro* = electrical / *myo* = muscle / *graphic* = recording) utilizes a needle and a recording device that displays the patterns of electrical discharges from muscles at rest and muscles during activity. Muscles that are not receiving proper nerve messages can be detected and to some extent the duration of that abnormality can be gauged. There are a number of diseases that affect muscles or nerves that may need to be distinguished from muscular weakness secondary to a cervical (or other) nerve root compression from a disc or spinal cord tumor. Electromyographic studies can be very useful in determining whether or not a patient has, in fact, a severely pinched cervical nerve or another neurological lesion (*See* ***The Anatomy of a Pain in the Neck***, *page 1*).

Electrodiagnostic studies are expensive, capable of error, and by and large *confirm* the obvious that can be determined by a careful medical examination (and when necessary, supplemented by x-ray and/or MRI or CT). An electromyogram usually does not reveal diagnostic abnormalities for at least three or four weeks after the onset of symptoms. Nonetheless, electrodiagnostic studies can help determine whether or not damage has occurred and whether the nerve is damaged from a disorder in the neck or some other cause. And they are occasionally useful to assess response to treatment.

There Are Still Other Tests

Besides the pain in the neck, we are all subject to the ills of men and women. The pain in the neck may just be a coincidence or an innocent bystander to more serious or complex conditions. By and large a pain in the neck is just a "pain in a neck". Occasionally, however, it may be the thing that takes you to the doctor where further inquiry leads to further testing and to the unraveling of other medical problems that range from heart disease, to cancer, to AIDS. The point to remember is that most pains in the neck are a pain in the neck and nothing more. See a competent physician, have a proper medical evaluation, institute appropriate therapy, and avoid morbid speculation about what else might be doing on, because a pain in the neck is usually a "pain in the neck" — and that's enough!

Chapter 6

Now What Should I Do About It?

What should I do about it -- now!

In every society for every ailment there is available a selection of treatment options. These vary in time and place. We have only to look at the history of patent medicines and other pain relieving therapies in the United States to recognize how fickle are the fashions for the cures of the day. Sure cures of one season can become the false hopes (or worse) of the next, but many treatments have stood the test of time.

Therapy Treatment Options: Choose Wisely and Well

If you start to get a pain in the neck, usually the first impulse is to take a "pain" pill until the pain eases; or if the pain is tolerable, to try to ignore it in hopes it will just go away. There are, in fact, a wide variety of treatment options ranging from simple home treatments, exercises (*See Chapter 10 and 11*) and OTC (over-the-counter) medications to surgery that might need to be utilized.

Drugless Pain Relieving Therapies-For Pain Relief at Home

Cold Compresses

By and large, the simplest and most effective treatment for **acute** neck pain is the application of a cold compress. Cold packs can be purchased from most drug stores, placed in the freezer and when chilled applied either directly on the skin or wrapped in a towel to relieve the initial cold impact. Twenty minutes of cold compresses usually eases the pain. A longer application of cold can sometimes cause frostbite.

If need be, cold compresses can be repeated for twenty minutes out of every hour. Generally this is a very safe treatment for pain relief without risk of drug side effects. If cold packs are not avail-

able, they can be made by putting ice in a plastic bag, or even by using a flexible vegetable package from the freezer such as frozen corn or frozen peas on your aching neck.

For Pain Relief at Home After Professional Instruction

Hot Packs

Hot packs (compresses) can be very soothing for a milder pain. A hot shower or warm tub can be helpful in relieving muscle tension and muscle spasms. If your neck pain is **moderate** to *mild*, it is helpful to use warm compresses to relax muscles before stretching and strengthening exercise. Then follow the exercise session with cold compresses to relieve any sense of irritation resulting from the exercises.

Warm, moist heat is usually the most comforting and this can be applied with a hot wet towel, with a Hydrocollator,™ or by a Thermaphore™ moisture-attracting electric warmer pad. The duration of a hot pad application should also be limited to twenty minutes out of each hour at the most. Electric heating pads may do the job but tend to be less effective, though easier to use. If cold packs can produce frostbite, hot packs and heating pads can surely produce burns if misused.

Ice Massage

Since cold numbs the nerves that send painful messages, the use of ice massage for two to three minutes can provide pain relief. They can be applied as frequently as once an hour or three or four times a day as needed over very tender spots or trigger points. An ice massager can be made by freezing water in a small paper cup. Ice when first applied feels very cold. It should be first applied gently, with firm strokes, until the area becomes numb and then a deeper massage over the painful area can be applied

for two to three minutes. ***Caution:*** *more prolonged ice massage can also produce frostbite.*

Ice, or Spray and Stretch

Ice, or spray and stretch produce a brief intense cold irritation on the skin and sends messages along the nerve pathways that lessen the intensity of pain. The use of a wiping motion with an ice cube or a vapocoolant spray over the area of muscle irritation and spasm will cause hyperstimulation analgesia—strong pain-relieving stimulation.

Fluori-Methane gas is a vapocoolant (cold) spray widely used for this purpose because of its ease of application and rapid evaporation cooling of the muscle. Due to concerns about atmospheric contamination with volatile gases, it is possible that vapocoolant sprays will not be available in the future; however, a substitute vapocoolant which helps protect our atmosphere is expected to be available soon.

Wiping the problem area with ice can help relieve pain

Because a quick rub over the area with ice has a similar effect to a vapocoolant spray, we can also use a series of quick cold wipes over an area of muscle spasm to produce the hyperstimulation analgesia muscle-relaxing effect. A gentle stretch immediately after the cold wipe will often help to relieve the muscle spasm for many hours. Generally this is a treatment that is performed by a physician or therapist; but since a family member can be instructed to do this for you, it can be a practical and safe home treatment for recurrent muscle spasms.

Manual Massage

Gentle stroking massage over an area of painful muscles will make almost anyone relax and feel better. Caution! Too vigorous deep kneading massage can damage previously injured tissue. But well directed deep massage over a painful trigger point (acupressure or Shiatsu) with the pressure applied for five to ten seconds can sometimes relieve painful trigger point muscle spasms in both moderate and mild cases. Acupressure-type deep massage can be quite painful and is best left to experts such as physical therapists or trained massage therapists, because over-zealous massage by well intended but unskilled massagers can cause injuries.

Transcutaneous Nerve Stimulation (TNS or TENS)

TENS is a another form of what is called hyperstimulation analgesia. Without thinking, you might rub over a bruise, much as a dog will lick its wounds. These are natural forms of hyperstimulation analgesia which can be soothing and do not have to be painful.

TENS, acupuncture, acupressure, vibration, massage, and even "biting the bullet" are all capable of producing hyperstimulation analgesia. TENS does this by passing a painless electric current from a little beeper-sized battery-powered device (that can be attached to a belt or bra) to generate stimulation via electrodes on the skin. This stimulation sends a message along the nerves from the painful area to the spinal cord and brain centers, stimulating the release of pain-blocking chemicals such as the body's morphine-like endorphins.

TENS can also be administered by passing a smaller current through a blunt, pen-like probe called a point-stimulator. Brief stimulation over focal trigger points, although sometimes provoking transient discomfort, will often relieve pain for several hours to days. As is true of most treatment formats, transcuta-

neous nerve stimulation by any method is not always helpful. TENS can be prescribed by a physician and can then be used as a drugless pain relief treatment at home, particularly in severe cases where a pinched nerve in the neck sends pain into the arm.

Cautions: TENS electrodes occasionally will cause skin irritation. Cardiac pacemakers can be disturbed by some TENS devices and metal plates or artificial joints can cause short-circuiting and interfere with proper TENS function. TENS units are not recommended during pregnancy.

Pain Relief by Professionals Only

Traction

Spinal traction is another time-honored method to treat neck and back disorders. Although it seems reasonable to think that the purpose of traction is to adjust and properly align the skeleton and thereby enhance healing, this is clearly an over-simplification. One has only to think about our anatomy to realize just how complicated our anatomical structures are, and certainly the neck is as complicated as any region (*See **The Anatomy of a Pain in the Neck,** page 1*). Nonetheless, neck traction can be helpful, even though the reasons for its benefit are not adequately understood.

What seems to make sense is that traction relieves pain by the stretching of tight muscles and tight ligaments, producing a form of hyperstimulation analgesia. Traction may also cause alteration in the circulation in the deep tissues and thus disturb and remove stagnant pools of irritating chemicals which helps bring pain relief. Whether or not alignment of the discs and facet joints (with the exception of traction for acute facet dislocations) during the time that the traction is applied plays any role in the therapeutic process is moot. Traction, by lifting the weight of the

head off of the neck, can produce a prompt easing of pain that may last for hours, or even days, and may help expedite the healing process.

Traction Methods

There are a number of ways of performing cervical traction. No matter what the method, the head must be aligned properly (usually with the head in the midline [not tilted to either side] positioned so as to avoid any neck or arm pain, numbness or tingling). Traction can be done horizontally in a hospital bed with about 5 to 10 pounds of force pulling on the head (the average head weighs between 10 and 15 pounds). Intermittent traction in the supine (lying on your back) or in a seated position using a motor-driven traction force is used in many clinics. There is also the widely used seated traction that can be performed for 15-20 minutes by a simple over-the-door water bag or other weight suspension device for use at home. Almost all neck traction involves the use of a halter-like device that is placed under the jaw in front and the base of the skull behind to which ropes or struts are attached to the traction mechanism.

If traction in the doctor or therapist's office proves comfortable, it can be utilized as an inexpensive self-applied home therapy. The patient must be instructed in its application and a home traction device should be obtained.

When Not to Use Traction

There are two contraindications to traction. It should not increase pain nor increase signs of numbness, tingling or weakness in an arm or elsewhere (radiculopathy), nor should it cause any discomfort in the jaw. Anyone who has had a painful dental or jaw disorder (TMJ - *TemporoMandibular Joint dysfunction*) should be very cautious about the use of neck traction and initial-

ly use a dental "bite plate" to help prevent jaw discomfort. There are also some traction devices and techniques that avoid using a halter applied to the jaw. They can prove beneficial, but generally are not as effective in our experience. Like any treatment, traction can be misused. If there is any question about its use, check back with your health professional, and if need be, consult your dentist.

Experience Versus Science

Over the years that I have treated neck problems, I have been impressed with the apparent relief that many patients get with the use of a simple home neck traction program. I have not been unaware that the research has not shown impressive benefits from neck traction; nonetheless, I have found home cervical traction (utilizing a carefully fitted head support [halter] with proper instructions) to be helpful in relieving neck pain, and our recent research confirms this.

Cervical Collars and Braces

The cervical collar (soft collar) is designed to help support the head in a position of comfort. Soft collars are not sufficiently rigid to prevent forcible head and neck motion, as in a whiplash accident, but they do give support to the head in a manner similar to an Ace bandage wrap for an ankle sprain.

Does My Collar Fit Properly?

A properly fitted cervical collar should allow the head to be bent slightly downward so that the front of the collar allows the chin to rest on it. The back of the collar should also be sufficiently high to help hold the head slightly tilted forward position. Soft collars that are too thick, too narrow, or too wide or that bend the head backward can cause more discomfort than comfort. Since most, but not all, soft collars are made of stockinette filled with foam rubber, it is sometimes advisable to remove the cloth

cover and trim the foam to get a "customized" best fit. Collars with more rigid plastic or leather sides cannot be as readily adjusted.

Ideally, the soft collar should fit like a comfortable glove, so start with a 4 inch high soft foam collar and trim it with a curved scissors as needed. The collar should not choke and it can be loosened periodically for comfort. It can be worn at night but with the use of a proper neck pillow, this is usually not needed. The soft collar definitely should be worn during the day when driving (unless you feel the restriction of neck motion to be a hazard) or when engaging in activities that put the neck into stressful postures (*See **Ergonomics,** page 145*).

The major problems with soft collars are that they can be uncomfortably warm in hot weather and when worn over time they tend to weaken neck muscles. Exercises to offset any weakening effect should be incorporated as soon as they can be performed without pain. The key exercises are the isometric exercises in Chapter 10, exercise 1, 2 and 3.

A soft collar is quite noticeable, and indeed should be worn at the beauty parlor or barber shop and at the dentist in order to remind them that you have a painful neck. Unfortunately, they rarely win applause for enhancing your cosmetic appearance. To that end, particularly in the winter, but even in summer, wearing an attractive scarf may provide some cosmetic redemption.

Cervical Braces versus Soft Collars

A cervical brace is used to help relieve pain and stabilize the cervical spine in patients with severe pain and particularly in patients who have the manifestations of a cervical radiculopathy. In contrast to the soft collar where neck stabilization can't be achieved, a cervical brace can provide more rigid neck stabilization, by means of an under-the-chin extension, and an occipital (base of the skull) and chest support. Cervical braces provide

their greatest neck stabilization below the third cervical verte-
brae, where the majority of the neck problems arise.

One of the most widely used cervical
braces is the Philadelphia Collar™.
The Philadelphia Collar is a commer-
cially available plastic (plastizote) brace
that is adjustable and generally com-
fortable to wear, although it may take
"getting used to." From a cosmetic
standpoint, as with all braces, it defi-
nitely takes "getting used to."
Nonetheless, when properly fitted,
braces do an excellent job of relieving

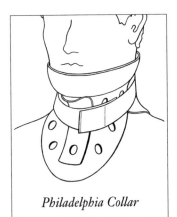

Philadelphia Collar

pain and facilitating recovery from severe cervical disc sprains
and bulges complicated by a pinched cervical nerve.

The Philadelphia Collar and any other brace (and even a soft
collar) should be fitted by a knowledgeable professional and
adjusted to maximally relieve neck pain and nerve root pressure
symptoms. This usually means holding the head in slight flexion
in a manner similar to the soft collar. The position of optimal
comfort must be sought, and it may be necessary for the orthotist
(or brace fitter) to make modifications in order to optimize the
fit. The chief disadvantage of the Philadelphia Collar is that it,
like most braces, tends to be uncomfortable in warm weather and
sometimes irritates the skin. When the use of any form of cervi-
cal bracing is advisable, whether it be a Philadelphia Collar,
other plastic braces, or more rigid metal ones, the brace should
be prescribed by the attending physician as to its fit, expected
benefit, and duration of use.

In most municipalities, wearing a soft collar while driving is per-
mitted, but wearing a rigid neck brace may not be. You should
plan to be a passenger, not a driver. If driving with a cervical col-
lar or brace is permissible in your community, it is advisable to

obtain a wide angle, rear-vision mirror and to avoid driving in rush hour heavy traffic.

By and large, being told that you must wear any kind of a neck brace is not good news. But there is good news, and that is that proper bracing usually does the job of relieving severe neck and arm pain and numbness and braces rarely need to be worn for more than a few weeks.

Acupuncture

Although the mechanism by which acupuncture treats diseases or relieves pain is poorly understood, it is widely recognized and accepted that acupuncture can provide significant pain relief in many patients with both acute and chronic neck pain and other musculoskeletal disorders. Acupuncture has been shown to sometimes affect endorphins (the body's morphine-like pain relievers) but the release of endorphins alone does not fully explain its effect on pain.

Clearly, we have a great deal yet to learn about the treatment of pain and the mechanisms by which hyperstimulation analgesia in its various forms work. Acupuncture is safe and moderately cost-ly. It typically requires twice weekly visits to a licensed acupuncturist or physician trained in the use of acupuncture.

Caution: the use of disposable needles by the acupuncturist is essential to prevent the spread of AIDS, viral hepatitis, or other infections.

Ultrasound and Diathermy

Ultrasound produces very penetrating deep heating by means of sound waves pitched beyond our hearing ability, hence "ultra" sound. The ultrasound waves can be focused to produce heating deep into muscles, ligaments, and even joints. The heat can relieve pain and by virtue of the effect of heat on enhancing circulation, may have some benefit on the healing process.

Ultrasound when used for neck pain problems is best reserved for persistent *moderate* or *mild* cases. It is generally safe, must be administered by a health professional, and is moderately costly.

Diathermy, which means "deep heat," not too long ago was the "cure all" for painful musculoskeletal conditions. Diathermy uses electromagnetic energy like microwaves that can penetrate more widely but less deeply than ultrasound into the tissues and produce a warming effect. Although generally soothing, diathermy has no curative benefits and is much less widely used today. Those of us who remember its popularity have to wonder what all the fuss was about.

Mobilization or Manipulation - Hands On or Hands Off?

Hands-On Manual Therapies

Manual therapies have been used for thousands of years in the treatment of various disorders, most notably aches and pains. Modern medicine as we know it, for all practical purposes, has only existed in the Twentieth Century. It is not surprising, therefore, that in the past any conceivable therapeutic intervention would find a place, particularly if there were perceived benefits. Treatment was limited to gruesome crude surgery or cautery and a variety of local herbs, insect bites, purgings, emetics (you can vomit from that) and hands-on manual treatments. It would not be surprising that if the latter proved soothing by gentle massage and soft non-thrusting mobilization, or provided dramatic relief by more vigorous thrusting manipulations, that these hands-on therapies would find a place in many cultures.

Manipulation

Manipulation is a word used to describe a technique of quickly stretching and repositioning a joint that has been either totally or partially dislocated. Dislocated joints in the arms or legs result-

ing from sports injuries are often quickly relocated on the sidelines by a physician or trainer. Under these circumstances, if the manipulation is done promptly, realignment is usually readily accomplished and the manipulation is less painful than the pain of the dislocation itself. When this is not possible, an anesthesia is necessary to get sufficient relaxation to allow for repositioning of the dislocated, or subluxated (partially dislocated) joint structures. So manipulation clearly has its place.

The problems with the neck and back are that most of the worrisome presumed minor subluxations and dislocations that are daily being treated by manipulation therapists have never actually been demonstrated to exist by reputable research. That does not mean that manipulation does not do something or that it has no therapeutic benefit. To be persuaded, one has only to experience the rewarding sensation that occurs with knuckle cracking. This is actually a form of self-manipulation that creates the same cracking sound as a manipulation of the small facet joints in the neck or back.

Whether the mechanism of relief involves an actual restoration of normal joint alignment, releases a pinched facet fat pad, or provides a vigorous hyperstimulation analgesia that relieves pain and secondary muscle spasm is not known. What is known is that repeated manipulations week after week, or even annually, designed to achieve overall body alignment and a healthy flow of nutrients through the nerves and to the various organs of the body to "fight" disease has *no scientific basis (See **Chiropractors**, page 70)* and is of questionable value.

What are the risks when manipulating the neck?

Manipulation requires a rather vigorous and quick maneuver of the skeletal structures. This is a maneuver in which the actual tissues being moved cannot be seen (although it is thought by some treating practitioners they can be felt). The fact is that what is going on in the region of the disc and the adjacent spinal cord

nerves cannot be monitored. The result is that the vigorous manipulation of the cervical spine can sometimes result in ripping disc material out of the confines of the disc and into the spinal cord or nerve roots, causing paralysis and even death. Manipulation of the lumbar spine is much safer. Because the spinal cord stops at the second lumbar vertebra, well above the areas of the 4th and 5th lumbar vertebrae where most lumbar disc problems occur, most lumbar manipulations take place relatively safely. Needless to say, if there is a tumor or vascular condition, the consequences of manipulation can be catastrophic.

Mobilization - Hands On

Mobilization is a somewhat all encompassing term involving moving skeletal structures in such a way as to relieve muscle spasm and restore motion. It does not technically include the high-speed thrusting movements of manipulative therapies. Nonetheless, the word mobilization is often used more broadly and may include manipulative procedures as well. So mobilization consists essentially of massage and graded, small movements to relieve muscle tension and restore mobility in tight painful skeletal structures where motion has become restricted. These are very effective therapeutic techniques when used by a skilled professional, and by and large can be safely applied to *moderate* and *mild* painful neck conditions. Because these movements are made under control, the patient can report to the therapist any untoward discomfort. This is in contrast to manipulation where, if damage or pain is occurring once the manipulation is in motion, there is no way to stop it.

Any treatment that is soothing and feels good, particularly if it is provided by an empathetic health practitioner, can be seductive and can therefore be overused far beyond any practical benefit. By learning the self care techniques in this book which you can

perform independently at home, the need for prolonged supervised therapy should be significantly lessened.

Rest and Relaxation

If you feel that you are overworked and underpaid; if you feel uptight; if what you have to put up with every day is a pain in the

Are you having chronic neck pain and feel stressed out or fatigued?

Yes:
Consider some form of relaxation therapy.

No:
Skip to Diet and Nutrition, page 121

neck — tension will mount. And if your neck is your weak spot, you will probably feel it there.

Clearly, if you have a pain in the neck, and it's brought on by tension, it's not all in your mind. But what is going on in your mind does affect what's going on in your neck in many ways. Nerve pathways from the brain through the spinal cord and into the neck transmit the messages that determine how tense your muscles will be and how tightly you will hold your neck and head. The nerves control the kind of pain relieving, or pain intensifying chemicals that will be released in your spinal cord and at the nerve endings in the tissues of your neck, arms and the rest of your body. Whether you are exhausted from lack of sleep, prolonged sustained work, or even from vigorous recreation, your body will need to pause to give the "batteries" in your brain, muscles, and other tissues a chance to recharge. This enables the

nerve pathway circuits to again work normally so that the short circuits of pain and muscle spasm can be avoided.

Relaxation Methods

"You tell me to relax? Sure. I will sit back in my chair or lie on the couch and all that I can think of, and all that goes through my mind are all of the aggravating thoughts of the day. I just can't relax!" Well, that may not be so. There are a number of approaches to relaxation that you might want to consider.

Relaxation can literally have a down side as well. Twisting your head to relax can cause problems, but dropping off into a deep state of relaxation can literally leave your head hanging. Be sure before you start your relaxation process that you have good neck support, good posture, and if need be, are wearing a soft collar or a brace (*See Cervical Collars and Braces, page 110*).

Self Hypnosis

There are a number of techniques that are designed to refocus your thought processes to break the vicious cycle of anxiety-provoking thought patterns and rechannel that nervous energy into the comforts of relaxation. The techniques that are used amount to a form of self-hypnosis. This can be accomplished by focusing on a neutral thought like the number "one"; or repeating an arbitrary word (a mantra) like "calm" over and over; or by focusing on some very pleasant, relaxing experience that you have savored and can savor again, such as watching a beautiful sunset at the seashore. Deep, slow breathing, concentrating on each inhalation and each exhalation, and allowing the muscles to let go in the jaw, the scalp, the neck, the hands, the legs, and the feet, one by one, is a great way to ease into a relaxed state.

Relaxation takes practice and it takes time, usually about ten to twenty minutes. Relaxation can't be forced, but it can be expedit-

ed with the help of books or audiotapes that guide you into the relaxation patterns and practices that work best for you.

Biofeedback

Biofeedback techniques are popular because they have been found useful in a variety of tension-provoked problems, particularly those related to painful musculoskeletal disorders of the neck and upper back. It is almost impossible for us to be able to tell just how tense a muscle may be, just as it is almost impossible to know your blood pressure, without measuring it. With biofeedback, your body (bio) is able to tell you (to feed back to you) how it feels. You can measure the warmth of your skin and learn to adjust your skin circulation to raise or lower your skin temperature by means of an electronic thermometer that is constantly recording the skin temperature. You may see the temperature as numbers recorded digitally by the instrument, or you may hear sounds rising in pitch as the skin temperature rises. Similar electronic techniques can be used to record tension in muscles so that one can learn to enjoy the silence of a fully relaxed muscle.

Case Study: M.E., a 45 year old concert pianist and piano teacher, suffered from chronic neck and shoulder pain. Although she was not aware of it, on observation, it was obvious that just prior to playing she would shrug her shoulders up toward her ears and tense her neck forward. She would then continue to play in this stressful posture. When this was pointed out to her, with biofeedback monitoring of muscle tension, she learned to recognize when she was tensing the muscles, and how to relax them. The results of biofeedback training made it possible for her to continue with her career. That was music to her ears and ours.

Biofeedback methods are basically a relaxation teaching tool. Usually within about eight weeks one has learned what is needed in order to continue the relaxation method at home. Although

biofeedback and relaxation methods are not always helpful, they do tend to find their best applications in the treatment of neck and upper back pain, tension headaches and migraine.

It should not be forgotten that persistent tension is usually a sign of an unsatisfactory adjustment to the stresses of life. Relieving that tension by biofeedback is useful, and certainly comforting, but one should not overlook the possibility that psychological counselling to help you better cope with stress may get at the root cause of the tension. This can help you learn how to manage your personal affairs in a less stressful way.

The Spa

There is nothing like getting away from it all - especially if you have a chronic pain in the neck, and especially if your pain in the neck is what you are getting away from. Whether neck pain is due to psychosomatic stress, aggravated by work stress, or just a painful distress that won't go away, it is tempting to get away to a place devoted to soothing and healing both the psyche (the mind) and the somi (the body) and the psychosomatic pain in the neck.

Spas have been in existence since historic times and by whatever name they are called, have been found all over the world. Like many remedies, the therapeutic effects of spas have been attributed to special ingredients: to chemicals in the water or in the mud (let alone the massage and body wraps); or to the surrounding air and environs; or to special medications or ointments prepared from local ingredients related to hot springs of volcanic origin. It used to be felt if the medicine didn't taste bad, it couldn't do good. To some extent, this philosophy has been carried over to the sulphuric odors emanating from the various hot springs and mudbaths at some spas.

What seems to be apparent is that getting away to a place devoted to soothing, healing, rest and/or exercise and diet can have a

beneficial effect. Indeed many people, in Europe, as well as in the Orient, make annual pilgrimages to their favorite spas for healing and for physical and spiritual recharging of their body's energies. In the final analysis, a spa provides a nurturing and relaxing vacation environment. If you can afford it and it is properly supervised, you may even get some relief from your pain in the neck.

Diet and Nutrition - Fat Chance!

When it comes to arthritis, being overweight definitely gets its share of the blame, and rightly so. But you can't blame sore joints in the hands on obesity (unless they get that way from opening the cookie jar) and you can't blame a pain in the neck on too many calories.

We are all aware, and rightly concerned, about balanced nutrition, low cholesterol, low fat diets, and adequate calcium intake with a goal of a lean, but definitely not mean, physique. A balanced, nutritious diet is essential to good health, but other than its role in maintaining health generally, there is no specific diet or nutritional formula, vitamin or mineral preparation that can cause or relieve neck pain.

If being overweight is a "pain in the neck" for you, then by all means slim down. A nutritious calorie-conscious diet can keep you feeling better generally and probably looking better as well. The benefit of any "special diet," or special vitamin or mineral supplementation formula that is recommended for your pain in the neck may be nothing more than a lot of bother and just another pain in the neck for you.

Two More Thoughts

Primum non nocere - "First do no harm." This is the most important guideline for any health care practitioner and is basic to the development and implementation of any treatment pro-

gram. Today before powerful medicines are prescribed, or before any surgery is undertaken, the patient must be advised in great detail about the possible side effects, or lack of benefit, from the proposed procedure or treatment. Always ask the doctor what the chances of the treatment helping are and what the risks are. The final choice is yours.

The Placebo - "I shall please." The dictionary definition of a placebo is a medicine given merely to humor the patient; especially a preparation containing no real medicine but given for its psychological effect. There is nothing wrong and a lot right about trying to please a patient who is suffering or worried or otherwise made distraught by some medical condition or injury.

In times gone by, the physician was aware that he/she could seldom cure, but that he/she was obliged to "comfort always."

We can now recognize that the placebo effect can stimulate brain and nerve pathways to create chemical changes that enhance immune mechanisms and healing as well as give pain relief. This may also explain some of the apparent benefits from a wide variety of therapies for which there is no scientific explanation. That is not to say that anything from bee stings to witch doctoring have not produced benefit to patients suffering from a variety of disorders, but it is to call into question whether or not the treatment that was credited with the benefit deserved the credit or whether it was a placebo effect.

Placebos work. They are accepted as a confounding factor during research studies. If harmless, they should be encouraged as useful adjuncts to any treatment, but they should not be exploited for monetary gain nor should they be so expensive as to waste limited health care resources, nor your money.

All medications have side effects. If that's all they had to offer, we wouldn't use them. But medicines of various kinds have been the mainstay of treatment for centuries and they still can play an important role in easing your neck pain. Chapter 7 helps you pick and choose the right medicines, when and if you should need them.

Chapter 7

Medication for
Neck Pain Relief

DEPENDING ON THE CAUSE of the neck pain and its severity, there is often a great deal of relief that can be had by the use of medication.

To guide you in your medication selection, see the Tables at the end of this chapter. If your neck pain is **SEVERE**, see Table 1 (*page 135*). If your neck pain is ***moderate,*** see Table 2 (*page 136*). If your neck pain is *mild,* see Table 3 (*page 137*).

Relaxation By Medication Versus Meditation

Not everyone can be hypnotized and not everyone can learn relaxation methods quickly enough or well enough to obtain relief from pain. Medication can help and medication can be abused. Muscle relaxing medications can ease neck muscle spasms and thereby relieve pain, but they should only be used for short periods of time and in *moderate* and *severe* cases. Never use more than one pain-relieving, muscle relaxing, or sedative drug at a time without consulting your physician. All muscle relaxants are sedatives to some extent and all sedatives are capable of muscle relaxation. The fact that sedatives and muscle relaxants tend to make one feel drowsy is ample reason to use them with caution - the same caution that one would use with regard to alcohol and driving, alcohol and working around potentially dangerous machinery, and alcohol and making difficult decisions.

There are two other concerns: First, sedatives like alcohol can impair your coordination and balance and this can lead to stumbling, falling and injuries from the head and neck down. Second, heavy sedation can lead to deep sleep with the head and neck in an awkward position and the resultant rude awakening with more pain.

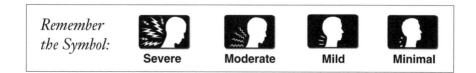

Remember the Symbol: **Severe** **Moderate** **Mild** **Minimal**

Muscle Relaxants

Sedative or muscle relaxant drugs should be reserved for
SEVERE or *moderate* neck pain or for a flareup of *mild* pain
and generally should be used for only a few days. Rarely should
they be used for periods longer than three weeks because they
tend to lose their effect and can lead to a pattern of dependency.
Because of the possible interaction of prescription drugs (and
over the counter drugs as well) and the possibility of the side
effects of medication, you should always consult your physician
before using these medicines.

There are a number of muscle relaxants available by prescription.
Flexeril® (cyclobenzaprine) is a commonly used and effective
muscle relaxant and may prove more effective when used with a
non-narcotic analgesic such as aspirin or acetaminophen. Other
sedative-muscle relaxants include Soma® (carisoprodol),
Robaxin® (methocarbamol), Parafon Forte® (chlorzoxazone),
Norflex® (orphenadrine), and these drugs can come in various
combinations, typically with aspirin and caffeine, as in Norgesic
Forte® or Soma Compound®.

Sedatives are widely used as muscle relaxants. They have all the
problems referred to above and in addition, may tend to aggra-
vate anxiety associated with depression. The most commonly
used drugs are the benzodiazepines. These include Librium®
(chlordiazepoxide), Ativan® (lorazepam), Valium® (diazepam),
Dalmane® (flurazepam), Tranxene® (chlorazepate), Xanax®
(alprazalam) and Serax® (oxazepam). All of these drugs are seda-
tives with a secondary effect on muscle tension causing muscle
relaxation. Some, such as chlorazepate, diazepam, and
lorazepam, can stay in your system causing some sedation to per-
sist for more than one day.

Other drugs used as muscle relaxants and sedatives include Miltown® and Equanil® (meprobamate) which are similar to barbiturate sleeping pills. These drugs and other sedatives should be used only for short term treatment of insomnia under the supervision of a physician.

If getting to sleep or staying asleep is the problem, other sedative drugs can also be considered, including Benadryl® (diphenhydramine), Dalmane® (flurazepam), Halcion® (triazolam), Atarax® (hydroxyzine), Ambien® (zolpidem tartrate) and chloral hydrate among others. Be alert that all sedating drugs can cause problems related to over-sedation and each drug may cause its own allergic or other toxic side effects.

Therefore, meditate well before medicating long with muscle relaxants and sedatives, and do so only under a physician's supervision.

Narcotic and Non-Narcotic Analgesics

If pain is what's keeping you awake and tensing your muscles, and medication is required for relief, then analgesic (anti-pain) medications are probably what you need.

Non-narcotic analgesics are usually the *first choice* unless your pain is **SEVERE**. They are primarily available over-the-counter in drug stores, requiring no prescription, and include aspirin, Tylenol® (acetaminophen), Advil® (ibuprofen), and Aleve® (naproxen).

There is a long standing gag where the doctor says, "Take two aspirins and call me in the morning." The reason for the morning call can be due to rare but nasty side effects from over-the-counter drugs that we ordinarily consider to be so safe. Aspirin can irritate the stomach and cause ulcers, as can Advil, Motrin or Aleve. Aspirin, in particular, and to a lesser extent other anti-inflammatory drugs, can interfere with blood clotting and can produce allergic reactions and problems with your stomach and

intestines, and very rarely liver and kidneys. Nonetheless, they are as *safe as it gets* – unless you are unfortunate enough to have a particular sensitivity or allergy to any one of them.

Ultram® (tramadol) is a new non-narcotic analgesic with about the same pain relieving effect as the narcotic analgesics. The good news is that it rarely causes addiction. The bad news is that it may have other side effects similiar to narcotic analgesics.

Narcotic Analgesics

Narcotic analgesics are generally more potent pain-relievers and are used for ***intolerable neck pain***. They all have a definite, albeit rare, tendency to cause addiction. They are all capable of dulling your senses, similar to the sedatives, and they tend to cause nausea or constipation. As is the case with most medications, individuals respond differently (individually) to these drugs, even though they all have similar effects on pain control. The narcotic analgesics include Tylenol® with codeine (acetaminophen with codeine), Vicodin® (hydrocodone with acetaminophen), Empirin® with codeine (aspirin with codeine), Darvon® compound (propoxyphene and acetaminophen), Percodan® (oxycodone with aspirin), Percocet® (oxycodone with acetaminophen) or DHC Plus® (dihydrocodeine/aceta-minophen/caffeine), among others.

If you have a known aspirin or acetominophen sensitivity, it is important to note whether or not these drug compounds contain aspirin or acetaminophen in order to avoid allergic reactions. An individual, for example, who is known to be allergic to aspirin might take Percodan® and suffer an unexpected aspirin side effect. All of these drugs require a prescription and all should be used with respect, so read the labels and talk them over with your physician.

It is rare for a patient with neck pain to require any of the seda-
tive, muscle relaxant, or narcotic analgesic medications for more
than a few days. Where more prolonged use of these medications
seems necessary, close coordination of the prescriptions and
other treatments by your physician is imperative.

Nonsteroidal Antiinflammatory Drugs (NSAIDs)

Although neck strains and sprains are
associated with irritation of the
strained tissues, and therefore with low grade inflammation, the
role of nonsteroidal antiinflammatory drugs in the treatment of
these disorders is somewhat disappointing. They do not cure the
neck pain. If you have a **SEVERE** or *moderate* neck pain, or
even if your neck pain is only *mild* but sufficient to make simple
activities difficult (such as a long drive or watching a movie), the
NSAIDs may help to take the edge off the pain.

All of the nonsteroidal antiinflammatory drugs are analgesic.
Advil® (ibuprofen) and Aleve® (naproxen) and Motrin® (ibupro-
fen) are now sold over-the-counter for that purpose. One should
not expect immediate pain relief upon ingesting the over-the-
counter antiinflammatory drugs as it takes about thirty minutes
to get an effect from these drugs. Like aspirin, their effect is usu-
ally largely worn off after three or four hours.

There are numerous nonsteroidal antiinflammatory drugs now
available. All have a similar chemical effect in your body, but all
have slightly different effects in terms of how they are metabo-
lized and how they react on pain problems. Some are long-acting
like Clinoril®, Feldene®, Oruvail®, Daypro®, and Relafen®, which
means that they can be taken once a day. But it also means that if
side effects should occur, it takes longer for them to get out of
your system.

Motrin®, Voltaren®, Indocin®, Orudis®, Lodine®, Naprosyn® and
Toradol® (a non-narcotic antiinflammatory drug that can be

given by injection for pain relief) tend to be metabolized and excreted more rapidly so they need to be taken more frequently. All of these antiinflammation drugs are generally well tolerated and safe, but they can occasionally cause side effects such as bleeding stomach ulcers, elevation of blood pressure, allergies, and rarely, kidney or liver problems. A new group of NSAIDs called COX_2 drugs (Celebrex®, Vioxx®) are less apt to cause serious side effects.

There are two antiinflammatory drugs that are similar to aspirin in that they contain salicylates (aspirin [acetylsalicylic acid] in large doses is an anti-inflammatory drug) but they have their antiinflammatory effects with much less risk of stomach ulcers or bleeding. They are Disalcid® (salsalate) and Trilisate® (choline magnesium trisalicylate). These drugs are generally well tolerated and safe. Like aspirin in large doses, they can cause temporary impairment of hearing, dizziness, indigestion, and other allergic reactions.

Basically all of these anti-inflammatory and analgesic drugs usually give some pain relief, and are similar in their effects and for the most part, in their side effects as well. It is therefore difficult to choose one drug for one individual's neck pain problem because even though similar drugs have similar effects in any individual, the effects may be dramatic relief for one person and only uncomfortable side effects for another.

Trial and error in consultation with your physician is necessary when your neck is hurting, and an unsuccessful trial of a medicine that causes serious side effects can be more than a pain in the neck.

Antidepressants — For Chronic Pains In The Neck

Pain is rarely uplifting and when pain persists, it is at least distressing and for many sufferers a significant cause (or aggravating factor) of depression. Pain impairs sleep and predisposes to

depression which further impairs sleep and increases pain and suffering. The use of some antidepressant medications can be effective in improving the quality of sleep, raising the threshold for pain, easing the tendency to muscle spasm, lifting the depressed mood, and improving the quality of life.

Some commonly prescribed antidepressant medications such as Elavil® (amitriptyline), Sinequan® (doxepin), and Norpramine® (desipramine) can be useful even when the psychological depression is not profound, because they do have a tendency, even in low dosages, to relieve pain or make it more bearable. These drugs can also have very troublesome side effects. The most common problems are severe drowsiness, dry mouth, constipation and or difficulty with urination. Although the side effects can be worrisome, they generally subside within 24 hours after discontinuing the medication. If these drugs should prove necessary and beneficial without disturbing side effects, they may be used over a period of months.

Don't Rub Me the Wrong Way - The Massage Ointments Message

One way to avoid the side effects of ingesting medication is to use an ointment and rub it in the skin over the area where it hurts. The skin over and around the area of painful muscular irritation can be lightly massaged and if soothing, a deeper massage can be applied for additional pain relief. Analgesic (pain relieving) salves can usually be applied three or four times a day. They can also be used in conjunction with five or ten minutes of massage. Be sure to follow the specific recommendations for each ointment provided with the label.

There is no pretense that these ointments and liniments are curative. They can ease discomfort and, if there are no problems with skin irritation, they are generally safe to use. Most of them contain methylsalicylate, or menthol, or camphor, and perhaps

alcohol and some have triethanolamine or trilamine salicylate. But all have in common their ability to cause a counter-irritating effect by which a stimulation on the skin induces a reflex which tends to block pain pathways and encourages the relaxation of tense muscles. Some of the more common ointments include Ben Gay®, Absorbine Arthritic Pain Lotion®, Deep Heating Rub®, Icy Hot®, Banalg®, Aspercreme®, Myoflex®, or Exocaine®. There's no magic in the ingredients but there are differences in texture and odor (do you smell something special going on here?). There are also definite differences in price, so shop before you buy.

Special Injection Procedures

Trigger Point and Tender Point Injections

Trigger points, which are very painful focal areas of muscle spasm, often respond to injections of a local anesthetic such as Novocaine® or Xylocaine® into the area of muscle spasm. By blocking the pain transmitting nerves in the region of the area of muscle spasm, the local anesthetic can relieve pain and permit muscle relaxation with relief lasting for hours or even days - long after the effect of the anesthetic has worn off. This is attributed to the anesthetic injection interrupting the short circuited spinal cord reflex caused by the persistent muscle spasm. The muscle spasm other-wise would tend to perpetuate the pain and not allow the muscle to relax and stretch to ease pain.

Tender point irritations are found at the points of attachment of muscles and in bursae. Shoulder bursitis occasionally occurs as a reflex phenomenon in association with neck pain. If these tender points are persistent and not responsive to other treatments, then local injections of very small amounts of a cortisone-like drug, usually with a local anesthetic such as Xylocaine, can give relief.

These hypersensitive painful areas may occur particularly around the shoulder blade, the shoulder and also the neck. The dosage of cortisone required in a single tender point injection need not be much greater than the equivalent of what the normal body's adrenal glands make every day in order to sustain life. Although a concentrated dosage of cortisone-like medication is injected into the tender point area, it is usually dispersed in a few days and the amount absorbed into the body is rarely sufficient to produce the well-known deleterious side effects of excessive oral or injected cortisone (*See **High Dose Oral Steroid [cortisone-like] Drugs**, page 139*).

Facet Joint Injections

The facet joints are small joints about the size of a finger joint that are placed on either side of the back of each vertebra (*See page 11*). They permit modest forward, backward and side-to-side neck movement. Like other joints in the body, the facet joints are capable of sustaining sprains, injury or pinching of their menisci (fibrous-fatty pads like knee-joint cartilages at their inner joint margins) and fractures.

Injuries to the discs in the neck and the facet joints are the usual causes of the gradual deterioration which leads to the wear-and-tear-type osteoarthritic changes. (*See **What About The Discs?**, page 10*). Few past the age of fifty escape x-rays changes of osteoarthritis in at least one or more of their facet joints. If this age group's facet joints were to be looked at under a microscope, they would all show degenerative changes.

So, it shouldn't be surprising that facet joints can contribute to pain and this has been the rationale for manipulation therapies and for local facet joint injections. What is surprising is that there a serious question as to whether or not facet joint injections are helpful.

Elaborate techniques using x-rays to determine the precise place-
ment of the needle, and then using local anesthetic injections to
determine that the pain is relieved precisely from that joint
before injecting a cortisone-like drug into the joint have been
tested. The results have defied all logic in most studies by the
failure to produce convincing evidence that steroid (cortisone-
type drugs) injections into facet joints under the most ideal, con-
trolled circumstances are effective in the treatment of neck and

Table 1

Medication for Neck Pain Relief – *for Severe Pain*

Oral Medications	Usually Helpful	Sometimes Helpful	Potentially Dangerous*
Narcotic Analgesics	■		■
Muscle Relaxants		■	
Non-narcotic Analgesics	■		
Nonsteroidals (NSAIDS)		■**	■
Non-aspirin salicylates			
Antidepressants		■	
Analgesic Ointments			
High Dose Oral Steroids	■		■
Injections			
Trigger/Tender Point	■		
Facet Joint***		■	
Epidural/Nerve Root	■		■

* *All drugs may occasionally cause significant side effects*
** *Prescription NSAIDs are usually no more effective than OTC (Over the counter) non-prescription NSAIDs*
*** *Of doubtful value*

Table 2

Medication for Neck Pain Relief – *for Moderate Pain*

Oral Medications	Usually Helpful	Sometimes Helpful	Potentially Dangerous*
Narcotic Analgesics	■		■
Muscle Relaxants		■	
Non-narcotic Analgesics	■		
Nonsteroidals (NSAIDS)	■**		■
Non-aspirin salicylates		■	
Antidepressants		■	
Analgesic Ointments		■	
High Dose Oral Steroids		■	■
Injections			
Trigger/Tender Point	■		
Facet Joint***		■	
Epidural/Nerve Root	■		■

* *All drugs may occasionally cause significant side effects*
** *Prescription NSAIDs are usually no more effective than OTC (Over the counter) non-prescription NSAIDs*
*** *Of doubtful value*

Table 3

Medication for Neck Pain Relief – *for Mild Pain*

Oral Medications	Usually Helpful	Sometimes Helpful	Potentially Dangerous*
Narcotic Analgesics			■
Muscle Relaxants		■	
Non-narcotic Analgesics	■		
Nonsteroidals (NSAIDS)**		■	■
Non-aspirin salicylates		■	
Antidepressants		■	
Analgesic Ointments		■	
High Dose Oral Steroids			
Injections			
Trigger/Tender Point	■		
Facet Joint***			
Epidural/Nerve Root			■

* All drugs may occasionally cause significant side effects
** Prescription NSAIDs are usually no more effective than OTC (Over the counter) non-prescription NSAIDs
*** Of doubtful value

specifically, facet joint disorders. It is basically a given that any-
one past fifty will show abnormalities in the facet joints. What is
not a given is definite proof that these rather elaborate, expensive
and not risk-free facet joint injection procedures offer more than
temporary relief.

Epidural and Nerve Root Steroid (cortisone-like) Injections

The rationale for using injections of cortisone or corti-
sone-like drugs into the tissues around the spinal cord
(the epidural space) or at the emergence of the spinal nerve roots
is to provide a highly concentrated amount of a cortisone-like
drug in the region of the swollen disc and nerve.

But epidural cortisone injections are not without risks. The tis-
sues (connective tissue, fat, and small blood vessels) between the
inner wall of the spinal canal and the rather hard membrane
called the dura, that contains the spinal fluid in which the spinal
cord effectively floats, is called the epidural space. Epidural
means "outside the dura" but clearly inside the spinal canal.
When severe bulging discs cause painful swelling on a cervical
spinal nerve root, relief can sometimes be obtained by careful
injection of a moderate amount of cortisone-like (steroid) drugs
into the epidural space.

This is an *extremely delicate procedure* because there is little room
for error in the narrow epidural space in the neck. Similar injec-
tions can also be made slightly further away from the epidural
space into the nerve root channel in an effort to get pain relief.
Typically, if these injections are going to help, benefit will be
achieved within *one to three injections* usually spaced about one
week apart. Further injections are rarely of additional benefit.

Like the facet joint injections, these injections can be done either
in a specialist's office or as a hospital outpatient procedure and
should only be performed by highly skilled specialists. With
epidural or nerve root injections, sufficient cortisone may be

injected to cause cortisone side effects. Other worrisome side effects in addition to infections are possible bleeding from needle trauma during the injection, or bruising of the delicate nerve tissues in that region. The epidural steroid injections are not perfectly safe, but are safer than surgical procedures, and when successful, may eliminate the need for surgery. The pros and cons of epidural or any injection procedure and the potential risks versus benefits should always be carefully discussed with your physician.

High Dose Oral Steroid (cortisone-like) Drugs

When a swollen, sprained disc is producing relentless pain (**SEVERE**) and in particular, manifestations of nerve root compression with pain and/or numbness and weakness, the use of high dose cortisone-like drugs taken in pill form or by an intramuscular injection can relieve the swelling and nerve pressure and speed up the healing process. Steroid dosages required to do the job carry with them risks of the complications of cortisone-like drugs.

The side effects of high dosages of cortisone and cortisone-like drugs include increased susceptibility to infection, elevation of blood pressure, aggravation of diabetes, stomach ulcers, skin bruising, mental disturbances ranging from euphoria (being too happy) to depression, and the remote possibility of some effect on blood clotting that can lead to clots in joints and joint damage in the shoulder, hip or knee. These serious complications are *fortunately rare* and are *less than the risks of epidural corticosteroid injections*, and are certainly *less than the risks of surgery*.

Cortisone-like drugs when given by mouth or intramuscular injection are typically administered over the course of a week. The side effects of the cortisone can be monitored during that time so that the treatment can be interrupted if need be. In our experience, in those patients where the disc disorder produced intolerable symptoms or a worrisome loss of nerve function, moderately high doses of orally administered cortisone-like

drugs have proved helpful (with few side effects) in the majority of such cases and have made it possible to avoid surgical treatment.

A pain in the neck needs more than just medicine

No treatment is perfectly safe, nor does any treatment work for everyone.

So, we are fortunate that there are many medicines and injections to help get us some control of our pain - but you may not even need any medicine. So what else can we do to help keep the neck pain under control, make it possible to resume our activities and to keep the pain in the neck from coming back? Lots! Medicines help you get relief so that *you* can do the rest of the job to get your neck in shape.

In the next chapters you will learn how to keep your head up in a comfortable posture, how to get through the day without neck strain, how to exercise your neck for pain relief, and recondition it for work and play.

Chapter 8

The Gravity
of Neck Posture

"GOOD POSTURE" REQUIRES THE NECK TO BE BALANCED over the head in such a way that the head is positioned directly over the trunk, not leaning forward or backward or sideways. It is pretty much the same situation that you see when you stack toy blocks. If one or two blocks are out of line, the whole stack will tumble and fall. The stack of blocks does not have any ligaments or muscles to hold things together as your neck does. But if those neck tissues have been injured, you will pay a painful price for letting your head hang down.

If your head is leaning forward, tilted to one side, or backward, the force of gravity is increased by the forward position of the head and the strain on your neck is thereby greater. If you have no discomfort, and no neck problems, the ligaments and muscles can hold your head in position without your being aware of any strain. If these tissues have been injured, then that strain is intensified and you can learn how poor posture can be a real pain in the neck.

The key to good posture and proper neck alignment is to respect gravity and balance. How do you do this? If you are sitting and your chin is level and you are looking straight ahead with your head tilting neither up, back, nor sideways, your head may still be pushed too far forward or backward over your trunk even though it is not tilted. The position of your head when balanced on the torso can be determined by looking at your profile in the mirror. Note when the bottom of your earlobe is in line with the tip of your shoulder. When your head is in that position, gravity is working with you and helping you relieve painful neck stress and strains.

At one time or another, we have all been reprimanded about our posture, or at least encouraged to have good posture. Most of us at some time have experimented with balancing a book on our head. We recognize that if we tilted our heads to one side or the other, or too far forward or too far back, the book would not stay

in place. Basically we pushed our heads up to straighten our necks and balance our postures. In taking a page from that "posture book," we have devised the **1-2-3–2 posture method** at the Swezey Institute. The 1-2-3–2 posture method is a simple technique that will keep you in a comfortable, balanced posture so that gravity will not be a pain in your neck.

1 - 2 - 3 – 2

Place your index finger by your eye.

Pick an object straight in front of you at eye level and keep it in focus.

This will keep your head level with the horizontal plane of the ground.

Place your index and middle fingers on your chin.

Keeping your eyes level, bring your chin back in on that horizontal line until you feel a gentle stretch at the back of your neck. Relax just off the point of that stretch. This gets your ear holes in alignment and over the point of your shoulder.

Place your hand over the vertex (the very top) of your head so that your three middle fingertips are pressing firmly down against the skull at that point.

Maintain the finger pressure but push your head up against the tips of your fingers by raising your head.

You'll feel your entire spine lengthen as your head assumes its proper alignment.

Repeat step 2.

Remove the fingers from the top of your head. Put your index and middle fingers on the tip of your chin.

Be sure you've kept your chin back in and your eyes level while you maintain your heads-up posture.

You don't need to make a double chin.

There is one more neck posture "back up" to help support the 1-2-3–2 antigravity posture aligner - the pelvic pinch.

The **pelvic pinch** is a gentle squeeze of the buttocks muscles that activates and aligns the spinal muscles. This straightens the torso and gives the 1-2-3–2 posture a firm base of support for standing, sitting, or changing positions and when lying down.

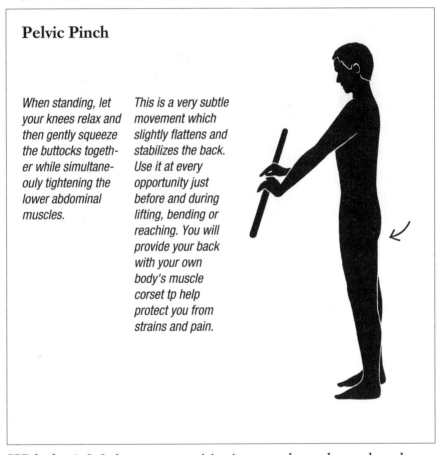

Pelvic Pinch

When standing, let your knees relax and then gently squeeze the buttocks together while simultaneouly tightening the lower abdominal muscles.

This is a very subtle movement which slightly flattens and stabilizes the back. Use it at every opportunity just before and during lifting, bending or reaching. You will provide your back with your own body's muscle corset tp help protect you from strains and pain.

With the 1-2-3-2 posture positioning, you have the tools to keep your head, neck and body in balanced alignment. Your head and neck are working together efficiently and painlessly. In Chapter 9, you will learn more about how to use your head - ergonomically. You will learn how to do your daily tasks efficiently, so that they won't be a pain in the neck.

Chapter 9

Ergonomics –
Necks at Work

ERGONOMICS - THAT'S AN IMPRESSIVE SOUNDING WORD, so it must be important. It is! Ergonomics is the science of human work. Ergonomics *(ergo* = work + *nomics* = economics in the sense of functioning efficiently and hence economically) is the science of making it possible for us to function and work in this complex environment in which we find ourselves. Application of proper ergonomics allows us to work and play without aggravating a painful neck.

Once there were no chairs. Then royalty discovered that being seated on an elevated throne while others kneeled or stood beneath them gave an aura of authority and power. Later, when chairs became standard equipment for the average citizen in the Western world, for even the average citizen, attention continued to be paid more to the chair's appearance than to comfort. But that has changed. Since the realization that the World War II fighter plane cockpits had to be carefully designed so that the pilot could see, maneuver, and successfully accomplish his mission, ergonomics has emerged as a major factor in the design of everything from car seats to faucet handles, from toothbrushes to computer keyboards, and from pens and scissors to footrests. The costs of work-related injuries resulting from stress and strain as a consequence of occupations ranging from manual labor to desk and driving jobs has made the investment in ergonomically designed tools, shops, and office work environments mandatory.

So what has this to do with a pain in the neck? Lots.

If you're an employer, paying for the ergonomically optimized work environment may cause you some pain, but the savings in reduced health care and disability insurance payments, and the increased productivity of your employees more than compensates. If you're an employee, self-employed, or a homemaker, and you have a pain in the neck, ergonomics is for you, too.

Use Your Head

When it comes to sore necks and ergonomics - use your head. Literally use your head not only to evaluate what you do and how you do it in terms of neck strain, but to be sure that your head posture is properly (ergonomically) balanced.

To the extent possible, everything you do from shaving or putting on makeup in the morning to watching television in the evening should be done with a balanced head posture. So use your head! Arrange your home, work, and play environments so that good "heads-up" neck-and-back posture can come naturally and save you from an unnecessary pain in the neck.

Ergonomics: Please Sit Down

We'll talk some more about this. Sitting down is a good place to take stock of ergonomic issues relevant to neck pain. This is true not only because royalty acquired the throne, but because we all spend a good part of each day sitting. Ergonomics and sitting requires a head-to-toe examination. In order for your approximately twelve pound head to properly balance over your neck and minimize the strain of gravity, your seat must do its ergonomic posture-supporting job so that fatigue and strain won't overcome your best efforts to hold your head up.

Feet First for the Best Neck-and-Back Posture

For the best neck-and-back sitting posture to relieve neck strain, start from the bottom and get off on the right foot — or better, both feet. Your feet, heel-to-toe, should be flat on the floor, or if dangling uncomfortably, supported in a tilted position upward on a foot rest. Why? Because dangling feet drag your lower back away from the chair's back support and cause strain to the back and neck. Dangling feet also increase pressure on the back of your thighs and can cause discomfort and excess pressure on the nerves and blood vessels in back of your legs.

The Chair - A Tool or Decoration?

The next step up from the floor or a footstool is the chair. From the standpoint of an interior decorator, all furnishings primarily serve a decorative function but can also be utilized for specific functional activities. The table and chairs in the breakfast room and dining room are there to be used at mealtimes, but the appearance of the dining room's decor is often given more consideration than the comfort of the diner.

The ergonomist has to look at the chair for what it must do for the person to enhance function and minimize stress and strain. When the chair is considered as a tool, and this does not preclude its having beautiful esthetic design features, the chair has to be able to function in its designated tasks. If the chair is used at a desk or work bench, then the person seated must be able to get close enough to perform the tasks at hand. If the chair has arms, the arms should not interfere with the ability to put the chair close to a desk or worktable.

The Chair and Table Should Match

In the same manner, the table, desk or workbench should be designed so that the person's legs can comfortably slide under it. This allows for seating that permits close work with minimal neck or back strain, or dining with food on the table and not in your lap.

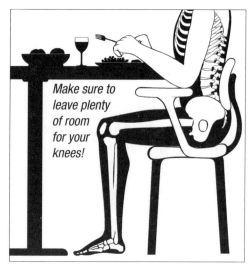

Make sure to leave plenty of room for your knees!

Even a designer or an architect suffering from a sore neck can and should

take advantage of the height and tilt adjustments that drafting tables provide (*See **Ready For Desk Work**, page 170*).

The Right Chair For You

In a less than perfect world, it is difficult to get too "preachy" about what an ideal chair for sore necks should be. Nonetheless, a great amount of research and design talent has given us the basis for making intelligent choices. If you're looking for a comfortable chair that will give you proper neck and back postural support where you need it, and will allow you to do what you must do with your neck under the least possible strain - you can find it!

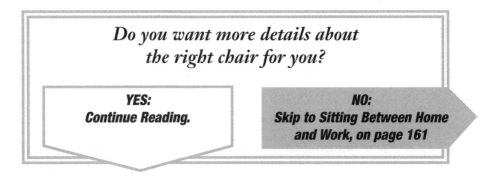

Do you want more details about the right chair for you?

YES: Continue Reading.

NO: Skip to Sitting Between Home and Work, on page 161

The Right Office or Work Chair For You: How To Check It Out From Bottom Up

- The office **chair** on casters should have five legs, or spokes, to provide a stable base. This is now a requirement in the United States for all new office chairs.

- The **casters** should move readily over the floor or carpet. Special casters are available for specific floor surfaces.

- The **seat height** should be low enough to allow you to place your feet flat on the floor, in order to keep them from dangling. The seat height should keep your knees and thighs level

and parallel to the floor. If your feet dangle, the chair is too high and you need a footstool. If your knees are elevated above 90 degrees, the chair is too low for sitting upright in good neck-and-back posture.

- The **Seat** (Pan). The chair's seat pan should slope slightly downward in the front (a "waterfall" edge) to minimize pressure on the thighs. The seat should be *wide enough* for ease of movement and *deep enough* to support your thighs so that when seated with your back supported, there are at least three finger-widths between the sloping front of the seat pan to the backs of your legs.

- **Upholstery.** The seat and chair back should be comfortably padded. Choose a porous fabric for upholstery. A hard seat may cause back discomfort and then neck strain. Upholstery using padding that is too soft causes the buttocks to sink in and limits comfortable movement. Too slippery upholstery causes the buttocks to slide beneath you, creating back and neck postural strain and pain — so check out your upholstery's texture.

- **Low Back Support**. (Lumbar Support and the"Firm Friendly Hand") When you sit up and lean back, the lumbar pad should feel like a firm, friendly hand placed against the small of your back to keep it from sagging backwards. Below the "firm friendly hand," there should be room for the buttocks to protrude slightly, either by soft padding on the seat or by the provision of an open space below the lumbar support. For most upright sitting the back rest should slope backward about 15 degrees from the seat pan. Support for the small of your back (the lumbar support should be about a foot wide) is essential to the support of your upper body, neck and head. A sagging back creates a forward head and causes neck strain.

- **The Upper Back**. If a chair has a high back the shoulder blades should be supported by a very slight forward sloping of the upper portion of the back rest over the arch of the lumbar

support. The old style secretary's chair has no upper back support which provided more freedom of arm movement when the fingers had to punch the old typewriter keyboards and shift the carriage. Modern word processors and keyboards no longer make this demand so both the secretary and the boss can utilize an upper back support to minimize back and neck pain.

- **Chair Arms**. Chair arms should be adjustable. With the elbows on the chair arms, the shoulders and neck should be relaxed without the shoulders being hunched up, cramped, and thereby causing secondary neck strain. Newer model chair arms permit outward or inward, as well as up or down, movement as needed. When sitting, the top of the chair arms should be supporting the backs of your elbows with the forearms bent at a 90-degree angle. Chair arms should slope downward slightly in front so that your elbows are still comfortably supported when leaning forward, and your arms can provide added support to your upper body, head and neck. The chair arm adjustment should allow the arms to be lowered permitting movement of the chair closer to the desk or work table.

- **Chair Adjustments**. The chair should have levers or knobs for adjustment that are easily reached when you are sitting to permit:
 - *proper seat height*
 - *proper seat pan angle for leaning forward or leaning back*
 - *proper chair back height to adjust lumbar support*
 - *proper chair back angle for leaning forward or leaning back*
 - *proper adjustment of each arm or removal of either arm*

So if the Chair is Adjustable - Adjust It!.

This Chair Feels Great! But What If I Have To Lean Forward?

To lean forward, which may be required for a variety of desk tasks, your seat pan and back rest need adjustment. In many chairs, your seat pan and back rest can be tipped forward and adjusted for optimal low back and upper back support to minimize neck strain and pain.

For tilting forward, the back of the seat pan may need to be raised to keep the knees and thighs at a comfortable angle with the feet flat on the floor. When seated and leaning forward, with the seat pan angled downward, your arms should be supported by resting on the desk or work table to minimize upper back and neck strain. "Toe to head support" reduces neck muscle fatigue and neck strain and pain.

What If I Have To Lean Back?

If tilting back to get a good stretch, or for a long phone conversation, you should be in a high back chair with neck support. When tilting backward for an extended period, you can lower the seat pan to keep your feet on the floor or foot rest.

It's Not A Perfect World and I Don't Have The Perfect Chair

The Imperfect Adjustable Chair.

No chair, however adjustable it may be, will give you proper back and neck support if you don't adjust it to fit you. If there are adjustment features on the chair, follow the guidelines for chair adjustments and you may be pleasantly surprised at how comfortable it can be. It is up to you to learn all of the features of your ergonomic chair to give the chair the chance to do what it wants to do to provide ergonomic seating to relieve your neck strain.

The Myth of the Straight-Backed Chair.

Tradition has taught us that the straight-backed chair is the key to proper posture which would imply posture relief for back and neck strain. Not so! A straight-backed chair has no room for your buttocks to protrude; therefore, it offers no support to the low back. If it is rigid and unpadded, it will cause stress and strain to the neck or back, particularly if the chair legs are too tall or the arms are too high or too low. A rigid chair that is not straight backed can give comfortable support, but it usually needs help.

Help! My Chair Is Rigid.

If the chair is rigid and the seat is too high for your legs, use a footstool (that can be anything from a telephone book to a brief-case, purse, lunch pail, styrofoam packing block or literally, what have you, that allows your feet to rest comfortably). Similarly, the rigid hard back or straight-backed chair can be made much more comfortable by placing a small lumbar pillow between the chair back and your back. Once again, a purse, briefcase, maga-zine, folded sweater or towel can be a big help to relieve back strain and a pain in the neck; and the towel, blanket or sweater can also soften a hard seat pan.

A Second Ergonomic Look at Your Chair

Think about how you are going to use your chair. Will you be writing, dining, computer inputting or driving? Make your chair work for you.

Start The Day Right

The Bathroom: this could be the most dangerous part of your day. Even before you go to the bathroom, the alarm goes off. You reach over, half-awake, to turn it off. Your neck tells you it's going to be one of those days. Your bedlight and alarm clock

should be easily accessible and positioned to avoid over-reaching and neck strain. Leave nothing to trip over on the way to the bathroom and nothing to slip on when you get there. All the bathroom equipment, from toilet paper to tooth brush, should be placed so that they can be reached and used without neck strain.

Self-Care Tips For Sore Necks

Use the shower and not the sink for hairwashing.

 An extra soft collar or a folded towel around your neck, pinned into position with a safety pin, can help a soothing shower and add extra comfort to your neck as well.

 Whenever possible, keep a "heads up" posture and bend at your knees, not at your neck, to get your head under the shower.

• Get a **shower head extender** to raise it if you're too tall (even when bending the knees) to keep your head up when wetting your hair.

• Do it with **mirrors.** Whether you are putting on makeup or shaving, get the right mirror for the job. Keep a heads-up, knees-bent posture. Use an extendable mirror with magnification to avoid neck craning. When shaving, avoid head tilting when possible (an electric razor can help).

• Drying hair. **Keep your head up** (never down to one side or back) and in the 1-2-3-2 posture *(See Page 143)* to blow dry your hair. Mounting the hair dryer on the wall can help. If all else fails, forget it and go natural.

Remember the Symbol: Severe Moderate Mild Minimal

- **Toothbrush** and Cup. **Stand close** to the sink and use a cup rather than a faucet for rinsing the mouth. Bend at your knees and hips, not at your neck to minimize neck strain.

If your neck pain is **SEVERE**, and tilting your head backwards to drink from a cup intensifies it, a long flexible straw can help to drain the cup without straining the neck.

With pain and loss of arm movement, you may find an electric toothbrush heavy and awkward to use.

- **Tub**. Sit upright if possible.

If you have *moderate* pain, or there is no shower available, or if you want to relax in the tub, use an inflatable pillow or towel roll to keep your head upright.

- **Dressing**. Maintain your 1-2-3-2 upright posture *(See Page 143)*, bring your feet up to you for donning socks or tying shoes and use a long-handled shoe horn.

 or

For **SEVERE** or *moderate* pain, put your soft collar or brace on before dressing and use clothes that easily slip over your head. You may find it easier to sit to don slacks.

Morning Exercise

If you haven't done them all ready, a warm shower is probably the best place to do your morning neck exercises *(See **Chapter 10**, page 191)*. The warm water relaxes you and makes it easier to stretch.

 or

If you are still having considerable discomfort, a cold compress for 10 - 20 minutes after exercising can help lessen discomfort.

All in a Day's Work

As you think through ergonomics, check the section and pick the headings that apply to your lifestyle - not necessarily someone else's lifestyle.

The Ergonomic Kitchen and What's Cooking In Your Neck

The general principles of ergonomics can't be overlooked in the kitchen. Even if you're at the *mild* pain level there are a lot of tips worth thinking about.

Storage of Essentials

or or or if you suffer chronic neck pain: Whether it be in the refrigerator, freezer, stove, on the counter or cupboards, heavier and bulkier items should be as close to elbow height as possible. The ideal counter height should be 2-3 inches below the bottom of your elbows when you are standing. Store heavy objects close to you and light objects above or below. Squat for the lower objects and use a step stool or ladder for the ones stored on high. Use short reacher tongs or barbecue tongs whenever necessary to avoid straining your neck.

Cooking

or For **SEVERE** to *moderate* neck pain you should wear your brace or collar. Use ready prepared, prepacked items or frozen foods as much as possible. Lift pots and pans with two hands, keeping them close to you. Avoid twisting by moving your whole body, including your head and neck, by turning (pivoting) with your feet. If one shoulder or arm is particularly painful, then move objects to the "good" side to minimize strain. Avoid mixing and stirring batters. Avoid grating cheese, vegetables, etc. Instead, use easy to use electrical kitchen aids.

Wheels and Carts

 Wear your brace or collar and use wheeled carts whenever possible. Use them for carrying heavy or bulky objects and for serving the meals that you have prepared.

Laundry

 Don't lift or drag more than you can easily handle. Send the laundry out whenever possible, and avoid ironing. If you send it out, ask the laundry to return your clothes in small bundles for easy lifting and carrying. If you insist on doing your own thing, bend your knees and use tongs to reach into the washer and dryer.

 Several small loads of laundry are better than one heavy load that you have to drag. Use wheels or slide your laundry load. Remember that wet clothes are heavy, so empty the washing machine in stages. Maintain the best head alignment posture possible, and if in doubt, wear your soft collar.

Brooms, Mops, Vacuum Cleaners and Light Bulb Changers

 If you have **SEVERE** neck pain get help with household chores. If your neck pain is *moderate,* don't forget your brace or collar. Whenever possible, keep your back flat and straight and your head in the 1-2-3—2 alignment. Lean forward at the hips, not the waist, stepping smoothly with a mop or vacuum cleaner like a fencer stepping with a forward lunge. Think about the long-handled or extendable handles on dusters, dust pans, ceiling cleaners, window squeegees, mops and brooms now on the market.

Detachable hand grips can make it easier for you to use these tools ergonomically and therefore with less neck and arm strain. Consider using long-handled ceiling lightbulb changers.

Trash - Don't Trash Your Neck

 If your neck pain is **SEVERE,** ask someone else to "handle" the trash.

or If your pain is *mild* to ***moderate,*** getting rid of the trash is a nuisance but don't make it a pain in your neck. Bend your knees to pick it up. If you keep papers or trash on the floor or try placing your trash at higher levels. Bundle the trash into small manageable packages (a trash compactor can be a big help) and make several trips carrying small bundles close to your chest, or better, use a trash container with wheels that roll easily. If you think taking several trips for the trash, or wearing a soft collar or brace sounds like a pain in the neck, use your head! You're avoiding a pain in the neck.

Necks Around the House

Couches and Lounges

The cushier the couch or lounge, the less likely that it is going to give you good neck-back postural support. Try to find a chair with comfortable back and arm supports. If you are having **SEVERE** neck pain, have someone help you bring a chair into the dining room or bedroom so that you can avoid couches and lounges whenever possible.

If the couch is your only soft choice, sit in the corner for best support.

E.C. = Ergonomically Correct

E.C., like P.C. (politically correct) is not always correct. Think of the Three Bears. Would the Baby Bear's chair fit the Papa Bear and vice versa? If you're 5 foot 3 inches, would you expect to sit comfortably in a chair adjusted for the 6 footer who just preceded you — or vice versa? What about orthopedically designed shoes - if they are two sizes too small, throw "ortho" and "ergo" and the shoes out the window. The same applies to all orthopedic and ergonomic equipment. They have to be adjustable to your size, height, weight, and especially your neck pain needs.

A Neck For A Day

Without rubbernecking, let's take a closer ergonomic look at how to get through the day with a pain free neck.

We often get so accustomed to our daily routine that we overlook minor, and sometimes major, problems. They just don't get our attention. If you've got a painful neck, then any activity that requires reaching, stretching, and straining can potentially aggravate your condition. This means that tight faucets, jammed drawers, stubborn doors or windows, or rusty or gummed up tools may need fixing. An ounce of prevention is always better than pounds of pain.

Don't Let the Phone Hang You Up

Whether at home or at work, or in the car or back yard, there is always the telephone. It is obvious that we can not function without a telephone; although there are times that we would like to. On a hard day just one more telephone call can really be a pain in the neck.

At home, loose wires and extension cords can trip you up. Rushing from one end of the house to the other to answer the phone can give your neck pain a painful busy signal. Avoid the

rush, stress and strain, by installing an answering machine and using a cordless phone if possible.

At home, and more particularly at work, it is tempting to do two things at once. In order to do this, we cradle the phone between our ear and our shoulder to take notes or write down important messages. Wearing a soft collar can keep you from cradling the phone and straining your neck. If this must be done, the phone should be cradled on the "good" side. It is best to avoid the problem entirely by having a speaker phone, a head set, and best, a cordless headset. Keep your note pad and pen positioned for easy access and minimal neck strain.

Phoning while driving is a convenience. If you are the passenger, it is hardly a problem; but if you are the driver, unless you have a speaker phone, it is best to pull over to the side of the road to make your call. Car phones are not safe for your neck and are probably unsafe for your car as well. In fact, in Brazil it is illegal for a driver to use a car phone.

Telephone Therapy?

The phone can also help relieve your neck pain in several ways. First, in an emergency you can use it to call the doctor. Second, whenever the phone rings you have a built in cue to remind you to relax in the 1-2-3-2 "heads-up" neck-strain-free posture. Third, if you have been sitting and working at your desk, you can stand up to answer the telephone, use the 1-2-3-2 posture cue and stretch to relax the muscles of your back and neck that may have fatigued from prolonged sitting. Try to keep your phone conversations short so you'll have more strain free time to get your job and chores done.

Sitting Between Home and Work - Driving

Fortunately for all of us, much of what we now know about car seating has evolved out of the realization by the automobile industry that comfort sells. Today almost all automobiles feature orthopedic seating adjustments that help make it possible to sit comfortably, even for people with back or neck problems. As in all things, some car seats do this much better than others (*See* the ***Neck Pain Driver's Check List***, *page 163*).

Shopping For a New Car

If you are in the market for a new car, check out the seating and head restraint adjustments and make sure they are right for you. While you are at it, look at the dashboard, instrument panels, adjustment knobs and levers and other features such as a CD, radio, tape deck, or car phone to be sure that they are all accessible and easily manipulated without neck (or back) strain.

But I don't Need a New Car

The same rules for sitting in comfort in a chair apply to sitting in comfort in your car. If your car seat cannot be adjusted satisfactorily, there are a number of back supports, pillows and cushions that may make it possible to drive in comfort.

If your neck is stiff and turning your head painful, a panoramic or wide "wink" mirror, available at automobile accessory stores, can allow better rear visibility without requiring you to turn your head. The arm rests in the car can help support your arms and relieve tension in the neck. Check to see that they don't push your shoulders up too high or drag your elbows down too low. In the latter case, if you are having *severe* neck pain, a pillow or pad to support your elbows can make for greater comfort for your upper trunk and neck while driving.

If your steering wheel has tilt or telescoping features that make it easier to drive or to get in and out of the car, then use it. If twisting to fasten your seat belt causes neck strain, attach a seat belt reacher. If the seat belt strap cuts across your neck, it can be padded or adjusted away from your neck area.

If your trunk is too deep, there are cargo holding devices to keep the heavier objects close to the rear of the car for easy reaching and reduced neck strain and pain. If you have the choice, choose a car with an automatic transmission, power steering, a steering wheel with tilt and telescoping features, electric window openers and locks and a four-door car for easier access.

If you haven't these features available to you in your car, and your neck is hurting severely, but somebody near and dear to you does, it may be a pain in the neck to ask to borrow the car, or to rent another car. The alternative of avoiding real pain in your neck may be worth it.

If your car seat can be lowered and/or moved back for better head room, then use your head to spare your neck when getting in and out of the car while driving. If you're too tall, and you must duck, try to bend forward at the hips rather than straining your neck forward to make room for your head. Pay attention to what your neck is doing at all times.

The Head Rest

Your car's head rest is a "head" rest. It should be positioned to stop the back of your head from jerking backward.

CAUTION: Although it is tempting to lower it and use it as a neck cushion, lowering the head rest actually creates a fulcrum at the back of your neck that can cause the head and neck to jerk back even more violently in the case of an accident.

If you want to support your neck, use a soft collar or small pillow, a rolled towel or an inflatable neck pillow that can be purchased to support your neck and help relieve **SEVERE**/*moderate* neck strain while driving.

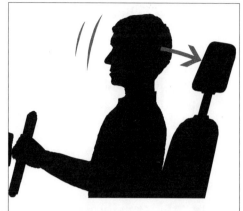

Adjust the headrest so that if your head was forced suddenly backwards, it would hit the center of the rest.

More Food For Ergonomic Thought

While we are still sitting and thinking ergonomically, here are some additional important thoughts: Check for adequate head room. Be sure that your head rest supports your head and doesn't push it forward. Use sunglasses to reduce glare. Make sure that the steering wheel is close enough so that you do not have to reach and strain your arms, shoulders, and neck.

One last tip while you are in the car. Raise your rear vision mirror slightly to help remind you to keep a "heads up" balanced head, neck-protected, posture.

The Neck Pain Driver's Checklist — *Don't leave home without it!*

Features for Everyone

- **Head Rest** - Adjust height to near top of back of head - not neck. Auto neck rest supports can be purchased (*See **Resources**, page 247*).

- **Seat Back Angle** - Upright

- **Back (Lumbar) Support** - Comfortable. (Firm, friendly hand)

- **Steering Wheel** - Adjust for comfort and posture when possible. Tilt and telescoping features are helpful

- **Controls** - Automatic and accessible control buttons and levers for windows, heater, radio, etc. and power steering, transmission and brakes are a help. Check for them if you are leasing or purchasing a new car, or even renting for travel.

Special Features for *SEVERE* and *moderate* Neck Pain

- Rear Vision Mirror -

 consider using a wide angle (wink) mirror

 or elevate mirror slightly for best 1-2-3-2 posture

- Soft Collar/Brace -

 wear during long drives.
(Be sure it is legal to use when driving in your State)

- Seat Belts -
Consider seatbelt pads and adjustable strap for comfort.

 obtain reacher strap for easy positioning

- Arm Rests -

 or use if available or add a pillow under elbows

Child Care

Some "Head's Up" Tips for Parents, Grandparents, and Baby Lovers

Babies are both irresistible and unpredictable, so wear your soft collar during child care. Try to keep your head up in the 1-2-3-2 or posture *(See Page 143)*, no matter how tired you are, by holding the baby close to you and by bending from your hips and not from your neck whenever possible.

If the baby's in the crib, keep the mattress as high as possible and then be sure to lower the crib rail before lifting. Keep your head in alignment and slide the baby toward you until it is old enough to crawl to you before being lifted. Bend from your hips and not from your neck or waist when lifting.

On outings, use a front "pouch" to cradle the very young baby close to you and use a stroller whenever possible. The stroller handle should extend upward so that you can push the stroller comfortably and then lock it into position. Keep your loads as light as possible. Babies are to be loved and cared for, but keep your head about you in a 1-2-3-2 posture so that if they are a bit cranky, they won't cause a pain in your neck.

Remember the Symbol: **Severe** **Moderate** **Mild** **Minimal**

Yards, Necks and Gardens

Don't Stick Your Neck Out

Whether you're a committed gardener or you just have to keep
the place looking decent, there are a lot of ways for your neck to
"get out of joint" in the yard and garden.

 If your neck pain is **SEVERE**, don't do any
work. If it is *moderate,* avoid doing all but
the essentials.

 It is likely that you wouldn't go out into the
yard without your work gloves. Thus, it's a
good idea even if you have only *mild* neck pain to let your neck
collar be a work glove to remind you that your neck is still heal-
ing and to protect your neck from further strain.

Pruning

Overhead work with your head tilted back and twisting
it from side to side puts your neck and the cervical
nerves as they leave your neck in their most vulnerable position.
If your neck pain is *mild* and you must prune, it's a good idea to
use your soft collar. Be sure to use the lightweight tools that are
right for the job and that the tools are well sharpened. Use a sta-
ble ladder so that you can work at elbow height as much as possi-
ble to avoid any neck and body twisting.

Raking and Hoeing

Raking and hoeing are the outdoor equiva-
lents of vacuuming, sweeping and mopping.
Use long handles and light weight tools with a two hand grasp
attachment whenever possible. Keep your body straight. Avoid
twisting and maintain your 1-2-3-2 head and neck alignment.
Don't forget your soft collar.

Shoveling

Use sharpened shovels and work in properly prepared soil. It may be a good idea to have somebody do the soil preparation for you. Keep the load close to your body. Keep your back flat and your neck in the 1-2-3-2 posture alignment. Turn your *feet first* to dump the load and avoid twisting, particularly twisting your neck, whenever possible.

If there's any question, put on your soft collar.

Weeding and Planting

Use long-handled weeders and trowels. Kneel on one knee and press one hand on the ground for added support. Be sure the soil is soft. It's best to get help to prepare it before you dig in. If you can't kneel comfortably, use knee pads or try a low stool. Don't try to get all the weeds out at one time. Stop and stretch every 10-15 minutes, or perhaps do another chore and then go back to pulling out those pain in the neck weeds.

Watering

Use a lightweight, kink-free hose that is easily coiled or uncoiled, preferably with a hose winder. A raised faucet, easily turned faucet valve, and a long-necked watering can, can eliminate one more strain on your neck. An automatic timed watering system is the best of all.

Garage and Workshop

Some of what you have to do in the garage or workshop is very rewarding. There is nothing better than meeting a craftsman's challenge and getting the job done right. Some of what you have to do is hard work but there may be no one else who can do it, or anyone who can do it

as well as you. Some of what you have to do in the garage or workshop can also be a pain in the neck. Create an ergonomically efficient workshop. Utilize proper tools. Remember always to think about your neck first and the job at hand next.

A Case in Point

B.P. was an outstanding wood shop teacher. His students loved his class, learned a great deal, and definitely did not think of the woodshop class as a pain in the neck. But B.P.'s neck felt otherwise. Although he was an outstanding teacher, he used his classroom facilities as they had been arranged for him. This meant that he had to put his body and particularly his head and neck in a variety of stressful postures. This was not a problem for him until he was rearended in a motor vehicle accident and developed a classic whiplash. After that, all the things he used to do easily were now literally a pain in the neck. He was ready to give up teaching because of his chronic neck pain problem. When he was given proper treatment, pain relief, exercise, and most importantly, appropriate ergonomic instruction, he was again able to work efficiently and teach effectively.

Help Your Workshop Work for You

or The advice given to B. P. is important to anyone who has had a neck strain. It's as easy to get a neck strain by carelessly bending and twisting to pick up a nail or a leaf as it is lifting a 25 pound load. Keep all your well sharpened tools within easy reach and all tools, drawers, and doors in smooth working order. Use reaching tongs and tools with extendable handles to avoid craning or bending your neck. Use power tools for screw driving, cutting, scraping, drilling, and similar tasks whenever possible.

or Keep your work bench surface about 2-3 inches below your elbows and leave enough room under the workbench for your feet so that you can sit or

stand close enough to the task at hand and avoid the strain of overreaching. Store light objects on high or down low and use a sturdy ladder or portable steps to avoid reaching. Even changing a light bulb overhead can be a wrenching experience for your neck and for you. Remember to pace yourself (a timer can be helpful) so as to avoid prolonged neck strain at any one task. If your neck pain is *moderate* or if there's any question, put on your soft collar. Change your work from sitting tasks to standing as frequently as possible and use each position change as a 1-2-3-2 heads-up posture and neck muscle relaxing opportunity.

Keep it Clean with Neck Pain - Car Washing

or If you have *moderate* or **SEVERE** neck pain, it's best to pay for a car wash.

or If you're at the *mild* to *minimal* neck pain level, it's still a good idea to maintain your neck alignment by using long-handled scrubbers and to stand on a step stool to extend your reach. Use hose extenders attached to soft hoses long enough to reach all the areas that need to be hosed down and a hose winder to keep them coiled out of the way. Keep your back and neck straight, bending from the waist and knees. Wearing a soft collar is a good reminder to keep your head and neck out of trouble and to keep you from being all washed up.

Necks, Dogs and Cats

You wouldn't let your dog out without its collar so if your neck pain is **SEVERE** or moderate, be sure you have your brace or collar on as well.

 If your neck pain is **SEVERE**, both your pet and you need attention and care. Your pets need you, but you may also need some help with feeding, grooming and handling chores.

 If your neck pain is ***moderate*** and your pet is a small dog or cat, kneel rather than bend down to it.

If your neck pain is ***mild*** and you're not sure about a frisky pup, wear your collar. If your pet is a large one, and for that matter, a frisky small one, use a choke chain when walking your dog and hold the leash with the "good" arm (side without pain) if you have that choice.

Groom with your "good" arm and put the dog at eye level rather than bending over.

Use a long-handled litter scooper. Fill the water bowl from a teapot or small hose connected to the sink faucet. Fill the food dish on your kitchen counter before kneeling or squatting to place it on the ground.

Desk Work - Another Pain in the Neck?

Desks and Necks

Sooner or later we've got to settle down, get back to our desks, and get the paperwork out of the way. For some of us desk work is an all-day commitment. For others it's the place where much of the day's work gets done - from keeping up with the correspondence and getting out the birthday and holiday cards, to those tasks that are more apt to give a pain in the neck - like paying bills or getting ready for income taxes. When you feel weighted down with desk work, no matter what it may consist of, it is very easy for a painful neck to feel the weight of the gravity of your responsibilities. The result— postural strains and more pains in the neck.

Ready for Desk Work

 or Sit down in your chair with your head up in a 1-2-3-2 posture and move the chair as close to the desk as need be for comfort. Be sure that your chair casters move easily over your floor surface. A lucite or plastic mat over a thick carpet can make it easier to move.

There should be at least three fingers clearance between the undersurface of the desk and the top of your knees. The chair arms should be removed if they cannot be lowered enough to allow you to get close to the desk for your work. Think ahead so that when you are seated at your desk, everything (so far as possible) you will be working with is within close arm's reach–not fully extended arm's reach. Your chair should swivel, so that with your arms relaxed and your elbows at your sides, you can access without twisting, all the objects that you need to work with frequently. If possible, all objects that you use infrequently should still be within your grasp when your arms are extended.

Telephone on Your Desk

The telephone on your desk can pose many problems. A telephone tilt stand can make the telephone keypad easier to see and use, or use a slanted desk book holder to hold reading material closer to you. If you can keep things from falling off your desk, tilt the whole surface of your desk upwards 15-20 degrees to help relieve neck strain. When you are talking on the phone, you're likely taking or reading notes as well. Keep a three ring binder

Do you want to learn how to keep computers from being a pain in the neck?

YES:
Continue Reading.

NO:
*Skip to Stepping Out Without Sticking Your Neck Out,
on page 176*

handy as a slanted surface for note taking to minimize neck bending and strain. Remember, the telephone can also serve a neck-friendly function. Each time the phone rings it helps to remind you to keep your head and neck posture in alignment and to do some shoulder and neck stretches (*See **Don't Let The Phone Hang You Up**, Page 159*).

To See The Truth, Let The Light Come In

The older a person gets the more light he/she needs to read–actually, 10 times the light is needed at age 60 than at age 20. Glare-free lighting is important for all desk work. Eye strain can literally be a pain in the neck. Overhead lighting may be insufficient and highly reflective surfaces or working while facing an open window may produce an eye straining glare. If you need glasses, properly refracted eyeglasses are essential. Your work may require reading glasses, bifocals, trifocals or, if you prefer, progressive lenses. Whatever is required should be obtained, and this may mean purchasing a second pair of glasses specially refracted for reading or for computer work.

Keyboards and Computers

Keyboards and computers, like cars and telephones, are no longer optional equipment for most of us. For many of us, they are essential to our day's work. For an increasing number of people, therefore, they are an important factor in causing or aggravating neck pain. Computers are a blessing but clearly they can be a pain in the neck.

To avoid that computerized neck pain, a number of factors should be considered. First and foremost is your seating position with your head up in the 1-2-3-2 posture, your back supported with a "firm, friendly hand," and your feet comfortably on the ground or foot stool.

Screen Placement

You should be close enough to the screen (somewhere between 18 and 30 inches, depending on the size of your monitor) so that you can easily read all the material in front of you. Look straight

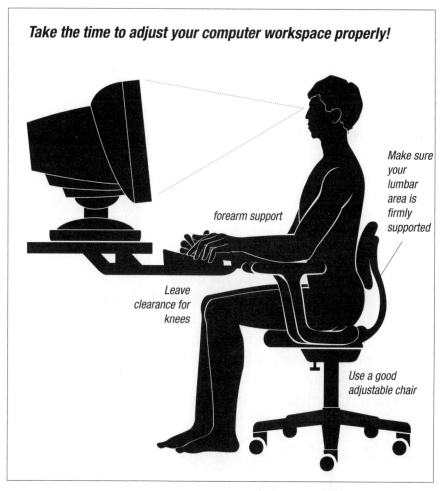

Take the time to adjust your computer workspace properly!

forearm support

Make sure your lumbar area is firmly supported

Leave clearance for knees

Use a good adjustable chair

ahead. The top of the monitor screen should be just below eye level so that your eyes will be looking slightly downward toward the center of the screen. Tilt the monitor screen backward about 15 degrees so that your gaze falls perpendicular to the center of the screen and the entire screen is easily read without changing your head and neck position.

Keyboard

The keyboard should be positioned within easy reach so that it slopes upward and can be easily visualized without changing your head and neck position. Try to keep your wrists and forearms relaxed and parallel to the floor. The keyboard should be either on the desk or on an adjustable surface, with your elbows relaxed at your sides and your arms in neutral position. This minimizes arm strain which otherwise leads to shoulder strain which leads to neck strain.

If your monitor is going to be looked at for hours on end, forearm supports as well as armrests on your chair, either with pads on the work surface or adjustable attachments, can provide greater finger, wrist and arm support and further lessen neck strain.

Document Holder

Adjust the document holder depending on how you plan to use your computer. Avoid keeping the document flat. When you have the display terminal and the keyboard adjusted and you are sitting comfortably, be sure that your document holder is also positioned so that it can be read without turning your head. Attaching the document holder to the side of the monitor can help make it possible to visualize the screen, the keyboard, and the document work sheet without changing your head position, thereby avoiding neck strain.

Eyes Right

All information on the display screen should be sufficiently large and legible (learn how to zoom and enlarge your type if necessary) so that it can be easily read without eye strain or neck strain. Similarly, the document holder should be adjustable for height, distance, angle of view, and be large enough to accommodate all necessary documents. Always face your work directly - do not twist your neck to read the screen or input data.

If the ideal arrangement for a computer work station is not possible, *make as many of the adjustments as you can*, in order to minimize your neck strain. Be sure that your lighting is optimal and any glare (from your desk, walls, windows) on the computer screen is minimal. Adjust window shades as needed. Adjust your monitor using the brightness and contrast controls. Wear your glasses if you need them. Then be sure that you are seated comfortably in your chair with your arms supported and your head and neck in a 1-2-3-2 neck-protected postural alignment.

So let the eyes have it. Respect the gravity of the problem on your neck; take frequent breaks for neck and back stretching. Prolonged, intense desk and computer work is difficult at best. Convincing first yourself (and that's easy if you're the boss) and then your boss, if need be, of the importance of an ergonomically efficient work environment is not always an easy job. All too often, an employer's first reaction is "You're making a big production out of nothing." Giving the employer credible information may make him/her think otherwise and will probably increase production as well!

Stepping Out without Sticking Your Neck Out

or If you had **SEVERE** or even *moderate*
neck pain, you may not have been getting
out much, so now there are some things that you will want to do.
Some are needed chores and others are well-deserved pleasures,
but don't stick your neck too far out, lest you find yourself with
more pain, no gain, and a frustrating pain in the neck.

Shopping

Particularly if you have been holed up recuperating from a severe
neck pain problem, accept the challenge of shopping without rub-
bernecking. There's a lot to look at, but there's also a lot to think
about if you want to avoid a pain in the neck. You will probably
notice a lot of people walking around with something less than
ideal posture. Let this remind you to check your own posture and
make sure that you are strolling in a 1-2-3-2 heads-up neck-pro-
tected posture. Very often you can see your reflection in the store
windows. This can tell you how you are holding your head up on
your outing. Plan to avoid rush hour driving and jostling at
crowded shopping centers, when everyone is rushing to a sale.
Pick your time carefully and plan for easy parking, valet parking,
or better, go as a passenger and let the driver drop you off up
front so that he or she can deal with any parking problems.

Be careful of your purse or briefcase — don't let this weigh you
down. Use a broad shoulder strap on your purse (or brief case),
carry your purse on your "good" side, and better, use a back pack
or fanny pack. If the whole process of shopping seems to be more
trouble than it's worth to you, you might look (in an ergonomi-
cally correct way) more carefully at the catalogues that come to
you in the mail and do your shopping that way — you may see
just what you want and you shouldn't have to strain your neck to
see it.

Shopping For Clothes

or If you don't need anything, don't go. Put off unnecessary shopping until it is no longer unnecessary. If your neck pain is *moderate,* wear your soft collar. If you are shopping for clothes, try to find a sales person who can help you so that you don't have to reach overhead to move heavy garments on hangers on racks or twist to select your garments. Women should consider purchasing bras with wide, cushioned comfort straps to lessen shoulder pressure and minimize neck strain. Front opening bras may also be easier to don particularly if you have shoulder or arm pain. Don't be embarrassed to ask the salesperson to put away the items that you have looked at or to carry the items you have purchased. Maintain your "heads-up" posture while shopping, and be particularly careful to protect your neck when trying on clothes. Keep the shopping time down to a minimum — you'll save your neck and probably some money as well. If you have **SEVERE** neck pain, some stores have personal shoppers who will do the hunting of clothes and bring them to you - make use of this service. Have the store hold or check your purchases in a central location for pick up when you're done.

Shopping Carts

Use wheels whenever possible and be sure that the wheels work smoothly. Select markets with shopping carts that have an extra-high basket for easy loading and unloading. Place your heaviest items in the high basket, leaving the remainder of the basket for

Remember the Symbol: Severe Moderate Mild Minimal

lighter packages that can be easily lifted without causing neck strain. When loading and unloading your shopping cart, remember to bend from your hips and not from your waist or your neck. When possible, shop at stores where the "bagger" will carry the groceries to your car as part of their service. At home, whenever it's possible, take in the perishables only and let someone else bring in the rest of the groceries.

Loading Your Car

Do your 1-2-3—2 posture check before you load and unload your car. Bend at your knees to help keep your back and neck straight. Load your bulky packages on the front seat of the car and not on the floor. Place the heaviest and bulkiest package within easy reach next to the door. If you have a four-door model and you have a lot of bags, try to place one or two of the bags on each of the unoccupied seats near the car doors. Place them carefully so they won't tip over. If you have to load small and large bags or packages, place the largest and heaviest ones closest to the door so that you won't have to reach to remove them. Trunks and hatchbacks are often difficult to unload, but the same principles apply - *place the larger packages closer to the door.*

Out for Pleasure - Don't stick your neck out

or If you have **SEVERE** or *moderate* neck pain, and you now feel ready for an outing, or if you must take one that you can't otherwise avoid, try to keep your travel time down to 20 or 30 minutes. If you're eating out, plan for a restaurant with good seating and if possible, good or at least quick service so that if your neck starts to pain you, you won't have to prolong the agony unduly. To be on the safe side wear your soft collar or brace, or take it along just in case.

Remember that for proper neck posture, good back support is essential so you may want to use a rolled scarf or sweater or small firm purse or back cushion to support the small of your back.

When you are dining out with friends or family, at a time when your neck pain is *moderate,* be sure to wear your soft collar. If you remove the collar while eating, try to maintain your 1-2-3-2 posture. Be sure to seat yourself across, and not alongside those with whom you will converse. This will help you avoid turning your head and twisting your neck, and the one thing you don't want when you're out for pleasure — more pain in the neck.

Good Moves For Movies and the Theater

No matter where you go, getting there and parking can be a problem. Make the same arrangements that you have made for your first shopping outing and avoid the hassle and the pain in the neck. Get to the theater early, wear your soft collar and leave either early or late to avoid the crowds and the crunch.

Seating: Whenever possible select a seat either in the center of the row, so people won't walk over you, or on the aisle, so that you can exit easily. Pick a seat that is far enough back so that you don't have to strain your neck to look up at the stage or screen. In fact, you can use the performance, even as a spectator, to provide you with cues during scene changes or actors' stage entrances or exits to remind you to sit upright in a 1-2-3-2 neck-protected posture.

Pick a theater with good seating and if need be, take along an extra purse, jacket, or small firm pillow to provide better back support to help ease neck strain. Try to remember to do your neck and shoulder stretches (as unobtrusively as possible) at 20 to 30 minute intervals (*See **Exercise For Relief and Recovery**, page 189*).

A great performance can be a source of great pleasure, but if you're totally captivated, you may stress your neck and become once again a prisoner of neck pain. A good way to help keep that from happening is to use your collar and your exercises to give you freedom from pain. Obviously, we are talking about the "legitimate" theater but the same general principles apply at the movies, ball games, tennis matches, horse races and outdoor shows as well.

It's been a long day - and so to bed

Pillows, Sheets, Blankets, Mattresses, and Necks

Pillows For Your Head and Your Neck

Your mattress may not bother you, but your pillow can be a pain in the neck. The old saying that "If you're not part of the solution, you're part of the problem" certainly applies to pillows.

There are two major considerations that apply to pillows when you are suffering from neck pain. If you have *mild,* *moderate* or **SEVERE** neck pain, you shouldn't be sleeping on your stomach, so the job for a neck pillow is to place your neck and head in the optimum position of comfort when you're lying on your back or on your side. This means that the pillow should be soft in the middle, allowing the back of the head and the neck to sink back and maintain a straight line with the trunk. It should also be firm on the sides so that when you lie on your side the space between your ear and the shoulder is supported and your head is prevented from twisting downward.

There are a number of pillows that are available and designed to provide neck support. By and large the simple Jackson Cervipillow (*See **Resources,** page 247*) seems to be comfortable for most patients with neck problems. There are several cylindrical pillows like the Jackson Cervipillow that are identical in out-

ward appearance but are made with different densities of foam or other cushioning materials inside. Some prefer a down-filled version - if they're not allergic to feathers. It's important to lie on and test whatever pillow you may purchase long enough to know whether it will provide the comfort and proper neck support that you need.

The variety of pillows that are designed to relieve neck pain come in many shapes and sizes. One is large and rectangular; another is in the shape of a butterfly and there is almost everything in between. Once again, try to test them carefully and long enough to make sure that they are comfortable for you when you are lying on your back and on your side, and not too noisy when you move. Then be sure that the one that you selected continues to be comfortable for 10-20 minutes in these positions.

Since you change positions in bed about 40 times each night, if you can't rely on your pillow for comfort, your brace or soft collar may help.

The Bowtie Pillow

If you haven't found a proper neck-supporting pillow or if you are away from home but your neck pain is still with you, the "bow tie" pillow will make a pretty good substitute. Take an ordinary pillow and fold it once lengthwise and then tie a neck tie or sash around the middle. Your neck goes on the sash when you are on your back and your ear goes against the folded pillow when you are in the sidelying position. You can insert a rolled bathtowel inside of the pillow slip for additional firmness. The "bow tie pillow" can give you enhanced support for sidelying while minimizing the bulk of the pillow beneath your head when lying on your back.

Bedding Down With A Sore Neck

Sheets and blankets rarely pose a problem and the right combination for comfort is readily found. A properly supporting mattress is essential for back pain sufferers, but a mattress has to be in pretty bad shape to pose a problem if the pain is in your neck. That doesn't mean that a poor mattress can't give you a pain in the neck, but there is a more room for error before the mattress will cause neck trouble.

A good mattress is one that is firm but not hard, and provides even nonsagging support for your whole body. If you're lying on your side, your shoulders and hips should sink in enough so that your entire trunk is comfortably supported. There should be no sagging pits to sink into nor lumps to push out at you.

Necks and Sex

"Not tonight honey - it's a pain in the neck." That can be an excuse with profound implications or a statement of fact about a painful neck. Clearly, if the problem is the former, then counselling is essential. If the pain in the neck is just that, a painful neck, then proper treatment and management of the neck pain problem is mandatory.

Love, romance, passion, and neck pain are not an ideal combination, but if you are having neck pain, then passion may need more attention. No one wants to be a pain in the neck, let alone have a pain in the neck, and when it comes to making love, both partners must consider the possibilities for mutual gratification.

 If you are having **SEVERE** pain, it is unlikely that you will be able to enjoy, nor would your loving partner enjoy, making love.

 or If your pain is *moderate* or *mild,* then as in all other activities, you may need to

make some accommodations in order to participate appropriately in the experience. If your pain is *moderate,* it would be well to wear a soft collar and to position yourself with adequate pillow support to minimize untoward neck twisting or awkward head and neck positions. For making love, by and large the most comfortable position is for the neck pain lover to be beneath his or her partner. Sidelying can be comfortable with proper pillow support and some find making love sitting on a chair or couch most comfortable. A warm shower or tub bath and some gentle neck stretching should be arranged prior to making love if possible. If you are having *moderate* neck pain, and your partner is understanding, a cold compress afterward may be a consideration. The idea of wearing a soft collar during a passionate embrace may not be appealing, but if the soft collar serves to remind both you and your partner that uncontrolled passion and **SEVERE** neck pain are incompatible, the wearing of the collar may not seem so troubling.

Medications For Love

or If you have *mild* neck pain you may feel the need for an analgesic medication to relieve your discomfort and permit full enjoyment of love-making. Non-narcotic analgesics such as Tylenol®, Advil®, Aleve® or aspirin taken twenty to thirty minutes prior to love-making can make a difference. Narcotic analgesics, alcohol, or tranquilizers and muscle relaxants may be helpful but they can also inhibit masculine potency and feminine desire. If you don't want your neck pain to be a pain in the neck when you are making love, it's best to first test your reaction to any medication that you contemplate using to be sure that you have no side effects such as nausea or drowsiness that would preclude satisfying sexual relations.

Don't Lose Your Head With Neck Pain

Sexual excitement and passion are powerful forces and once activated, difficult to control. Nonetheless, if you have *moderate* or

even *mild* neck pain, it is well to discuss this openly and candidly with your partner. So that there will be no misunderstandings, have an agreed-upon signal to let your partner know that your neck pain is increasing. Gently make accommodations to your neck discomfort so that sexual satisfaction can best be fulfilled.

Reading in Bed

Reading in bed is a pleasant luxury for many of us, but it can be a source of misery when the neck is in pain. Put aside your heavy bound books for later and only read light weight, (not necessarily light content) reading materials. Pillows placed under your elbows can help support the books or magazines to help relieve strain on shoulders and necks. Although it is possible with pillows and bolsters to sit upright and read in bed, it is very difficult to do so without bending your head down in order to read. Placing a pillow under your knees, a cervical pillow behind your neck and either another firm pillow on your thighs or one of a variety of lap-held devices can create a fairly comfortable lap desk for reading and writing in bed. If you are a "committed in-bed reader" and you just can't get comfortable holding reading material on your lap, there are adjustable bedside tables (that you may have seen when visiting in a hospital) designed for home use. The best news for sore necks is the BedLounge® (Cequal Products, Inc.; *see* **Resources**, *page 247*) which provides optimal comfortable, neck, back and arm support for the bed reader, TV viewer or lap top computer user.

Prism Glasses and "Through The Looking Glass"

or For those who have such **SEVERE** neck pain that they may be forced to wear a neck brace but still want to read before falling asleep, there are two

more options. One possibility is the use of prism glasses* (that can be fitted over your regular glasses if necessary) to make it possible for you to lie on your back with your head flat on the bed and read or watch television(For information on prism glasses, *see* **Resources,** *page 247*). The prism bends the light from your book or video at a right angle downward toward you so that you don't have to move your head. A second possibility is the use of lucite bookholders placed over your head that allow you to read material while looking straight up overhead through the lucite (*See* **Resources,** *page 247*).

Travel without Rubbernecking

or **SEVERE** neck pain, travel
should be avoided at all costs. If it is moderate and if with a cervical collar or bracing and mild analgesics you can be reasonably comfortable, then travel becomes feasible. If you are going to travel by car, and your neck pain is **SEVERE** or *moderate,* plan to travel as a passenger. The vibration of automobiles, the jostling on rough roads, and the fatigue of long trips can change a mild neck pain into a *moderate* or **SEVERE** one. Wear a soft collar or brace and use a neck-supporting pillow (an inflatable headrest pillow can be a great travel companion) whenever possible. Make sure that your car seat is comfortable and that you have help loading and unloading the trunk or the back of the car (*See* **Resources,** *page 247*).

Packing and Unpacking

 or ![icon] or ![icon] If your clothes are on hangers, arrange them so that they can be easily removed without reaching, twisting or bending. Place your suitcase on a bureau or table high enough to avoid unnecessary bending. Travel light. Use luggage with wheels that have a good turning radius. Carry only a light purse, briefcase or shoulder bag either in front of you or over the shoulder on the "good" side.

Coming and Going

If you're traveling by plane or bus, the same rules apply. Always allow extra time to avoid last-minute confusion, jostling, stress and strain. It may be a nuisance to get to the airport a little early, but it won't give you a pain in the neck.

When you're boarding the plane, be sure you have your brace or soft collar on and don't be embarrassed about asking for early boarding privileges. Ask for help with your luggage and get assistance when you need to place luggage in or remove it from the overhead rack. If you are tall, it's important to have a bulkhead or aisle seat so that you can stretch your legs for better comfort. You may want an extra pillow for back support in addition to head support.

![icon] It's always a good idea even if you have *mild* neck pain to wear your soft collar just in case you fall asleep. This will keep your head from slumping downward and straining your neck. Put one on when traveling in the car, train or plane - anytime there is a chance that you may get bored and start to nod off.

![icon] If you have **SEVERE** neck pain and are wearing a cervical brace, ask to be transported to and from the baggage counter and the departure gate. Take along pain medica-

tion, if you need it. Take a plastic bag (a Ziplock plastic bag works well) so that the flight attendant can provide you with ice cubes for a cold pack. With good planning, you should be able to hold your head up high - comfortably - and enjoy your trip.

Chapter 10

Exercise for Relief and Recovery

EXERCISE IS LIKE MUSIC. It can be soothing or jarring, exhilarating or harmoniously calming, invigorating or exhausting. It can also be painfully discordant and a pain in the neck. Obviously, the word exercise, like music, can connote an almost infinite spectrum of activities and experiences.

Our Center-tested exercises for your neck and shoulders are detailed for you in this chapter. Each exercise has a specific purpose. You will be guided in the selection of the ones that you need and when you may need them.

Stretching Exercises

There are two main functions of stretching exercises that must be considered when you have a painful neck. **The first is to relieve pain and the second is to restore mobility.** Both are accomplished by gentle stretching - easy movements that encourage circulation and an inpouring of healing nutrients to the painful tissues, while simultaneously massaging away stagnant pools of the body's chemicals that cause irritation and pain. This helps relieve stiffness and aching. It also helps to prevent formation of connective tissue adhesions that can bind muscles or ligaments and bones together and, if not stretched, can cause permanent stiffening.

Like music, stretching exercises must be properly orchestrated and properly performed to achieve the desired harmonious effect. To properly orchestrate our exercises for painful necks, we have divided these exercises into two groups which we call "Feel Good" and "Do Good" exercises.

Stretching can make the difference between a painful stiff neck and a permanent loss of neck motion - for example, an inability to look over your shoulder.

"Feel Good" Exercises

"Feel Good" exercises gently relieve tension in the muscles that stretch from the neck to the chest and shoulder blades. They are the initial pain-relieving exercises for **SEVERE** to *moderate* neck pain.

Initial Pain Relieving - "Feel Good" Stretches

1. *1-2-3—2 Posture Positioning (pg 143)*

2. *Shoulder Shrugs with Downward Stretch (pg 197)*

3. *Beginning Shoulder Circles (pg 198)*

"Do Good" Neck Stretching Exercises

"Do Good" stretching exercises progressively increase neck and shoulder mobility and overcome stiffness and muscle soreness. As motion is restored, vulnerability of the neck to aggravation of symptoms by unavoidable jolts and strains is diminished.

"Do Good" Strengthening Exercises

Just as all music is not melodic and rhythmic, all exercises to restore function are not limited to stretching. Muscles weakened by pain, restricted activity, or bracing, must be reconditioned. When neck mobility is improving, and stretching exercises are comfortable, strengthening exercises can commence.

How Do I Strengthen My Neck?

Before asking "How," one might ask, "Why should I strengthen my neck muscles"? The neck muscles are key to supporting the head. They can place the head and neck in whatever position necessary for the task at hand, as well as position the head and neck to relieve pain and strain. As in essentially all problems affecting the skeleton, the weaker the muscles, the greater the

likelihood that ligamentous, joint, and disc stresses and strains will occur.

"My neck can hold my head up all right, but do I have to carry a heavy bundle on my head to strengthen it?" You don't have to. There are many techniques and devices to strengthen muscles and some of them can be used to strengthen the neck. You don't need barbells or fancy "bells and whistles" exercise machines to strengthen the neck, or other muscles for that matter. If you plan to do yoga headstands or engage in vigorous contact sports that might put your neck in jeopardy, then you might consider using specialized gym equipment.

Isometric Exercise

Isometric *(Iso* = equal + *metric* = measure or force). An isometric exercise is performed by using muscles to push or pull against a resisting force without moving it. If you try to lift your car by pulling up on the bumper, nothing will move, but your arms and back will feel the strain. If you push your head against the wall, neither you nor the wall will move, but your neck flexor muscles will get a workout and you might get a headache and a pain in the neck.

These examples make the point that powerful muscular forces can be stimulated by isometric exercise, although neither of the above maneuvers is suggested (let alone recommended) as part of your treatment for a pain in the neck.

Many years ago, research at the Max Planck Institute in Germany demonstrated that a six-second isometric contraction at two-thirds of the maximum strength of a muscle was an adequate stimulus to strengthen that muscle. Since that time our own research at the Swezey Institute as well as numerous other studies have shown that isometric exercises using various formulae ranging from daily to twice weekly exercises and single to multiple repetitions lasting 1 to 12 seconds can significantly increase muscle strength (including the neck muscles) in as little as two months.

Strengthening Exercises - "Do Good"

Weakened muscles result from pain and lack of use (Neck braces and soft collars support the head without requiring normal muscle activity to do so, and can further weaken neck muscles.).

Strengthening of the neck, and when needed, the shoulder muscles, must be instituted as soon as pain relief permits (when your pain level is **moderate** to *mild*). All conditioning exercises must be done gradually beginning with gentle strengthening and progressing step by step to more vigorous exercises.

Initial Strengthening

1. Elbow Push Isometric (pg 212)

2. Neck Forward Flexion Isometric (pg 213)

3. Neck Lateral Flexor Isometric (pg 214)

4. Neck Extensor Isometric (pg 215)

Our four basic isometric strengthening exercises are designed to be held for a maximum of 6 seconds. Initially, the exercise is done for 1-2 seconds and as strength and endurance improve, the exercise can be increased to 6 seconds twice daily. Since the exercise is performed with your head pushing against your hand, if any discomfort should occur you are immediately in control, so the exercise can be stopped and injury avoided.

"Listen" To Your Pain

Pain is a powerful inhibitor of strength. If you have ever had a sore thumb, you know how difficult it is to hold a pen and write, let alone give a firm handshake. Therefore, the ability to position your neck so that painful motion is avoided allows you to apply the maximum possible muscle strengthening effort during the isometric exercise. This is critical to the effectiveness of isometric strengthening exercises for a painful neck as well as other

painful musculoskeletal disorders. Any attempt to strengthen muscles that causes pain is not only potentially harmful, but because of the pain it is unlikely to provide a contraction forceful enough to strengthen weak muscles.

When To Try It Again

If an exercise has caused pain:

1) Be sure that you are performing the exercise correctly by re-reading the instructions carefully and trying it again very slowly.

2) Any pain resulting from the exercise should have subsided for at least 24 hours, before attempting a second more gentle trial. If there is any question do not hesitate to obtain professional help.

So remember that exercises can both "feel good" and "do good." Determine your pain severity level and gradually add exercises as long as they are comfortable. They should cause no more than some achiness or stiffness that you might expect from any new activity or exercise. Any aching from the exercise should be almost gone in 2 hours and should not cause increased discomfort the following day.

Neck Exercises: Do - But Don't Overdo

Depending on the severity of your neck problem, you should start with the most gentle stretching exercises (pages 197 and 198). When those exercises are comfortable, add additional stretches one by one as tolerated (pages 200-210).

You may not need to keep doing all or any of the exercises once your neck motion has returned to normal. Nonetheless, it's a good idea to do each of the series of stretches once before progressing to a new exercise. The new milder exercises serve as a loosening up preparation for the next step. Finally, concentrate on the more advanced exercises that are still needed to try to overcome, to the extent possible, any remaining stiffness. Be sure to do your loosening up neck stretches before you do your strengthening exercises.

The goal of the exercises is to relieve pain and improve posture and neck motion to the extent possible. It is important to recognize that structural changes resulting from injuries or that may occur over time may limit the ability to restore full motion.

Check your Neck Pain Level (pg 53) before progressing with your Exercises.

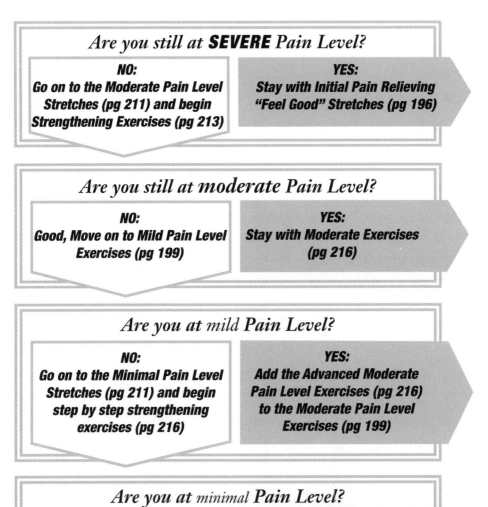

Are you still at **SEVERE** Pain Level?

NO:
Go on to the Moderate Pain Level Stretches (pg 211) and begin Strengthening Exercises (pg 213)

YES:
Stay with Initial Pain Relieving "Feel Good" Stretches (pg 196)

Are you still at *moderate* Pain Level?

NO:
Good, Move on to Mild Pain Level Exercises (pg 199)

YES:
Stay with Moderate Exercises (pg 216)

Are you at *mild* Pain Level?

NO:
Go on to the Minimal Pain Level Stretches (pg 211) and begin step by step strengthening exercises (pg 216)

YES:
Add the Advanced Moderate Pain Level Exercises (pg 216) to the Moderate Pain Level Exercises (pg 199)

Are you at *minimal* Pain Level?

NO:
Go back to Moderate Pain Level Exercises (pg 216) and progress again to the Mild Pain Level Exercises. (pg 199)

YES:
Go on to the 5 Minute Neck Saver Exercises (pg 219) and get ready for "Exercises for Fun"

Severe Pain Level Stretches

1. Shoulder Shrugs with Downward Stretch

2. Beginning Shoulder Circles

Shoulder Shrug with Downward Stretch *SEVERE* to *mild*

Purpose: To relieve neck tension. To increase motion in muscles connecting the neck and shoulders. To stretch tight muscles that connect the head and shoulders (the *trapezii*).

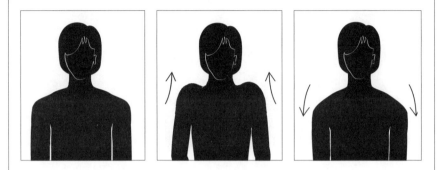

1 Sit in a **chin-in, head-up** position *(See page 143)*.

2 Take in a slow, deep breath. Relax as you exhale.

3 Shrug your shoulders gently up toward your ears. Maintain your chin-in position until you feel the upper shoulder muscles tighten.

4 Hold and slowly count out loud 1001, 1002, 1003, 1004, 1005, 1006.

5 Slowly relax your muscles.

6 Now continue to move your shoulders in a downward motion as you slowly reach toward the floor with your fingers, until you feel a s-t-r-e-t-c-h in your upper back near the base of your neck.

7 Hold and count out loud: 1001, 1002, 1003, 1004, 1005, 1006.

8 Relax slowly by placing your hands in your lap.

9 Repeat this exercise 2 - 3 times, 5 times a day and more often if needed for comfort.

Suggestion: Wear a soft collar during exercise if so prescribed.

Precaution: If this exercise increases pain, or feelings of numbness or tingling, discontinue exercise and consult your physician or therapist.

Beginning Shoulder Circles *SEVERE* to *moderate*

Purpose: To loosen and stretch tight muscles connecting the neck, chest and arms (*trapezii, pectorals and serrati*).

1 Sit in a **chin-up, head-up** position

2 Take in a slow, deep breath. Relax as you exhale.

3 Move your shoulders slowly in a gentle, circular, **forward** motion - up and forward, down and back 3 times.

4 Then in a gently **backward** motion, back and down, forward and up 3 times.

5 Between each repetition, relax a few seconds as you maintain a chin-in, head-up position.

6 Repeat this exercise 3 - 5 times a day, and more often if needed for comfort.

Suggestion: If needed, your soft collar can be used during this exercise.

Precaution: If this exercise increases pain, or feelings of numbness or tingling, discontinue and consult your physician or therapist.

Moderate to Mild Pain Level Stretches

1. Beginning Neck Rotations

2. Neck Forward Flexion Stretch

3. Intermediate Shoulder Circles

4. Elbow Touches

5. Pectoral Stretches

6. Intermediate Neck Rotation (Over the Shoulder Stretch)

7. Lateral Neck Flexion Stretch (Ear to Shoulder Stretch)

8. Neck Extension Stretch

9. Advanced Shoulder Circles
 If you can do your Intermediate Shoulder Circles comfortably, then move on to the Advanced Shoulder Circles

10. Assisted Neck Forward Flexion Stretch (Head Hang)

11. Assisted Neck Rotation

Beginning Neck Rotation *moderate* to *mild*

Purpose: To begin restoration of head and neck turning motion by stretching neck muscles (neck rotators).

1 Sit in a **chin-in**, **head-up** position.

2 Take in a slow, deep breath. Relax as you exhale.

3 Turn your head slowly to the right until you feel slight discomfort and/or a gentle s-t-r-e-t-c-h sensation. (It may be easier to guide your chin with your fingers.)

Do not hold this position!.

4 Return your head to a **chin-in**, **head-up** position.

5 Now turn your head slowly to the left side until you feel slight discomfort and/or a gentle s-t-r-e-t-c-h sensation.

6 Repeat this exercise 3 times, 3 times a day.

Suggestion: If this exercise increases pain, or feelings of numbness or tingling, discontinue exercise and consult your physician or therapist.

Neck Forward Flexion Stretch *moderate* to *mild*

Purpose: To loosen and stretch tight muscles and ligaments at the base of the neck *(upper trapezii* and *splenius capiti).*

 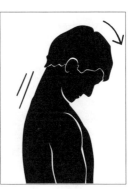

1 Sit in a **chin-in, head-up** position.

2 Take a slow, deep breath. Relax as you exhale.

3 Take another slow, deep breath. As you exhale, keep your chin in and slowly roll your head downward, trying to place your chin on your chest.

4 When you feel a comfortable s-t-r-e-t-c-h at the back of your neck, stop. Breathe slowly in and out as you count out loud from 1001 to 1005.

5 Keep your chin in as you slowly bring your head to a **chin-in, head-up** position. (If you wish, use your finger to guide your chin carefully.)

6 Repeat this exercise 2 times, 3 times a day.

Suggestion: Wear a soft collar during this exercise only if so prescribed. Remember to breathe in a relaxed manner during this exercise.

Precaution: If this exercise increases pain, or feelings of numbness or tingling, discontinue exercise and consult your physician or therapist.

Intermediate Shoulder Circles　　　*moderate* to *mild*

Purpose: To stretch and increase motion in the muscles and ligaments connecting the neck and arms. To relieve tension in muscles and ligaments connecting the neck and arms (*pectorals, rhomboids, trapezii, serati,* and *levator scapuli*).

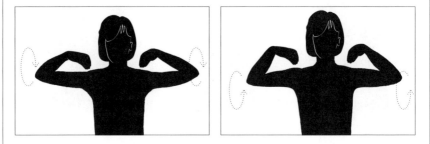

1 Sit in a **chin-in, head-up** position. Breathe properly.

2 Place your fingertips on your shoulders. Raise your elbows, pointing them away from your body by moving them directly out from the sides of your chest.

3 Use your elbows to draw small circles in the air about the size of a saucer. (Do not shrug your shoulders.)

4 First. rotate your shoulders up and forward, then down and back 3 times.

5 Then in the opposite direction, rotate your elbows down and forward, then up and back 3 times.

6 Repeat this exercise 2 times a day.

Suggestion:　Wear a soft collar during this exercise if prescribed.
Precaution:　If this exercise increases pain, or feelings of numbness or tingling, discontinue exercise and consult your physician or therapist.

Elbow Touches *moderate* to *mild*

Purpose: To s-t-r-e-t-c-h tense and tight muscles that connect the neck, back and shoulder blades (the middle and lower *trapezii* and *rhomboids*).

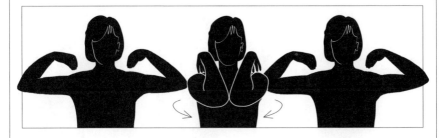

1 Start in your **chin-in, head-up** position. Breathe naturally.

2 Place your fingertips on your shoulders with your elbows as close to shoulder level as possible (just above arm pits).

3 Breathing out slowly, keep your arms up as you bring your elbows as close together as possible. Stop when you feel a minor s-t-r-e-t-c-h in or between your shoulder blades.

4 Slowly move your elbows until they are again in the starting position – with your elbows as close to shoulder level as possible and in a **chin-in, head-up** position.

5 Breathe in slowly as you point your elbows backward. Gently bring your shoulder blades together.

6 Hold and count: 1001, 1002, 1003 as you breathe out.

7 Relax slowly. Maintain your **chin-in, head-up** position as you slowly return to the starting position.

8 Repeat 3 times 2 times a day.

Suggestion: Wear a soft collar during exercise if so prescribed.
Precaution: If this exercise increases pain, or feelings of numbness or tingling, discontinue exercise and consult your physician or therapist.

Pectoral Stretch *moderate* to *mild*

Purpose: To s-t-r-e-t-c-h the upper chest and shoulder muscles and to improve and/or maintain upper back posture.

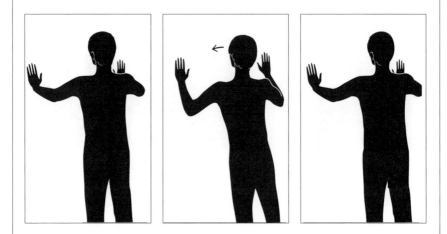

1 Stand facing a corner or in a doorway with your feet a shoulder's width apart.

2 Place your hands on opposite walls or on a doorframe approximately at shoulder level.

3 Keep your chin in.

4 Slowly lean forward, keeping your body straight and heels on the floor.

5 Count out loud "1001, 1002, 1003, 1004, 1005, 1006."

6 You should feel a stretch in the front of your chest and shoulders. You may also feel the stretch in your calves and in the upper back.

7 Relax to the starting position.

8 Repeat 3 times, 2 times a day.

Suggestion: Wear a soft collar during exercise if so prescribed.

Precaution: If this exercise increases pain, or feelings of numbness or tingling, discontinue exercise and consult your physician or therapist.

Intermediate Neck Rotation (Over the Shoulder Stretch)

moderate to *mild*

Purpose: To help restore head and neck turning motion (neck rotators).

1 Sit in a **chin-in, head-up** position. Do your natural breathing for exercise.

2 Maintaining a **chin-in, head-up** position, slowly roll your head downward, trying to place your chin on your chest.

3 Again do your natural breathing and relax. You should feel a s-t-r-e-t-c-h at the back of your neck from the weight of your head. (Your head should feel as if it were hanging without any support.)

4 Keeping your chin close to your chest, rotate your head to the right, trying to see the ground just behind your right shoulder. Stop when you feel a tolerable s-t-r-e-t-c-h.

5 Hold this stretch as you breathe in and out. Relax and count out loud "1001, 1002, 1003, 1004, 1005, 1006."

6 Keeping your chin close to your chest, slowly bring your head back to your original **chin-in, head-up** position.

7 Now, repeat by rotating your neck to your left side.

8 Repeat 3 times, 3 times per day.

Suggestion: If this exercise increases pain, or feelings of numbness or tingling, discontinue exercise and consult your physician or therapist.

Lateral Neck Flexion Stretch (Ear to Shoulder Stretch)

moderate to *mild*

Purpose: To loosen and stretch tight muscles and ligaments at the side of the neck in order to restore neck motion.

1 Sit in a **chin-in, head-up** position.

2 Do your natural breathing for exercise.

3 Maintaining a **chin-in, head-up** position, breathe in, and as you exhale, slowly lean your head to the right so that your right ear approaches your right shoulder. Stop when you feel a tolerable s-t-r-e-t-c-h on the left (the opposite side) of your neck.

4 Continue the stretch. Try to gently stretch further with each count. Count slowly "1001, 1002, 1003, 1004, 1005, 1006."

5 Return slowly to your original **chin-in, head-up** position.

6 Breathe in and as you exhale, relax and repeat the exercise, stretching to the left.

7 Repeat 3 times, 2 times a day.

Suggestion: If this exercise increases pain, or feelings of numbness or tingling, discontinue exercise and consult your physician or therapist.

Neck Extension Stretch *moderate* to *mild*

Purpose: To improve general mobility by stretching muscles at the front of the neck. To allow looking up and turning neck with greater ease.

1 Sit in a **chin-in, head-up** position.

2 Breathe naturally.

3 Take in another breath and perform a chin tuck.

4 As you exhale, lift your chin up and gently tilt your head backwards (as if looking up at the sky). Do not hold your head back.

5 Breathe in as you slowly bring your neck and then your head to the original **chin-in, head-up** position. (You can use your hands clasped at the base of your skull to prevent over stretching and to help return your head to the original **chin-in, head-up** position.

6 Now, breathe out and relax.

7 Repeat this exercise 3 times 2 times a day.

Precaution: If this exercise increases pain, or feelings of numbness or tingling, discontinue exercise and consult your physician or therapist.

Advanced Shoulder Circles *moderate* to *mild*

Purpose: To fully stretch shoulder blades and shoulder joints.

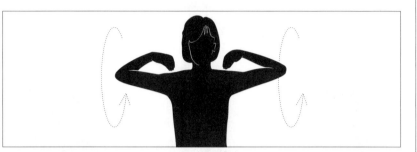

1 Stand tall or sit up straight in a comfortable chair (preferably without arm rests).

2 Assume a **chin-in**, **head-up** position and place your fingertips on your shoulders.

3 Take in a slow, deep breath to expand your chest, and relax as you exhale.

4 With your elbows pointing out to your sides, slowly draw large circles in the air. Do not shrug your shoulders.

5 Slowly inhale as you circle your elbows up and back. Then slowly exhale as your elbows circle down and forward..

6 Repeat 3 times.

7 Do 2 times a day.

Alternative exercise: If shoulder pain interferes with the performance of this exercise, try doing the exercise as described above, but without placing your fingertips on your shoulders. Let your arms hang; move your shoulders in a circular fashion 3 - 5 times. Do 2 times a day.

Suggestion: Wear a soft collar during exercise if so prescribed. Remember to breathe in a relaxed manner during this exercise.

Precaution: Stop if breathing causes lightheadedness. If this exercise increases pain, or feelings of numbness or tingling, discontinue exercise and consult your physician or therapist.

Assisted Neck Forward Flexion Stretch (Head Hang)

moderate to *mild*

Purpose: To loosen and stretch tense and tight muscles and ligaments at the back of neck and upper back by gravity assisted stretch. To increase motion of neck as it bends forward. To relieve chronic tension and strain.

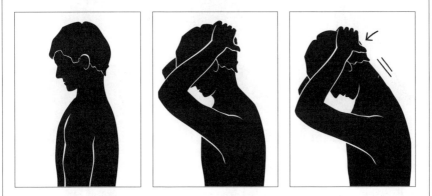

1 Sit (or stand) in a **chin-in**, **head-up** position.

2 Exhale as you slowly drop your chin toward your chest, let your head hang until you feel a mild s-t-r-e-t-c-h on the back of your neck.

3 Clasp your hands and place them on the top of your head..

4 Breathe in again and as you exhale gently allow the weight of your hands to assist the stretch.

5 Allow your elbows to drop toward the floor continuing to stretch the back of your neck and upper back. Breathe in and out as you hold and count: "1001, 1002, 1003."

6 Let your hands down to your sides.

7 Slowly raise your neck and then raise your head to your original **chin-in**, **head-up** position. Relax.

8 Repeat 2 times, 2 times a day.

Precaution: If this exercise increases pain, or feelings of numbness or tingling, discontinue exercise and consult your physician or therapist.

Assisted Neck Rotation *moderate* to *mild*

Purpose: To improve neck mobility which allows your head to turn with greater ease (a movement which is especially necessary when driving).

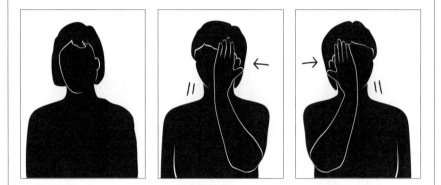

1 Sit in a **chin-in, head-up** position.

2 Breathe in deeply and slowly turn your head to the right as far as you comfortably can.

3 Breathe out and place your left hand on your left cheek.

4 Take in another breath and as you exhale, gently push your head farther to the right.

5 Release your hand and slowly bring your head back to the **chin-in, head-up** position.

6 Repeat the exercise on your left side by turning your head to the left as far as possible and continuing to push your head further to the left with your right hand.

7 Repeat 3 times, 2 times a day.

Precaution: If this exercise increases pain, or feelings of numbness or tingling, discontinue exercise and consult your physician or therapist.

Isometric Strengthening "Do Good" Exercises

Commence when you are at the ***moderate*** to *mild* Pain Level.

Do these exercises in the following progression:

1. Elbow Push Isometric

2. Neck Forward Flexion Isometric

3. Neck Lateral Flexor Isometric

4. Neck Extensor Isometric

Elbow Push Isometric *moderate* to *mild*

Purpose: To increase strength in muscles supporting the back of the neck and shoulder blades (*trapezii* and *rhomboids*).

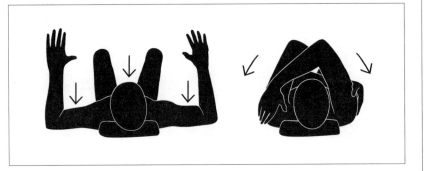

1 Lie on your back with your knees bent and your feet resting flat on the floor. Use a cervipillow under your neck for support.

2 Place your arms out to the side at shoulder level with elbows bent and your fingers pointing toward the ceiling.

3 Begin with your chin-in and pinch your buttocks together. Hold this position to prevent your back and neck from arching.

4 Push the back of your arms and head into the floor.

5 Take a deep breath and exhale slowly as you count out loud "Push 1, Push 2, Push 3, Push 4, Push 5, Push 6." With each count, push harder. Take an extra breath if necessary to complete the six counts.

6 Relax slowly and bring your arms across your chest for a mild stretch between your shoulder blades.

9 Repeat 2 times, 2 times a day.

Suggestion: Wear a soft collar if so prescribed.
Precaution: If this exercise increases pain, or feelings of numbness or tingling, discontinue exercise and consult your physician or therapist.

Neck Forward Flexion Isometric — *moderate* to *mild*

Purpose: To restore and maintain strength to the neck muscles.

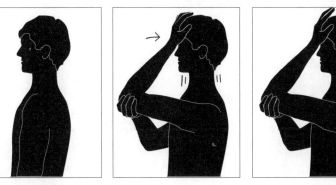

1 Sit (or stand) in a **chin-in, head-up** position.

2 Place the palm of your hand (the least painful arm) in the middle of your forehead and support the elbow of this arm with your other hand.

3 Take a slow deep breath. As you exhale (try not to move your head), push your forhead into the palm of your hand while maintaining the **chin-in, head-up** position. Resist this movement with the palm of your hand.

4 As you push, count out loud "Push 1, Push 2, Push 3" and with each count, try to push harder. Apply as much force as comfort allows.

5 Slowly relax.

6 Repeat this exercise 2 times, 2 times a day.

7 As you are able to tolerate it, try to increase pushing your forehead into the palm of your hand from a count of "1, 2, 3" to a count of "1, 2, 3, 4, 5, 6."

Suggestion: If this exercise increases pain, or feelings of numbness or tingling, discontinue exercise and consult your physician or therapist.

Neck Lateral Flexor Isometric *moderate* to *mild*

Purpose: To restore and maintain strength to the neck muscles, especially at the side of the neck.

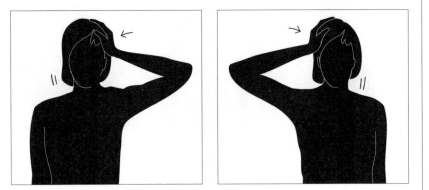

1 Sit (or stand) in a **chin-in, head-up** position.

2 Place the heel of your right hand above your right ear.

3 Without moving your head or neck, push the side of your head into your hand, as if you were trying to touch your ear to your shoulder and resist this movement with the heel of your hand.

4 Count out loud: "Push 1, Push 2, Push 3, Push 4, Push 5, Push 6." Increase the force of your contraction as you push harder and exhale with each count.

5 Release the contraction slowly, and relax.

6 Repeat the exercise on the left side.

7 Repeat this exercise 2 times, 2 times a day.

Precaution: Do not hold your breath. Do not reduce the force of contraction. If this exercise increases pain, or feelings of numbness or tingling, discontinue exercise and consult your physician or therapist.

Neck Extensor Isometric *moderate* to *mild*

Purpose: To restore and maintain strength to the neck muscles, especially at the back of the neck (extensors).

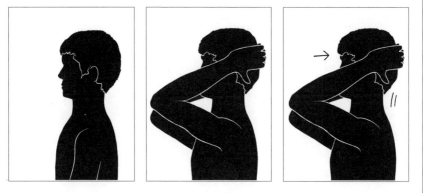

1 Sit in a **chin-in, head-up** position.

2 Clasp your hands and cup them in the back of your head.

3 Take a slow deep breath and relax as you exhale.

4 Keeping your chin level, push your head straight back into your clasped hands. Resist with your hands so that no motion occurs in your neck or head.

5 Count out loud "Push 1, Push 2, Push 3, Push 4, Push 5, Push 6." Increase the force of your contraction as you exhale with each count. Apply as much force as possible.

6 Relax slowly and carefully place your hands in your lap.

7 Repeat this exercise 2 times, 2 times a day.

Suggestion: Do not hold your breath during the exercise. When pushing your head into your hands, do not reduce the force of contraction.

Precaution: If this exercise increases pain, or feelings of numbness or tingling, discontinue exercise and consult your physician or therapist.

Advanced Mild to Moderate Stretches

1. Assisted Neck Side Bend Stretch

2. Isometric "Contract-Relax" Assistive Neck Stretch

And then, progress to 5 Minute Neck Saver Exercises (Pg 219)

Assisted Neck Side Bend Stretch *mild*
(Ear Toward the Shoulder)

Purpose: To improve side neck bending motion by stretching muscles at the side of the neck.

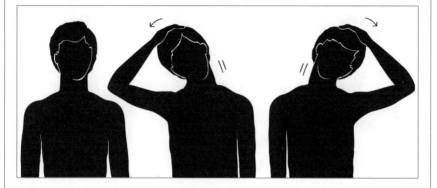

1 Sit in a **chin-in**, **head-up** position.

2 Breathe in and as you exhale bend your head with your right ear moving toward your right shoulder.

3 Raise your hand over your head and place your hand on the left side of your head on or above your ear.

4 Breathe in again and as you exhale use your hand to gently push your right ear toward your right shoulder.

5 Hold the s-t-r-e-t-c-h. Breathe in and out. Count "1001, 1002, 1003, 1004, 1005, 1006."

6 Relax.

7 Bring your right arm down and return your head to the **chin-in, head-up** position.

8 Repeat on the opposite side in a similiar manner, bending your left ear toward your left shoulder.

9 Repeat 2 times, 2 times a day.

Precaution: If this exercise increases pain, or feelings of numbness or tingling, discontinue exercise and consult your physician or therapist.

Isometric *Contract-Relax Assistive Neck Stretch *mild*

Purpose: To improve neck mobility which allows your head to turn with greater ease (especially important when driving).

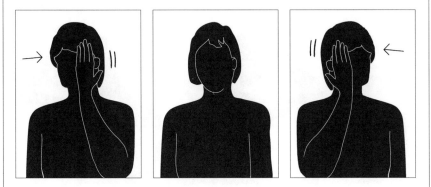

1 Begin *Assisted Neck Rotation* exercise (*See Page 210*)

2 When your left hand is on your left cheek as though it were to push your head to the right, slowly try to turn your head to the left (contract) while your left hand resists any head movement.

3 Hold and count "1001, 1002, 1003, 1004, 1005, 1006."

4 Release the pressure from your head movement and then, assisting with your left hand, gently turn your head further to the right.

5 Hold. Stretch. Breathe in and out. Count "1001, 1002, 1003, 1004, 1005, 1006."

6 Repeat 3 times.

7 Release & slowly bring your head back to a **chin-in, head-up** position.

8 Repeat the exercise on your left side by turning your head with your right hand.

9 Repeat 3 times, 2 times per day.

Precaution: If this exercise increases pain, or feelings of numbness or tingling, discontinue exercise and consult your physician or therapist.

**Contract-Relax: Relaxation takes place after a gentle contraction; contraction in one group of muscles allows other opposing muscles to relax.*

5 Minute Neck Saver Exercises

Save your Neck

When your neck pain is *mild* to *minimal* and you no longer want to deal with the pain in the neck, the *5 Minute Neck Saver* will help keep your neck in shape.

5 Minute Neck Saver Exercises

1. Start with the 1-2-3-2 "heads up" position (pg 143).

2. Beginning Shoulder Circles (pg 198)
- 3 repetitions forward and 3 repetitions backward.

3. Intermediate Shoulder Circles (pg 202)
-3 repetitions forward and 3 repetitions backward.

4. Elbow Touches (pg 203)
- 3 stretches forward and 3 stretches backward.

5. Neck Forward Flexion Stretch (pg 201)
- 3 repetitions.

6. Intermediate Neck Rotation (Over the Shoulder Stretch) (pg 205)
- 3 repetitions to each side.

7. Lateral Neck Flexion Stretch (Ear to Shoulder Stretch) (pg 206)
- 3 repetitions to each side.

8. Neck Extension Stretch (pg 207)
- 3 repetitions.

9. Neck Forward Flexion Isometric (pg 213)
- one 5 second hold.

10. Neck Lateral Flexor isometric (pg 214)
- one 5 second hold on each side.

11. Neck Extensor Isometric (pg 215)
- one 5 second hold.

Cautions

Remember, whether an exercise is to make you "Feel Good" or "Do Good," if it causes more discomfort than a stretch pain sensation, pain that lasts for more than two hours, pain that radiates into the shoulder or arm, or causes any numbness, stop the exercise. Wait at least forty-eight hours before carefully trying the exercise again. If any of these problems persist or recur, or if the pain is **SEVERE**, check with your physician or therapist before resuming any exercise.

If you can do the advanced neck and, if you need to, the shoulder exercises comfortably you are *ready* for fun and games!

Are you also having shoulder or arm pain?

YES:
Continue

NO:
Skip these exercises and
go to Exercises for Fun (pg 235)

Exercise for Sore Shoulders and Arms

Pain in the shoulder and arm is an all too common accompaniment of painful neck disorders. Shoulder pain in neck disorders is usually due to pain referred from the discs, muscles, ligaments or facet joints and only relatively rarely from an actual "pinched" nerve root in the cervical spine. Regardless of the cause, shoulder pain can result in stiffness and loss of shoulder motion and strength. Once shoulder motion has been lost, (we call it a "frozen shoulder") it can be difficult to get the motion back. It is important to try to maintain as much shoulder mobility as possible - neck and arm pain permitting. When pain has eased, shoulder exercises to restore any lost motion are essential.

The shoulder exercises in this section are designed to help prevent and restore lost mobility and strength as a consequence of shoulder pain. They should be done only if they can be performed comfortably and if they do not produce any aggravation of either arm or neck discomfort. The shoulder exercises should be implemented in a stepwise fashion depending on the severity of the shoulder pain.

Determine the severity of your shoulder pain by the criteria below:

SEVERE: Shoulder pain at rest or with slight shoulder movement

moderate: Shoulder pain during moderate daily activities - e. g. combing hair, dressing, driving

mild: Shoulder pain with unaccustomed or repetitive activity requiring vigorous lifting, carrying or stretching - e. g. heavy household chores, carrying luggage, resuming tennis or golf.

Be sure to note in the upper right corner of the exercise page that your shoulder pain level is correct for the exercise you have chosen.

Shoulder Exercises: Don't do any more than you need to

All of the shoulder motion stretching exercises may not be necessary for your shoulder problem. If only one shoulder is painful, you can check to see if your motion on the painful side is now equal to the "good" side. If that's the case, then you may not need to do that specific stretching exercise, or you may only wish to do it once daily for one to two repetitions in order to be sure that you are not losing any mobility that you have regained. Once your shoulder motion has returned to normal, it is usually not necessary to continue with the shoulder stretching exercises, but the shoulder motion restorers are always a good warm up stretch before a tennis match, bowling, housecleaning or any other activity that puts a strain on the shoulder.

Feel Good Stretching Exercises

 1. 1-2-3-2 Posture Positioner (pg 143)

 2. Shoulder Shrugs with Downward Stretch (pg 197)

 3. Shoulder Pendulum Stretch (pg 225)

 4. Beginning Shoulder Circles (pg 198)

The Hot and Cold Shoulder and Exercise

All vigorous exercise, and particularly all stretching exercises, are best accomplished when your muscles are warmed up. If you are having shoulder pain, a warm shower or a hot pack before

stretching and a cold pack afterwards helps to give you the best stretch with the least strain. After you exercise, do yourself a favor and give yourself the "cold shoulder" and a cold neck pack.

As with all exercises and treatments, it is best to have a health care professional determine the need for any exercise and to make sure that if the exercises are proper for you, and that you are performing them correctly.

Shoulder Stretcher Exercises

Shoulder motion stretching exercises are designed to stretch all of the ranges of motion of the shoulder. They are to be done in a stepwise manner beginning with "Feel Good." The shoulder stretchers are best initiated after the *Advanced Shoulder Circles (page 208)* can be done comfortably.

They are:

Shoulder Pendulum Stretches (page 225),

Beginning Shoulder Circles (page 198) and then progressing with

Intermediate Shoulder Circles (page 202) to the

Shoulder Stretch (Forward Flexion - Supine)(page 226) on to the

Advanced Shoulder Stretch (Internal Rotation)(page 219).

Shoulder Strengthening

When shoulder motion has been largely restored and shoulder movement causes mild to no discomfort, strengthening should commence. Once again, the strengthening effect is optimized by using isometric muscle contractions performed in a pain free position.

Shoulder Strengthening Exercises

Shoulder strengthening exercises help recondition the shoulder and arms and thereby prepare you for more vigorous activities and sports.

The old song about the knee bone connecting to the thigh bone applies equally well to the neck bones and the shoulder. Neck pain can trouble you without any shoulder or arm connection. Shoulder pain caused by tendinitis or arthritis does not involve the neck. But pain from the neck *is* commonly referred to the shoulder. So if both the neck and shoulder are involved the next set of exercises will help take care of the neck-shoulder "connection."

A Sore Shoulder is NOT FUN

If your neck symptoms are now **mild** to *minimal*, your shoulder may determine your ability to return to both work and recreational activities. A painful shoulder can be a real "pain in the neck."

Persistent neck and or shoulder discomfort and stiffness should always be given careful professional medical evaluation.

NOW, LET'S START YOUR
SHOULDER EXERCISES!

Shoulder Pendulum Stretch **SEVERE** to *mild*

Purpose: To increase shoulder range of motion. To warm up before more vigorous shoulder exercises.

1 Stand up.

2 Support yourself by leaning on a table top or on the back of a chair with your "good" hand.

3 Bend forward. Let the weight of your arm gently swing in a pendulum motion (or if you prefer, hold an object about 1-2 pounds, such as a purse or teapot, in your hand and swing it). Move your arm forward (flexion) and then backward (extension) approximately five times. Try to stretch as far as possible in each direction.

4 Next, make a circular motion with your arm, moving away from your body (abduction). Do this circular motion approximately 4-5 times.

5 Relax.

Precaution: Discontinue this exercise if there is an increase of pain or feelings of numbness or tingling.

Shoulder Stretch
(Forward Flexion - Supine) **SEVERE** to *mild*

Purpose: To stretch shoulder muscles. More specifically, to stretch the overhead reaching muscles of the shoulder.

1 Lie down on your back with a stick within easy reach. Use a cervical pillow and/or a soft collar for neck support.

2 Hold stick* with your hands close together, palms facing down.

3 Lift the stick over your head (trying to keep elbows straight), s-t-r-e-t-c-h-i-n-g your arms back as far as you can..

4 Hold stretched position and count "1001, 1002, 1003."

5 Relax and bring the stick back to your thighs.

6 Repeat 3 times, 3 times a day.

*May be done *without* a stick by lifting both your arms together; or, if you prefer, lift one arm at a time. Try to keep your elbows straight and s-t-r-e-t-c-h your arms back as far as you can.

Precaution: If this exercise increases pain, or feelings of numbness or tingling, discontinue exercise and consult your physician or therapist.

Shoulder Stretch (Internal Rotation) *moderate* to *mild*

Purpose: To maintain or improve range of shoulder motion.

 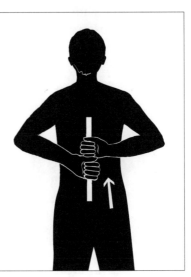

1 Stand, or if you prefer, sit down with stick.

2 Place stick behind your back with hands touching and palms facing upward.

3 Slide stick up your back as far as possible.

4 Hold s-t-r-e-t-c-h-e-d position with stick and count "1001, 1002, 1003."

5 Slide stick down your back to starting position.

6 Relax.

7 Repeat 3 times 2 times a day.

Precaution: Discontinue this exercise if there is an increase of pain or feelings of numbness or tingling.

Shoulder Stretch
(Abduction and External Rotation)

moderate to *mild*

Purpose: To maintain and improve range of shoulder motion. To improve posture. To s-t-r-e-t-c-h chest muscles.

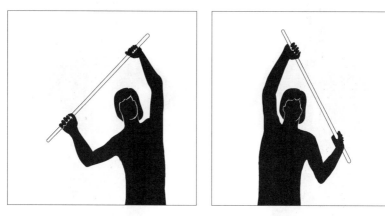

1 Stand up, or if you prefer, sit down with a stick in your hands.

2 Hold the stick with the palms of your hands facing downward and about 16 inches apart at thigh level.

3 Lift the stick over your head as far as possible, keeping your elbows straight.

4 Let elbows relax a little.

5 Sway stick to your left side and s-t-r-e-t-c-h. Hold stretched position. Breathe in and out. Count "1001, 1002, 1003, 1004, 1005, 1006."

6 Sway to your right side creating an arc motion with the stick overhead. Hold s-t-r-e-t-c-h-e-d position. Breathe in and out. Count "1001, 1002, 1003, 1004, 1005, 1006."

7 Repeat swaying from your left to your right side two more times.

8 Bring the stick back to your thighs. Relax.

9 Repeat 2 times a day.

Precaution: If this exercise increases pain, or feelings of numbness or tingling, discontinue exercise and consult your physician or therapist.

Advanced Shoulder Stretch (Internal Rotation)

moderate to *mild*

Purpose: To maintain or improve range of shoulder motion.

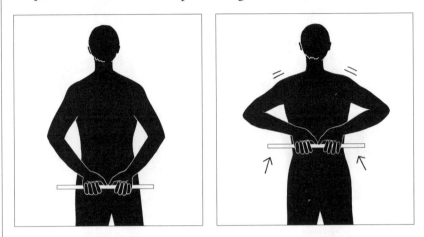

1 Stand, or if you prefer, sit down with a stick in your hand.

2 Place the stick behind your back with your palms facing upward and hands touching.

3 Slide the stick up your back as far as possible.

4 Hold s-t-r-e-t-c-h-e-d position with the stick. Breathe in and out and count "1001, 1002, 1003."

5 Slide the stick down your back to starting position.

6 Relax.

7 Repeat 3 times 2 times a day.

Precaution: If this exercise increases pain, or feelings of numbness or tingling, discontinue exercise and consult your physician or therapist.

Advanced Shoulder Stretch (External Rotation)
moderate to *mild*

Purpose: To maintain or improve range of motion in shoulders.

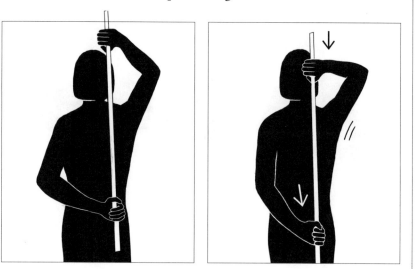

1 Stand, or if you prefer, sit down with a stick.

2 Place the stick behind your back in your left hand with your palm downward at the bottom of the stick (at the level of your buttocks). Place your right hand with the palm upward at the top of the stick (above your right shoulder).

3 Pull your right arm down behind your back as far as possible. Hold this s-t-r-e-t-c-h-e-d position. Breathe in and out, and count: "1001, 1002, 1003".

4 Relax.

5 Repeat this exercise 3 times, 2 times a day.

6 If indicated repeat the exercise by placing your right hand at the bottom of the stick and your left hand at the top of the stick.

Precaution: If this exercise increases pain, or feelings of numbness or tingling, discontinue exercise and consult your physician or therapist.

Shoulder Blade Strengthening (Isometric Adductor) *SEVERE* to *moderate*

Purpose: To strengthen shoulder blade muscles. To improve posture. To use muscles which stimulate bones to retain calcium.

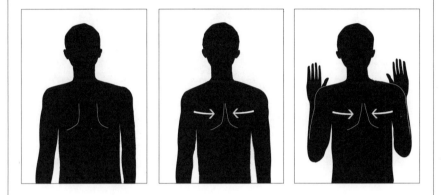

1 Stand or sit with the palms of your hands on your thighs.

2 Assume a **chin-in, head-up** posture.

3 Pinch your shoulder blades firmly together without raising your hands. Do not shrug your shoulders.

4 If this movement is comfortable, bend your elbows and raise your hands to shoulder height. The palms of your hands will be facing forward.

5 Pinch your shoulder blades firmly together.

6 Hold and count out loud "Push 1, Push 2, Push 3, Push 4, Push 5, Push 6." Do not hold your breath.

7 Relax.

8 Repeat 2 times, 2 times a day.

Precaution: If this exercise increases pain, or feelings of numbness or tingling, discontinue exercise and consult your physician or therapist.

Shoulder Blade Strengthener (Isometric Abductors)

moderate to *mild*

Purpose: To strengthen muscles that move and support the shoulders.

1 Sit down.

2 Place soft belt or sash loop slightly above your elbows.

3 Rest your upper arms on your ribs, with your forearms and hands in your lap.

4 Push your upper arms away from your chest stretching the loop slowly and forcefully.

5 Hold this stretched position and count out loud: "Push 1, Push 2, Push 3, Push 4, Push 5, Push 6." Do not hold your breath.

6 Relax.

9 Repeat 2 times, 2 times a day.

Precaution: Discontinue this exercise if there is an increase of pain or feelings of numbness or tingling.

Shoulder Strengthener (Isometric Flexors) *moderate* to *mild*

Purpose: To strengthen flexors (shoulder muscles).

1 Stand up.

2 Place a soft belt or sash loop slightly above your wrists.

3 Rest your arms on hip bones in front of you with palms of your hands touching thighs.

4 Keep your left arm down against your body.

5 Keeping your right elbow straight and the palm of your hand down, lift your arm straight up against loop.

6 Stretch loop up slowly and forcefully.

7 Hold belt or loop in stretched position and count "Push 1, Push 2, Push 3, Push 4, Push 5, Push 6." Do not hold your breath.

8 Relax.

9 Repeat shoulder strengthening exercise with your left arm lifted straight up against the loop.

10 Repeat 2 times, 2 times a day.

Precaution: Discontinue this exercise if there is an increase of pain or feelings of numbness or tingling.

Chapter 11

Exercises for Fun

Sports

EXERCISE, LIKE MOST HUMAN ACTIVITIES, COMES IN A WIDE VARI-
ETY OF SIZES, SHAPES AND FORMS. We have already taken a good
look at the exercises to help the neck "feel good" and help the
neck "do good." These exercises are specially designed to relieve
pain, recondition the neck and help keep neck pain away. We
have also learned the 1-2-3-2 "heads up" exercises. Now if your
necks and arms are comfortable and any numbness, tingling, or
weakness has subsided or stabilized in a *mild* form, you should
be ready to exercise for general physical and cardiovascular con-
ditioning, for sports and for fun.

"SAFE" Sports for Sore Necks

Before attempting any new exercise or sport, it is essential that
you ask yourself the question, "Is it **SAFE**?"

For an exercise to be **SAFE**, it must meet the following criteria.

"SAFE" Sports

Have You:

S = strength enough?

A = agility enough?

F = flexibility enough?

E = endurance enough?

When you think about getting back to "sports," the exercise can
be anything from downhill skiing to swimming laps, or cross
country running to shooting pool. The question that you have to
ask is, "Are these exercises safe enough for my neck?" Activities
that involve twisting the head, risk of falling, or prolonged awk-
ward head, neck and body positioning are best avoided until the

neck pain is well behind you. They are best avoided indefinitely if you had a **SEVERE** nerve root or spinal cord injury. The easiest advice to give anybody who has ever had a painful musculo-skeletal problem is, "Whatever it is, don't do it." The best advice to give the person in that situation is, "Let's see what you can do that is apt to meet your exercise and recreational objectives with the least risk of reinjury to your neck." The best test for exercise readiness is your ability to comfortably perform neck warm up exercises.

The "SAFE" Warm Up Test

The best test of your neck's readiness for more action is the five-minute *Neck Warm-up Exercises (See page 238)*. When you can perform all of these exercises with minimal or no discomfort, you are ready to start your favorite mild sport. Start slowly and play vigorously only after you've been able to play at "half speed" with no more than natural post-exercise stiffness and soreness. Once you've had success with an easy sport, move on with the same precautions to more demanding athletic activities.

Warm-Ups and Cool-Downs

Any coach, trainer, or competitive athlete will tell you that the best protection against injury and the best way to maximize per-formance is to warm up before you start your sport. Warming up gets the blood circulating, clears the head, helps you relax, and above all, stretches and prepares the muscles and joints for action. If you have a neck problem, the warm-up also has to focus specific attention on the structures that support, stabilize and move the neck. So, a walk, a jog, and a gentle overall stretch of your body for about five minutes should get you ready, provid-ed that your overall stretching exercise routine does not put undue stress on your neck.

Once you are warmed up generally, and even during the warm up, it is time to pay specific attention to your neck. This is also

the time to remind yourself of the 1-2-3-2 posture because a well-aligned head and neck will not only minimize neck strain but it also can give you that "heads-up" balanced posture to enhance your competitive edge.

The *Neck Warm Up Exercises* are a series of shoulder and neck stretches designed to get the kinks out before you start to play. The *Neck Strengthening Exercise*s that are part of the *5 Minute Neck Saver* exercises need not be included as they are not necessary for your warm up stretching.

The *Basic Neck Tension Relievers* and the *Shoulder Stretchers* are great exercises to prevent the buildup of neck muscle tension during the day. Use them frequently, even before you feel the neck and shoulder muscle tension building when at your desk (especially working on a computer), watching T.V., at the movies, or when you have come to a stop in your car.

Neck Warm-up Exercises

Always start in the 1-2-3-2 posture. (pg 143)

Basic Neck Tension Relievers

1. *Shoulder Shrugs with Downward Stretch (pg 197)*

2. *Beginning Shoulder Circles (pg 198)*

Initial Warm Up Exercises

3. *Beginning Neck Rotation (pg 200)*

4. *Neck Forward Flexion Stretch (pg 201)*

5. *Intermediate Shoulder Circles (pg 202)*

6. *Elbow Touches (pg 203)*

Final Warm Up Exercises

7. *Advanced Shoulder Circles (pg 208)*

*8. Intermediate Neck Rotation Stretch
(Over-the-Shoulder Stretch) (pg 205)*

9. Lateral Neck Flexion Stretch (Ear To Shoulder Stretch) (pg 206)

10. Neck Extension Stretch (pg 207)

Do one to three repetitions of each of these exercises to complete your warm up.

These warm up exercises should be comfortable for you to perform. After you do them, you should be ready to play and to win. If any of the exercises causes discomfort, then it may not be your day for sports; or it may be that you will need to hold off for a while until your neck has further improved.

Remember that any pain in the neck can be an important message. If your neck is giving you some twinges, you may be able to shrug them off, but if it is anything more than that, it may be a message that tells you that your neck can't be ignored for now, lest you really get a pain in the neck.

The Safe Sports for Sore Necks

After you determine that you are **SAFE** (*See page 236*) enough for the sport in mind, and you have checked out the warm-up and neck limbering exercises, what are the sports for you? By now, you have probably already decided on the kinds of sports and games that you enjoy and you will want to continue to do them if your neck will let you.

Any sport that produces neck jostling, wrenching, repeated or sustained awkward positioning, or a high risk of falling and injury is a sport that can get you in the neck.

Walking and Jogging

Even walking, if you do it with your chin sticking out in a deter-
mined manner, may be stressful for your neck, and particularly so
if you are walking up and down hills and over rough terrain. For
walking to be successful, the 1-2-3-2 posture is critical. The same
thing applies to jogging. The impact of jogging can be too jar-
ring for your neck. If a soft terrain, cushioned shoes and a short-
ened stride are not sufficient to lessen the impact, jogging may
not be for you. No matter what the sport, be sure to warm up
properly, wear a soft collar initially, and cool off with a cold pack
afterwards.

Tennis

Tennis, with the "heads up" 1-2-3-2 posture and a good steady
stroke, can be well tolerated by mildly sore necks; however, you
may have to avoid the high overhead shots and the power serve
in which your head is thrust backward and then down.

Golf

Keep your head down and your eye on the ball! The head pos-
ture in golf has to be carefully considered. Whether putting,
chipping, or driving, you have to keep your head down. But it
doesn't have to stay down any longer than necessary. Your stroke
may have to be shortened to one that turns the body squarely
and does not cause twisting in your neck. Most golfers with sore
necks do get back in the swing.

Bowling

Bowling (and horseshoes) pose problems similar to golf. With
good 1-2-3-2 head positioning posture (and if in doubt, a soft
collar) these sports can usually be resumed when neck symptoms
are mild.

Tai Chi, Yoga and Karate

Tai Chi and Yoga, if done in a neck-protected fashion, are excellent overall exercises and provide a component of relaxation as well. Karate can be enjoyed successfully but the vigor of karate performance makes the chance for neck strain, falling and injury very real. Karate should only be attempted after neck and nerve problems have been well healed. Yoga exercises can be readily adapted for both neck and back problems. Obviously head stands are out if you have a sore neck, and extreme neck positioning, either flexed, extended, or rotated, can only be gradually resumed when neck symptoms are minimal. Yoga does provide an excellent opportunity for meditation and relaxation and general stretching. Of the three activities, Yoga and Tai Chi are generally the easiest and safest when your neck symptoms have improved to the *mild* level and you can perform all of the neck warm up exercises.

Weight Lifting and Gym Workouts

Getting back on a conditioning program is usually successful if the 1-2-3-2 head posture body alignment, and a gradual increase in strengthening exercise is observed. Start light, with a few repetitions and build gradually. Exercise every other day to allow your body to recuperate from and then rebuild following a vigorous workout.

Bicycling

Bicycling is a good overall, well tolerated exercise. Biking in the crouched position can keep your neck under constant strain and this can be compounded by the jostling from biking on rough terrain. If you are a biker and you don't want a pain in the neck, start out with a stationary bike with the seat and handle bar adjusted so that you can pedal in an upright 1-2-3-2 posture. When you can handle that comfortably, then move along to an outdoor bike that keeps your head up and your neck safe. Make

sure your helmet is right for you. Save biking in the mountains for last.

Dancing

Let your neck call your tune. When you first get back on the dance floor, be sure that the music is smooth, and so is your dancing.

You can choose to dance in a variety of ways: ballroom, salsa, tap, modern and folk dancing. But you must also use your head to spare your neck, whatever style you choose. Folk dancing, for example, can be anything from a slow square dance to an any-thing-but-square Highland fling. Aerobic jazzercise dancing can give you a great workout, but aerobic jazzercise dancing like the Highland fling, is best put off until your neck symptoms have been *mild* for a month or more and you can do the full warm-up neck program. The chances are good that if you're not ready, jazzercising or any vigorous dance will be a pain in the neck.

Skating

Whether it is ice skating or rollerblading, if you have good bal-ance and good posture and you keep it smooth, your neck will thank you. Unfortunately, most skating areas require dodging other skaters or pedestrian traffic so that the risk of stumbling and/or falling is very real. So skating can be fun and pain-free, but be sure that you are SAFE.

Swimming

For most musculoskeletal disorders, and neck pain is no excep-tion, swimming offers an excellent exercise activity - but noth-ing's perfect. If you are not a good swimmer, then there is the possibility that thrashing and twisting your body and neck in the water may cause neck pain and undo any benefit that you might otherwise get. Your stroke should allow you to keep your face down. It is advisable to start out swimming with a snorkel and

possibly a flotation vest so that you don't have to twist your head and neck to breathe. Modifying your freestyle stroke by rolling your body so that your arm swings out over the water rather than bending upward can often relieve arm and shoulder discomfort. When you are no longer using the snorkel, then twisting (rolling) your whole body rather than just your head to breathe, will also minimize neck strain. Side stroke on your comfortable side and freestyle swimming are your best strokes. The back stroke may work; the breast stroke is generally not well tolerated, at least until you are fully recovered. Diving and surfing, let alone water skiing, are best avoided. If you love those activities, avoiding them may be a pain in the neck, but if you try them, you are almost sure to get a pain in the neck.

Rowing, Kayaking, Canoeing and Sailing

If we have learned anything recently, it's that *white water can be dangerous*. Obviously kayaking in white water is a dangerous sport in many ways and even when you haven't rolled over, your sore neck is never trouble free. Kayaking and canoeing in smooth waters with attention to head and neck posture can be well tolerated and enjoyed and the same applies to rowing, motorboats and sailing.

Fishing

If the fish are not biting, by and large that's the only pain in the neck you'll have. But if you are working hard casting, hauling heavy gear, or trying to land a vigorous fighting fish, it is pretty hard to keep your neck out of the action. You can do it, but you have got to work at it and it is probably wise to have a soft collar on as a reminder, just in case you catch a fish. When the fish don't strike, that's a pain in the neck, but if the fish do strike, don't stick your neck out.

Sports Too Numerous To Mention and Sports Not Worth Talking About

There is a sport for almost anyone, sports for almost everyone, and there are sports for almost no one; but there is not a sport for everyone's neck. So, some sports that are not worth mentioning if you have a neck problem or previously had a severe problem are football, basketball, boxing, wrestling, waterskiing, windsurfing, hang gliding, and parachute jumping. Surely there are others, if you really want to stick your neck out.

There are many sports that we consider to be relatively sedentary and not apt to cause injury, but they can still be a pain in the neck — and that includes just being a spectator.

Watch Out For Your Neck While You're Watching The Game

If you are a sports fan, there is no way to dodge it. You are bound to find yourself at the game with your heart, your soul, and your neck in on every play. You will be sitting on a bleacher or folding chair, your back won't be well supported and your head and neck will feel the strain. It is also a pretty safe bet that if you are on the short side, that some tall fan or a not-so-tall fan with a tall hat will sit right in front of you and you will have to crane your neck from side-to-side to see the action. If your neck pain is more than *mild*, get a seat in the shade if you can, to avoid glare. Take your binoculars. Avoid sports like tennis where your head is moving back and forth repeatedly. Take along an extra back support, do your "Feel Good" exercises, take your soft collar, and stay in the 1-2-3-2 "heads-up" neck-protected posture.

No matter how sedate the activity, whether it be archery, target shooting, lawn bowling or darts, if you place your head and neck in stressful positions repeatedly or hold a stressful posture for prolonged periods of time, or even if you are a spectator and not a player, win, lose or draw, you can suffer a pain in the neck.

So, BE SAFE. Warm up, keep your HEAD UP, and play for fun and to win!

Conclusion

So it's just another pain in the neck - is that all? Perhaps. There are all kinds of pains in the neck — from the next door neighbor, to the neck pain of a severe whiplash.

Neck pain can have many causes. Most neck pains will resolve if given a chance. Your neck pain needs your help and the help of your doctors and therapists. But by and large, as I so often tell my patients, if you understand the severity of your neck pain problem you can then play the major role in helping to heal it.

Neck Relief Now! gives you the benefit of many years of research, patient care and patient education at the Arthritis and Back Pain Center. *Neck Relief Now!* represents the essence of what we have learned and have found helpful in treating patients with neck pain problems. *Neck Relief Now!* can help you put your neck pain to rest!

Neck Relief Now!

Resources

Cequal Products
1328 Sixteenth Street
Santa Monica, CA 90404
(310) 458-1102
(310) 458-0444
1-800-860-3949
www.cequal.com

Manufacturers of the Swezey Institute recommended line of posture fitness products including The BedLounge®, AdaptaBak® (go-anywhere adjustable back cushion), OsteoBall® (osteoporosis bone formation exercise program), and the Swezey Institute's books, videos, and audiotapes. Call for brochures.

Crown City / The Natural Bedroom
11134 E. Rush Street
South El Monte, CA 91733
(626) 796-9101

Fine quality, superbly supportive mattresses. They manufacture their own. Call for brochures.

InteliHealth Healthy Home
97 Commerce Way
Dover, DE 19903
1-800-988-1127
www.intelihealth.com/store

Extensive line of "health care products from healthcare experts". Call for their catalog or visit their informative website.

BackSaver.com, Inc.
840 Apollo Street, Suite 314
El Segundo, CA 90245
1-800-222-5728
www.backsaver.com

An on-line resource for back & neck relief products, along with a
diverse selection of pillows, recliners, and ergonomic seating
options.

Gaiam, Inc.
360 Interlocken Blvd., Suite 300
Broomfield, CO 80021
1-800-869-3446
www.gaiam.com

Well-chosen line of health and yoga products with a emphasis on
natural fibers and eco-friendly items. Actually, several lifestyle
catalogs under the umbrella of Gaiam. Visit their website for
more information.

Discovery Health Catalog
8145 Holton Drive
Florence, KY 41042
1-800-627-9419
www.discoveryhealthstore.com

Part of the Discovery Channel's website covering a wealth of
information on health issues and questions. The on-line health
store portion of the website consists of wide array of useful and
healthful products. Visit the website.

Alimed Ergonomics & Occupational Health
297 High Street
Dedham, MA 02026
1-800-225-2610
www.alimed.com

Catalog of ergonomic supplies for the workplace. A nice variety
of office aids, keyboards, etc.

Hello Direct
5893 Rue Ferrari
San Jose, CA 95138
1-800-444-3556
www.hellodirect.com

Telephone headsets and hands-free telephone accessories. Call
to request catalog.

Magellan's
P.O. Box 5485
Santa Barbara, CA 93150
1-800-962-4943
www.magellans.com

Catalog supplier of travel accessories including pillows, luggage,
etc.

Relax The Back Stores
880 Apollo Street, Suite 353
El Segundo, CA 90245
1-800-290-BACK
www.relaxtheback.com

Retail stores devoted exclusively to neck, back and wrist pain
relief products and ergonomic solutions. Stores now in most
major cities and growing nationwide. Call for the nearest loca-
tion or visit their website.

Sammons Preston
P.O. Box 5071
Bolingbrook, IL 60440
1-800-323-5547
www.sammonspreston.com

Long-handled reacher and other neck relief and assistive aids.
Call to request their catalog.

Select Comfort
6105 Trenton Lane North
Minneapolis, MN 55442
1-800-831-1211
www.comfort.com

Manufacturers of the premiere adjustable air mattress system
known as the Select Comfort Sleep System. Call for free video
and brochure.

Neck Relief Now!

Index

A

ability to feel
- *heat or cold* 91
- *light touch* 91
- *pain* 91
ability to function 60
abnormal disc 99
accident 88
aching 190
acupressure 46, 72, 107
acupressure therapists
72
acupuncture 34, 46, 59,
72, 81, 113
- *points* 72
- *therapists* 72
adam's apple 2, 22
adaptive equipment 72
addiction 129
adjustable chair 152
adjustable surface 174
adjusting misaligned
vertebrae 70
adjustment knobs and
levers, chair 161
adjustment of chair
arms 151
adhesions 188
adrenal glands 134
Advanced Shoulder
Stretch (External
Rotation) **230**
Advanced Shoulder
Stretch (Internal
Rotation) **229**, 233
Advanced Shoulder
Circles **208**
age 32
aging 21
aging population 78
AIDS 42, 101, 113
airport 186

aisle seat 186
alcohol 183
alignment 142
allergy 129, 131
allergic effects 128
allergic reactions
128, 129, 131
American Pain Society
80
American Academy of
Pain Management 80
Analgesics 62, 64, 182
- *(pain relieving)*
salves 132
- *medication 182*
- *ointments 135,*
136, 137
anatomy 2, 76
anesthetist 61, 63, 66
anger 15
angry 60
ankylosing spondylitis
41, 42, 92, 93
anterior approach 76
antibiotics 78
antidepressant
medication 34, 47
antidepressants 131,
135, 136, 137
antihistamines 62, 64
anti-inflammatory
drugs 92, 128, 131
anxious 60
arm 4, 13, 17
- *rests 161, 163*
- *strain 172*
- *support 173*
arteries 3, 40
arthritic knee or hip
joint replacements 73
arthritis 4, 12, 32, 41,
48, 92, 94, 121, 224
- *conditions 68*
- *specialist 43*

artificial joints 108
asleep 185
Assisted Neck Forward
Flexion Stretch (Head
Hang) **209**
Assisted Neck Rotation
210
Assisted Neck Side
Bend Stretch (Ear
toward the Shoulder
Stretch) **217**
athletics 63
atlas 5, 7
atmospheric
contamination 106
atrophy 89
attorney 30
audiotapes 119
automobiles 184
axis 5, 7

B

B27 positive, negative
93
babies 165
back (Lumbar) support
163
back flat 166
back seat support 60
back pack 175
back strain 48
back support 177
balance 126
balanced 142
balanced alignment
144
balancing a book 142
ball games 179
barber shop 111
base of the skull 109
bathroom 153

- equipment 154
rinsing mouth 155
bed 179
twin bed 62
bed reader 183
BedLounge® 183
bedside tables 183
Beginning Neck
Rotation **200**, 238
Beginning Shoulder
Circles 191, **198**, 219,
222, 223, 238
biceps muscle 14
tendon reflex 14
bifocal 66, 172
biofeedback 47, 80,
119
bladder 92
- irritability 47
blankets 179, 180
bleeding 139
blood 6, 92
- cells 92
- clotting 128, 139
- count 92
- pressure 89, 139
- supplier 22
- tests 59, 92
- vessels 12, 17
Board-Certified
specialist 69
body wraps 120
bolsters 183
bones 3, 6, 7, 9, 96
- hypertrophy 13
bony
- fusion 48, 76
- proliferations 97
books 119
bowling 193
brace 28, 61, 62, 63,
110, 112, 118, 155,
177, 185
brace fitter 112

brachial plexus 17
bracing 8, 50, 59, 71,
72
brain 11, 14, 22, 35,
78, 117
- and nerve pathways
122
- and spinal cord 74
- function 30
- injuries 68
- trauma 69
bras 176
breast bone 6, 17
breathing slowly 61
brightness controls 174
briefcase 175, 184
broad shoulder strap
176
bulging discs 12, 138
bulkhead or aisle seat
185
bulky packages 177
bunion 31
burns 105
bursae 133
bus 186
buttocks 144
buyer beware 80

C
caffeine 127
calcium 6, 121
calories 121
canals 8, 40
cancer 101
car 177, 184
new 161
seats 161, 184
shock absorbers 10
trunk 178
wash 168

cardiac pacemakers 95,
96, 108
carotid artery 4, 22
carpet 170
casters 149, 170
CAT scans 31, 32, 59
catalogues 175
cats 169
cautery 114
caveat emptor 80
cervical
- brace 111
- bracing 112
- collar 8, 57,
110, 185
- disc 28
- discography 99
- nerve root 12
- nerves 14
- pillow 58, 62,
64, 66, 184
- radiculopathy 69,
74, 83, 111
- spondylolisthesis
50, 90
- traction 109
- vertebrae 2, 7,
27, 94
C1 (first cervical
vertebra) 7
C2 (second cervical
vertebra) 7, 8
C7 (seventh cervical
vertebra) 8
chair 36, 118, 146, 148,
149
- adjustments 151
- arms 151, 171
- back angle 151
- back height 151
- comfortable 149
- legs 153
- upper back 150
- waterfall edge 150

channels 8, 77
chemicals 190
chemical changes 122
chill 61, 64, 66
chin 15, 142
chin-in, head up
 position 197, 198,
 199, 200, 202, 203,
 204, 206, 207, 208,
 209, 210, 212, 213,
 214, 215
chin out 15
chiropractic 34, 70
Chiropractors (DC) 70
choking 15
cholesterol 121
chores 176
chronic
 - *fatigue 47*
 - *neck pain 113*
 - *pain 30, 80*
 - *pain disorders 80*
 - *viral diseases 47*
circulation 190
circulatory changes 17
classroom 167
clinician 91
clinics 72
clothes 176, 184
clots 78
 - *in joints 139*
 - *in the lungs 78*
cold 71
cold compresses 58,
 61, 104, 105
cold packs 35, 104,
 187, 193
cold shoulder 193
collar 163, 164, 165,
 166, 179
collar bones 15, 17
comfort straps 176
compensation 30
complications 77, 99

compresses 105
computer 96, 146
 - *work station 36,*
 173
 - *screen 172, 173*
Computerized Axial
 Tomography 95
congenital anomalies
 76
congenitally fused
 vertebrae 49
conservative treatment
 69, 74, 75, 97
constipation 129, 132
consulting specialist 91
conventional medical
 practices 81
coordination 126
cortisone 138
 - *side effects 139*
cosmetic appearance
 111
costs 30, 96
couch 118
cough medicine 62, 64
coughing 62, 64
counselling 60
counter-irritating 133
COX-2 NSAID 131
cradle the phone 67
crane your neck 65
crib 165
 - *rail 165*
cricoid cartilage 22
crippling 44
 - *arthritis 40*
CT scan 94, 95, 96, 98,
 100
cure 130
cutting 168

D
damage
 - *to the nerves 99*
 - *to the spinal cord*
 78
danger signals 26,
 68, 81
Daniel David Palmer
 70
death 116
deep breath 19
deep breathing 17
deep heat 114
deep kneading massage
 107
deep, slow breathing
 118
degenerative 21
 - *arthritis 36*
 - *changes 32*
 - *osteoarthritis 40*
degrees of motion 20
dens 7
dental bite plate 110
dental or jaw disorder
 109
dentist 61, 62, 63, 65,
 110, 111
depressed mood 34,
 132
depression 127, 131,
 139
desk 36, 148, 170, 171
diabetes 78, 139
diagnosis 58, 68, 87
 - *and treatment 89*
diagnosticians 75
diaphragm 13
diathermy 71, 113, 114
diet 58, 83, 121
 good diet 47
 low fat 121

dining out 179
disability 30
discs 4, 12, 21, 27, 28,
 29, 32, 40, 97, 99, 115,
 134
 - *degeneration 32*
 - *disorders 68, 139*
 - *protrusion 74, 95*
 - *removal 76*
 - *stresses and strains*
 192
discography 99
 - *complication 99*
disease 74
DISH 48
dislocations 10, 49, 115
disorders of the nervous
 system 69
display terminal 174
disposable needles 113
Disseminated
 Idiopathic Skeletal
 Hyperostosis 49
dizziness 131
dizzy 4
DO'S 61, 63
"Do Good" Neck
 Stretching Exercises
 190, 191
"Do Good"
 Strengthening
 Exercises 191
doctor 23, 29, 32, 61,
 62, 63, 65, 66, 82, 88,
 89, 101, 109, 122
document holder 173
dogs 169, 170
DON'TS 61, 62, 67
doors 168
dorsal spine 43
DOZE 61, 62, 66
drawers 168
dressing 155
drinking

 - *long straw 161*
driving 71, 161
 long drive 130
drowsiness 132
drugs 42, 126, 128
 See Medications
 - *abusers 42*
 - *compounds 129*
 - *stores 104*
drugless
 - *pain relief 108*
 - *pain relieving*
 therapies 104
drying hair 154
dry mouth 132
dura 12, 138
DXA 44
dye injection 99

E
ear 17
 earlobe 142
Ear to Shoulder Stretch
 (Lateral Neck Flexion
 Stretch) **206**
Ear toward the
 Shoulder Stretch
 (Neck Side Bend
 Stretch, Assisted)
 217
easing exercises 57
eating out 178
economic needs 80
 - *worries 35*
eight cervical nerves 13
elastic 11
elbows 161, 170, 183,
Elbow Touches **200,**
 238
Elbow Push Isometric
 193, **212**

electric razor 154
electric toothbrush 155
electrical stimulation
 59, 71, 80, 100
electricity 83
electrodiagnosis 34, 50,
 59, 99
 electrodes 100
electrodiagnostic stud-
 ies 59, 100
electromagnetic
 energy 114
electronic
 techniques 119
electronic
 thermometer 119
elevated sedimentation
 rate 92
elevation of blood pres-
 sure 131
emergency 57
emetics 114
EMG - electromyo-
 graphy 100
emotional stress 47
endorphins 107, 113
environmental
 needs 80
epidural 138
 - *injections 138*
 - *space 12, 59, 138*
 - *steroid injections*
 139
epidural/nerve root
 135, 136, 137
ergonomic 37, 38, 58,
 61, 71, 146, 147, 163,
 167, 175
 - *chair 152*
 - *efficiency 64, 66*
 - *guidelines 72*
 - *seating 152*

ergonomically efficient work environment 174
esophagus 2, 4
euphoria 139
examination 89, 91
excitement 15
exercise 47, 65, 67, 71, 75, 80, 83, 120, 168
- *session 105*
- *therapy 68*
- *with braces 14*
exercises 111, 180
extendable handles 168
extendable mirror with magnification 154
extended neck muscle list 16
extensors 208
extra-high basket 176
eye strain 37, 60, 171
eyeglasses 36, 171

F

facet 12
facet joints 11, 20, 21, 31, 40, 78, 94, 97, 115, 135, 138
facet joint injections 134, 138
facial artery 16
facial muscles 15
faint 4
falling 126
family member 106
family physician 68
fanny pack 176
fatal 78
faucet 169, 170
favorable results 77
fear 15

feeding 169
"Feel Good" Exercises 190, 194, 220, 236
"Feel Good" Stretches 191, 222, 223, 244
feet 150, 153, 168
feet first 166
fever 42
fibromyalgia 45, 46, 47, 50
fibrositis 46
fibrous tissue 10
financial stakes 31
fingers 15
fingertips 14
- *support 173*
Firm Friendly Hand 150, 163, 172
First Do No Harm 75, 121
first law of medicine 75
flexed neck muscle list 16
flexible straw 155
flexors (shoulder muscles) 222
foam rubber 110
folded pillow 180
followup 77
footstool 150, 153
foramen 77
foramina 13
foraminotomies 78
forearms 172
- *supports 173*
fracture 6, 43, 44, 96
frostbite 104, 105, 106
frozen corn, peas 105
function 30
functional activities 148
fusing two vertebrae 76

G

gallbladder 44
garage 167
gardens 165, 166
genetic predisposition 93
gentle mobilization 59
gentle strengthening 213
germs 42
glare 37
glasses 37, 60, 61, 63, 66, 172, 174, 183
goiters 22
gout 41, 43, 83
grandparents 164
gravity and balance 142, 143, 147
grooming 169
gym equipment 192

H

hairdresser 61, 62, 63, 65
hairwashing 154
 blow dry 154
 drying 154
halter 110
halter-like device 109
hand 13
handling 169
hands-on therapies 72, 114
 chiropractic 70
hangers 176
hangman's noose 13
hatchbacks 177
head 142

Head Hang (Assisted Neck Forward Flexion Stretch) **209**
head rest 162, 163
"heads-up" posture 147, 164, 168, 176
1-2-3-2 66
1-2-3-2, feet first 61, 64, 154
healing 28, 122, 139
healing process 28, 139
health care professionals 80
hearing 131
hearing aid 61, 63, 66
heart disease 101
heat 58, 71
heating pads, electric 105
herbs 83, 114
pill 82
herbal medicine 81
herbs or drugs 83
history 59
history of your neck problem 89
HLA B-27 test 93
hoeing 166
holding 20
holistic approach 80, 81
holistic medicine 80
home therapy 58
home treatment 106
homemaker 37
hose 167
- extenders 169
horse races 179
hospital outpatient procedure 138
hot packs 105, 222
hot springs 120
household activites 30
housecleaning 193

Hydrocollator 105
hyoid bone 20, 22
hyperostosis 48
hyperstimulation analgesia 106, 107, 108, 113, 115

I

ice 58
- cubes 106, 187
- in a plastic bag 105
- massage 105
- massager 105
idiopathic 48
immune system 42
- mechanisms 122
impaired circulation 78
implanted metal equipment 96
indigestion 131
infections 4, 42, 139
infection rate 78
infectious discitis 41, 83, 92
inflammation 12, 92
inflatable headrest pillow 155, 163, 185
informed consent 78
injections 12, 95, 135, 136, 137
- for pain relief 131
- into the spinal canal 98
- of cortisone 59, 134
- of local anesthetics 59
injury 10, 12, 21, 30, 34

injured client's attorney 30
injured nerve in the neck 100
injurious 72
injury to arteries 78
- to carotid 78
- to vertebral 78
insect bites 114
Intermediate Neck Rotation (Over the Shoulder Stretch) **205**
Intermediate Shoulder Circles **202**, 219, 223, 238
intermittent traction 109
internal medicine 68, 69
intestines 129
intolerable pain 80
- neck pain 129
- symptoms 139
intramuscular injection 139
invasive therapy 95
Isometric Adductor (Shoulder Blade Strengthening) **232**
Isometric Contract-Relax Assistive Neck Stretch **218**
isometric strengthening exercises 111, 193
Isometric Flexors (Shoulder Strengthener) **233**

J

Jackson Cervipillow
 179
jaw 13, 17, 22, 109
joint alignment 115
Joints of Luschka 21,
 94, 97

K

keyboard 37, 173, 172
kidney(s) 131, 92, 129
knee 150
 joint cartilage 134
kneading massage 72
knot-like muscle
 swellings 45
knowledgeable
 professional 112
knuckle cracking 115

L

ladder 168
laminae 12, 20, 77
lap top computer 184
lap-held devices 184
larynx 2, 15, 22
Lateral Neck Flexion
 Stretch (Ear to
 Shoulder Stretch)
 206
lawyers 30
leash 169
legal 28, 29
 - proceedings 31
 - protection 30, 98
legs 4

levator scapulae 20,
 198
Lhermitte's sign 90
ligaments 2, 9, 10, 12,
 13, 27, 28, 29, 32, 40,
 48, 49, 142
lighting 168, 171, 174
liniments 132
litigation 29, 36
litter scooper 169
liver 92, 129, 131
load, loading 177
loading the trunk 184
local anesthetic 133
local injections 46
local tenderness 90
log roll 62, 64
long-handled scrubbers
 169
long-handled shoe horn
 155
longus capitus muscle
 16
look upward 65
loose connective tissue
 12
love 181, 182
low back support 150
lucite bookholders 184
luggage 185
 - with wheels 184
lumbar spine 43, 116
 - disc problems 116
lumbar pillow 153
lumbar support 150
lump(s) 15, 23
lungs 13
lymph glands 4, 23
 - nodes 3

M

M.D. physicians 70
magical cure 82
magnetic fields 95, 96
magnetic healer 70
Magnetic Resonance
 Imaging 95
magnetism 83
magnification 77
mainstream of medicine
 81
malalignment 94
malignancies 42
managed care programs
 79
manipulation 21, 70,
 71, 114, 115
 - injury 70
 - therapists 115
 - therapies 70, 116
 - treatments 72
mantra 118
manual muscle
 testing 91
manual therapies 70,
 71
marijuana 82
massage 58, 59, 70, 71,
 107, 114, 116, 120,
 132
 - ointments 132
 - therapists 72, 81
mastoid 17
mattress 62, 64, 66,
 181
Max Planck Institute
 192
medical backup 58, 60
medical
 - centers 30
 - expenses 30
 - needs 80

- *specialists 68*
medications 30, 46, 59,
68, 80, 89, 92, 123,
132, 183
 Absorbine Arthritic
 Pain Lotion® 133
 acetaminophen 35,
 59, 127, 128
 - *sensitivity 129*
 - *with codeine*
 129
 acetominophen acetyl-
 salicylic acid 131
 Advil® 35, 128,
 130, 182
 Aleve® 35, 128,
 130, 182
 alprazalam 127
 Ambien® 128
 amitriptyline 132
 Aspercreme® 133
 aspirin 35, 59, 127,
 128, 131, 182
 - *sensitivity 129*
 - *with codeine*
 129
 Atarax® 128
 Ativan® 127
 Banalg® 133
 barbiturate sleeping
 pills 128
 Ben Gay® 133
 Benadryl® 128
 benzodiazepines 127
 camphor 132
 carisoprodol 127
 chloral hydrate 128
 chlorazepate 127
 chlordiazepoxide 127
 chlorzoxazone 127
 choline magnesium
 trisalicylate 131
 Clinoril® 130
 codeine 59

corticosteroids 12
cortisone-like
 - *drugs 59,*
 133, 135,
 139
 - *medication 134*
COX-2 NSAIDS 131
cyclobenzaprine 127
Dalmane® 127,
 128
Darvon® 59, 129
Daypro® 130
Deep Heating Rub®
 133
desipramine 132
DHC Plus® 129
diazepam 127
dihydrocodeine/aceta-
 minophen/caffeine
 129
diphenhydramine
 128
Disalcid® 131
doxepin 132
Elavil® 132
Empirin® with
 codeine 129
Equanil® 128
Exocaine® 133
Feldene® 130
Flexeril® 127
fluori-methane 106
flurazepam 127,
 128
Halcion® 128
oral steroids 135,
 136, 137
 - *high doses 139*
hydrocodone with
 acetaminophen
 129
hydroxyzine 128
ibuprofen 35, 128,
 130

Icy Hot® 133
Indocin® 130
Librium® 127
Lidocaine™ 59
Lodine® 130
lorazepam 127
meprobamate 128
methocarbamol 127
methylsalicylate 132
Miltown® 128
Motrin® 128, 130
Myoflex® 133
Naprosyn® 130
naproxen 35, 128,
 130
non-aspirin
 salicylates 135,
 136, 137
non-narcotic
 analgesic(s)
 127-129, 135-
 137, 182
nonsteroidal anti-
 inflammatory
 drugs (NSAIDs)
 59, 130, 131,
 135, 136, 137
Norflex® 127
Norgesic Forte®
 127
Norpramine® 132
Novocaine® 59, 133
NSAIDs 130
opium 82
orphenadrine 127
Orudis® 130
Oruvail® 130
oxazepam 127
oxycodone with
 acetaminophen
 129
oxycodone with
 aspirin 129
Parafon Forte® 127

Percocet® 129
Percodan® 59, 129
propoxyphene and
 acetaminophen
 129
Relafen® 130
Robaxin® 127
salicylates 131
salsalate 131
Serax® 127
Sinequan® 132
Soma Compound®
 127
Toradol® 13
tramadol 129
Tranxene® 127
triazolam 128
triethanolamine 133
trilamine salicylate
 133
Trilisate® 131
Tylenol® 35, 183
Tylenol® with
 Codeine 129
Ultram® 59, 129
Valium® 127
Vicodin® 59, 129
Voltaren® 130
Xanax® 127
Xylocaine® 133
zolpidem tartrate
 128
medicine(s) 36, 82,
 122
medicine cabinet 58
meditation 81, 126
menisci 20, 134
mental disturbances
 139
metabolized 130
metal braces 112
metal in the body 96
 - *plates* 108
 - *implants* 95

microsurgery 77
microwaves 114
migraine 47, 120
Miltown® 128
mind 117
mineral 121
mirror 15, 154, 164
"Mixers" 70
mobilization 114, 116
monitor 173, 174
morning exercise 155
movement in neck 90
movies 130, 179
MRI or MRIs 31, 32,
 59, 94, 95, 96, 98, 100
mud, mudbaths 120
multiple sclerosis 69,
 90
muscle
 - *action* 2
 - *relaxants* 62, 64,
 127, 128, 130,
 135-137, 183
 - *relaxation* 133
 - *relaxing* 126
 - *soreness* 44
 - *spasm* 45, 118,
 132, 133
 - *tension* 116, 119
 - *relaxing effect* 106
muscles 3, 5, 8, 13, 14,
 28, 89, 95, 96, 100,
 133, 142
musculoskeletal
 disorders 68, 69, 113
musculoskeletal
 mobilization 71
muscle strengthening
 213
myelogram 98
myofascial irritability
 46, 72, 90
myofascial pain 44, 45
myogelosis 45

N

narcotic analgesics 59,
 62, 64, 128, 129, 130,
 135, 136, 137, 182
natural 82
nature('s) 28, 29, 40,
 45, 99
nausea 129
neck and back postural
 support 149
neck and shoulder
 stretches 178
neck brace(s) 113, 184,
 193
neck craning 154
Neck Extension Stretch
 207
Neck Extensor
 Isometric **215**
Neck First Aid 57, 58, 68
Neck Flexion Stretch,
 Lateral (Ear to
 Shoulder Stretch)
 206
Neck Forward Flexion
 Stretch **201**
Neck Forward Flexion
 Stretch, Assisted
 (Head Hang) **209**
Neck Forward Flexion
 Isometric **213**
Neck Lateral Flexor
 Isometric **214**, 193,
 219
Neck Rotation, Assisted
 210
Neck Rotation,
 Beginning **200**
Neck Rotation,
 Intermediate (Over
 the Shoulder Stretch)
 205

neck muscle
- *fatigue 152*
- *spasms 126*
- *list 16*
neck posture 144
neck protection 58
Neck Second Aid 57, 58
Neck Side Bend Stretch, Assisted (Ear toward the Shoulder Stretch) **217**
neck stabilization 111
neck strain 60, 130
- *and pain 142, 152*
Neck Stretch, Isometric Contract-Relax Assistive **218**
neck, stiff 79
neck traction 108
needles, infected 42
nerve
compression 59
conduction response 100
endings 29, 117
function 30, 139
injury 59
pathway 117, 118
pressure 139
nerve root 12, 14, 77
- *channels 50*
- *compression 139*
- *damage 78*
- *decompression 79*
- *injections 138*
- *pressure symptoms 112*
- *steroid (cortisone-like) injections 138*
nerves 3, 4, 5, 17, 40
nervous energy 118
neural 21

neural canal 20
neurocentral joints 21
neurological complications 50
neurological lesion 100
neurologist 69, 74
neurosurgeon 73, 74
neurosurgical procedures 80
"neurotic" patient 98
nodules 23
non-pharmacological treatment 59
non-surgical 68
nose drops 62, 64
numbness 4, 13, 17, 28, 59, 109, 139
- *tingling, or weakness 88*
nurturing 121
nutrition 121
nutritional counselling 81
nutrients 188

O

OA "open access" MRI 96
obesity 121
occiput 5
occupational therapists (OT) 71
occupations 36
ointment 132
operate 74
operation 77, 79
second operation 99
oral medications 135, 136, 137
oral steroid (cortisone-like) drugs 134, 139

organic herbal medicines 81
orthopedic surgeons 73, 74
orthotist 112
osteoarthritic 21
osteoarthritis 40, 83
wear-and-tear 134
osteomyelitis 41, 42
osteopaths 69, 70
osteophytes 31
osteoporosis 6, 43, 83
osteoporotic cervical fracture 41
OTC (over-the-counter drugs) medications 104, 127, 128, 130
other illness 88
outdoor shows 179
outcome 31
over-exercise 65, 67
overgrowth of bone 12
Over the Shoulder Stretch (Intermediate Neck Rotation) **205**

P

packing 184
pads 173
pain 104, 132
- *suffering 33*
- *intensifying chemicals 117*
- *medication 186*
- *or weakness in arm or hand 79*
- *pathways 133*
- *pills 58, 104*
pain level
mild *pain level 57, 59, 66, 67, 105,*

114, 116, 126, 127,
130, 137, 165, 166,
167, 168, 169, 170,
181, 182, 184, 185,
186, 193, 219, 222,
224, 237, 241, 242,
244
minimal pain level
59, 67, 169
moderate pain level
57, 59, 63, 64, 65,
105, 114, 116,
126, 127, 130,
136, 155, 164-
170, 175-179,
181-184, 191,
193, 221
severe pain level
57, 58, 60, 61, 62,
126, 127, 128,
130, 135, 139,
154-157, 162, 164,
165, 168, 176,
177, 181, 183-186,
191, 219, 222,
236, 238, 240,
241, 244
pain relief 122
- *at home* 104, 105
- *therapies* 104
pain treatment center
79, 80
pain blocking chemicals
107
pan seat 150
paralysis 73, 78, 116
paraspinal muscles 6,
20
parathormone 6
parathyroid glands 6
parents 164
parking 175
passion 181
patent medicines 104

patience 78
patient's history 91
Pectoral Stretch **204**
pedicles 11, 12
pelvic pinch 144
penetrating deep heat-
ing 113
peripheral nervous sys-
tem 74
pets 169
pharyngitis 23
pharynx 2
Philadelphia Collar
112
phone 152, 171
phony cures 82
phrenic nerves 13
fifth phrenic nerve
13
fourth phrenic nerve
13
physiatrists 68
physical (nonmedical)
treatments 71
physical examination
59, 89
physical medicine and
rehabilitation 68, 69
physical therapists (PT)
71
physical therapy 34, 46,
59, 69, 80
- *treatment modali-*
ties 68
physicians 58, 69, 71,
72, 75, 80, 81, 91, 106,
108, 112, 113, 127-
131, 139
pillows 161, 179, 180,
182, 183, 184
bow tie 58, 181
butterfly 181
- *neck-supporting*
184

pinched
- *cervical nerve 100*
- *facet fat pad 21, 115*
- *nerve root 77*
pinching 15
pivot 7
placebo 82, 122
plane 185
planting 166
plastic bag 185
plastic braces 112
platysma muscle 15
plug of bone 76
PM&R 68
point-stimulator 107
poking 21
porous bones 43
posterior approach 77
posterolateral (back-
side) approach 77
postural strains posture
72, 90, 142, 147, 163,
179
dynamic 66
instruction 72
strains 10, 170
posture alignment (1-2-
3—2) 143, 144, 155,
154, 164, 167, 171,
172, 175, 176, 178, 179,
191, 219, 222, 236, 238,
240, 241, 244
posture instruction 72
power tools 168
powerful medicines
122
practitioner 121
pregnancy 108
prescription drugs 127,
130
preventable complica-
tions 58
primum non nocere
121

prism glasses 183
prodding 21
professional treatment 58, 108
progressive lenses 66, 171
proper diagnosis 91
prostatic enlargement 78
protruding disc 76
pruning 166
pseudogout 41
psoriatic arthritis 41
psyche (the mind) 120
- *counselling 34, 36, 47, 60, 80, 120*
- *depression 132*
- *effect 122*
- *needs 80*
psychosomatic stress 117, 120
punching 20
purgings 114
purse 175, 178, 184

Q
quack 82
quackery 82
quality of life 132

R
radiculopathy 109
radio signal (MRI) 96
raking 166
reacher strap 164
reaching 20
reaching tongs 168
reading
- *in bed 183*

- *glasses 172*
- *material 171*
rear visibility mirror 113, 161, 163
rearended 167
recording device 100
recreational activities 30, 117
reflex hammer 91
reflex muscle spasm 29
reflex phenomenon 45, 133
rehabilitation 68, 69
rehabilitation specialists 68
Reiter's syndrome 41, 42
relax 61, 63, 65, 67
relaxation 117, 118
relaxation by medica-tion 64, 126
repetitive stress disorders 36
research 82, 122
rest 117, 120
restaurant 178
restore mobility 116
results
good 77
fair 77
poor 77
rheumatoid arthritis 41, 42, 47, 83, 92
rheumatologist(s) 43, 68
rheumatology 69
rhomboids 212
rib attachments 6
first rib 17
second rib 19
RICE 57
risks
- *of surgery 7, 139*

- *of drug side effects 104*
rolfing-type massage 72
rolled
- *scarf or sweater 179*
- *towel 163*
romance 181
rotation 8
RSD 36, 37

S
scalene muscles 17
scarf 64, 66
scientific basis 115
scraping 168
screw driving 168
seat 150
- *back angle 163*
- *belt reacher 162*
- *belt strap 19, 162*
- *belts 164*
- *height 149, 151*
- *pan angle 151*
seated 148
seating 178
second opinion 32, 43, 78, 79
sed rate 92
sedimentation rate 92
sedating medication 96
sedation 62, 127, 128, 129, 130
self hypnosis 118
self-manipulation 115
sensitivity 129
septic discitis 42
serati 198
serious complications 77, 99

severe
- *arthritis* 93
- *paralysis* 75
- *problem* 89
sex 181
- *excitement* 182
- *relations* 182
shaving 154
sheets 180, 182
shiatsu 72, 107
shingles 89
shock absorbers 10
shopping 17, 176
- *cart* 177
short circuited spinal
cord reflex 133
short-circuiting pace-
makers 108
shoulder
- *bag* 186
- *blades* 19, 45
- *bursitis* 133
- *exercises* 193,
221-223
- *joints* 199
- *motion* 21
- *muscles* 201
- *strengthening* 224,
238
- *strain* 17
Shoulder Blade
Strengthening
(Isometric Adductor)
232
Shoulder Blade
Strengthener **231**
Shoulder Circles,
Advanced **208**
Shoulder Circles,
Intermediate **202**
Shoulder Pendulum
Stretch **225**
Shoulder Shrug with
Downward Stretch
191, 193, **197**

Shoulder Strengthener
(Isometric Flexors)
233
Shoulder Stretch,
Advanced (External
Rotation) **230**
Shoulder Stretch,
Advanced (Internal
Rotation) **229**
Shoulder Stretch
(Forward Flexion -
Supine) **226**
Shoulder Stretch
(Abduction and
External Rotation)
228
Shoulder Stretch
(Internal Rotation)
227
shovels, shoveling 166
shower 154
shower head extender
154
shrunken disc 49
side (lateral) view of
neck 94
side bending 8
side effects of medica-
tion 89, 127, 129,
135, 136, 137, 139
sidelying 18, 66, 182
sink 154
sitting 144, 147, 161
skeletal (DISH) 48
skeletal structures 5,
115
skill of the surgeon 77
skilled specialists 138
skin
- *circulation* 119
- *of the neck* 15
- *temperature* 119
skull 5
slanted desk book
holder 171

slanted surface for note
taking 171
sleep 47, 127, 131, 132
- *deprivation* 60, 117
- *face down* 65
- *on back* 62
- *wrong* 87
- *in bed* 71
- *on stomach* 179
- *poorly* 35, 117
slouch 65, 67
sneezing 62, 64
social
- *contacts* 60
- *needs* 80
- *worries* 35
soft collar 21, 28, 58-
65, 110, 111, 112, 118,
154, 155, 163, 164,
165, 169, 177, 178,
179, 182, 184, 185,
193, 240, 243, 244
soft tissue structures 95
somi (the body) 120
soothing 72, 120
sound waves 113
spas 120
spasm 29, 106
speaker phone 61, 64
special diagnostic
procedures 99
special expertise 73
specialists 68, 138
spinal canal 11, 12, 40,
138
spinal cord 4, 8, 12, 13,
20, 28, 40, 50, 59, 74,
76, 78, 95, 115, 116,
117, 138
- *and brain centers*
107
- *compression* 42, 77
spinal cord function
30
- *injury* 59, 77

- *pinching* 98
spinal
 - *fluid* 12, 138
 - *nerve roots* 138
 - *nerves* 28, 59
 - *slippage* 49, 94
 - *traction* 108
spinal-mobilizing
 maneuvers 70
spinous process 5, 7, 12
 fifth - 5
 fourth - 5
 seventh - 5
 third - 5
splenius capitis 17
splinting 72
spondyloarthritis 41
spondyloarthropathies
 42
spondylolisthesis 49,
 93, 94
sports medicine 74
sprains 28, 130
spray and stretch 106
Spurling's test 90
spurs 97
standing 144
steering wheel 162,
 163
steps, step stool 169
sternocleidomastoid 17
sternomastoid 17
sternum 6, 17
steroid injections 135
stiff neck 2
stiffening 19
stiffness 190
stockinette 110
stomach 128
stomach ulcers 131,
 139
straight-backed chair
 153
"Straight"s 70

strained muscle 9
straining eyes 61
strength of the muscles
 91
strengthen 21, 191-
 194
strengthening exercises
 105, 191, 193, 194,
 224, 238
stress 34, 35, 36, 120
stretching 63, 65, 67,
 133, 182
stretching exercises 19,
 37, 49, 105, 190, 191,
 222, 223
stroke 68, 78
stroking massage 107
stroller 165
stumbling 126
subclavius muscle 16
subluxations 49, 76, 94,
 115
suffering 30, 34, 36,
 132
sulphuric odors 120
sunglasses 163
supine (lying on your
 back) 109
surgeons 73, 74, 76, 78,
 82
surgery 32, 74, 78, 79,
 95, 104, 139
surgical
 - *complication* 79
 - *consultants* 73
 - *fusion* 49, 50
 - *intervention* 59
 - *management* 74
 - *options* 75
 - *procedures* 74, 77,
 139
 - *treatment, avoid*
 140
surgically repaired 28

swallow 2, 15, 22
Swezey Institute 143,
 192
swivel 171
swollen
 - *glands* 4, 23
 - *lymph glands* 23
swollen, sprained disc
 139
sympathetic nerves 4
systemic illness 92

T
table 148
teacher 167
telephone 152, 171
 - *headset* 61, 6
 - *keypad* 171
 - *tilt stand* 171
television 183
temporo mandibular
 joint dysfunction 109
tender point 9, 46, 47
 - *injections* 133
tendon 9
tendinitis 224
tennis elbow 30
tennis matches 179,
 193
TENS (Transcutaneous
 Nerve Stimulation)
 10, 107
tense 19
tensing 35
tension headaches 35,
 120
theater 178
therapeutic 114
 - *benefit* 11
 - *techniques* 116
therapist 106

therapy treatment
 options 10
thermaphore 105
thermogram 98
thermography 9
third opinion 79
Thoracic Outlet
 Syndrome (TOS) 17
thoracic spine 19
throwing 20
thrusting manipulations
 11
 - movements 116
thyroid
 - cartilage 2, 15, 16,
 22
 - gland 2, 15, 2
 - isthmus 22
 - low function 47
 - tumor 22
tight collar 15
tilting backward 152
tingling in an arm or
 hand 10, 59
TMJ 109
tobacco 8
toilet paper 154
tolerable pain 80
tongue 4, 2
tonsillitis 23
tools 166, 168
tooth brush 154, 155
torso 144
TOS (Thoracic Outlet
 Syndrome) 17
towel
 - roll 15
 - folded 154
toxic side effects 128
trachea 2, 22
traction 58, 71, 108,
 109
 - contraindications to
 109

- devices 110
- for acute facet dislo-
 cations 108
- methods 109
- motor driven 109
tranquilizers 182
Transcutaneous Nerve
 Stimulation (TNS or
 TENS) 10, 59, 107
transverse processes
 11, 17, 22
trapezii 197, 198, 201,
 202, 203
trapezius muscles
 (traps) 6, 16, 19
traumas 32, 36
travel, traveling 177,
 184, 185
 - by car 184
 - by bus 185
 - time 177
treatment options 104
trifocal 66, 171
trigger point injections
 133
trigger/tender point
 45, 59, 90, 107, 135,
 136, 137
trunks (cars) 177
tub bath 155, 182
tuberculosis 92
tumors 4, 22, 23, 43,
 74, 92, 94, 96, 116
TV viewer 183
twinges 35
twist 20, 65
twitchings 89
type 15
typewriter keyboards
 151

U

ulcers 128
ultrasound 71, 113, 114
uncinate process 21
uncomfortable chairs
 65, 67
uncovertebral joint
 21, 40
uncus 21
unifocal glasses 66
unloading 177
 - the trunk 177
unpacking 184
upholstery 150
upper back of chair 150
uric acid crystals 43
urination, difficulty
 with 132
urinary tract infections
 78
urine test 92

V

vapocoolant (cold)
 spray 106
veins 3
vertebrae 10, 12, 21,
 40, 43, 48, 76
vertebral arteries 11,
 22
vibration 107
vigorous exercise 193
viral hepatitis 113
vital centers 13
vitamin 121
vocational activities 30
voice box 2, 4, 15, 22

W

walls 175
warm shower(s) 63,
 155, 182
warm, moist heat 105
warm up 65, 67, 222,
 236-242, 244
water bowl (dog) 169
waterfall edge 150
watering 167
weeding 166
weak 4
 weakening 14
weakness 13, 17, 28,
 59, 139
 - in an arm 109
wear and tear 21, 31,
 36, 40, 97, 134
wear, tear and repair
 32
weather, cold 4
weight suspension
 device 109
wheels 176
whiplash 27, 28, 29, 31,
 36, 167
white blood cells 93
wide angle (wink)
 mirror 161, 164
windows shades 174
windpipe 2, 4, 22
wire sutures 96
word processors 36,
 151
work 30, 117, 169, 171
 - bench 168
 - gloves 166
 - situation 37
 - station 37
 - stress 120
 - related injuries 38
workshop 167, 168

worktable 148
worry 35
writing 15
wrist support 172
wry neck 90

X

x-ray exposure 94, 95,
 98
x-ray therapy 74
x-rays 31, 32, 34, 40,
 48, 59, 93-95, 135
Xylocaine® 133

Y

yards 165
yoga 81

Z

Ziplock plastic bag 185
zygapophyseal 20